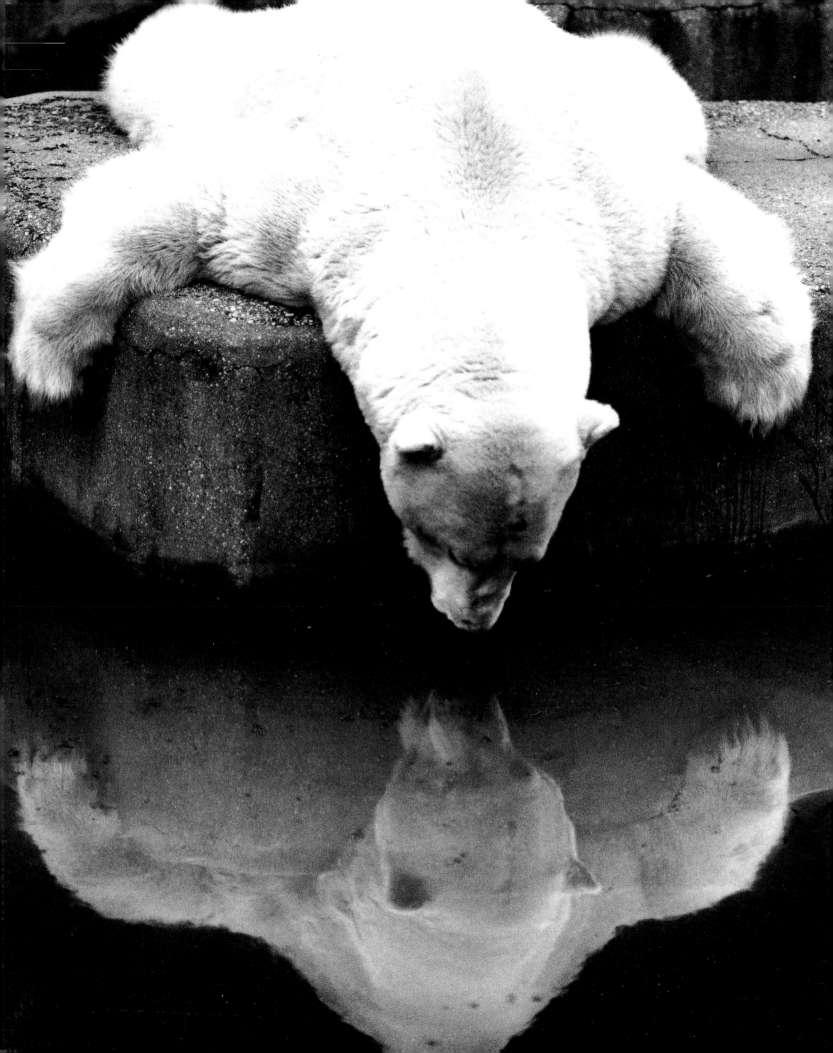

ON REFLECTION
Jonathan Miller

National Gallery Publications Limited, London
Distributed by Yale University Press

This book was published to accompany an exhibition entitled
Mirror Image: Jonathan Miller on Reflection at
THE NATIONAL GALLERY, LONDON
16 September – 13 December 1998

© NATIONAL GALLERY PUBLICATIONS LIMITED 1998

First published in Great Britain in 1998 by
NATIONAL GALLERY PUBLICATIONS LIMITED
5/6 Pall Mall East, London SW1Y 5BA

ISBN 1 85709 236 8 hardback
525274

ISBN 1 85709 237 6 paperback
525275

British Library Cataloguing-in-Publication Data.
A catalogue record is available from the British Library.
Library of Congress Catalog Card Number: 98-66560

Publisher
Suzie Burt

Designer
Chloë Alexander

Assistant Editors
John Jervis, Katya Ford,
Samantha Luckhurst

Picture Researcher
Edward Tilley

Indexer
Dorothy Frame

Special Photography
Colin Harvey

Illustrations
Kevin Jones Associates

Editor
Valerie Mendes

Printed in Hong Kong by
South China Printing Company

Colour Reproduction by Keene Repro (London) Ltd.

Front cover: Unknown Artist *Reflections in a Mirror*
mid-19th century

Back cover: (left) Eckersberg *Woman standing in front of a Mirror*
1841 (right) Brandt *Self-Portrait with a Mirror, East Sussex Coast* 1965

Front flap: (top) Cartier-Bresson *Place de l'Europe in the Rain* 1932
(middle) Follower of Leonardo *Narcissus* c.1490–9
(bottom) Bierschwale *Chimps* 1997

Back flap: Miller *Self-Portrait* 1956

Title page: Gibet *Polar Bear at Vincennes Zoo* 1988

Page 6: Attributed to De Man *The Card Players* 17th century

Acknowledgements

THIS EXHIBITION and the catalogue which accompanies it are the indirect result of discussions between Neil MacGregor and Patricia Williams as to the possibility of my giving four lectures on the relationship between painting and perception. As a result of their kind and forceful encouragement I settled on four topics, one of which became the basis of this exhibition. It started out as an enquiry into the representation of glimmer, gleam, glitter, sheen and shine, but the topic inevitably enlarged to include mirrors and reflections in general.

I owe a special debt of gratitude to Professor Richard Gregory with whom I have had many discussions over the last thirty years and whose own work on reflection is to be found in his recently published *Mirrors in Mind*. I have also enjoyed the all too brief acquaintance with the late Professor Irvin Rock of the University of California at Berkeley. And during my residency at the Exploratorium in San Francisco I profited from the work of Sally Duensing who is responsible for some of the most interesting exhibits in the Perception section of the museum. I have always been an admirer of V.S. Ramachandran, but it was as a result of meeting him for the first time on one of his brief visits to New York that I was introduced to his work on mirror synæsthesia.

I have enjoyed the friendly advice and criticism of Erika Langmuir, Nicholas Penny and Lorne Campbell of the National Gallery and I hope that they will forgive any stupid mistakes and omissions on my part. My discussion of Dürer's contribution to the art of self-representation relies heavily on J.L. Koerner's *The Moment of Self-Portraiture in German Renaissance Art* (Yale 1993).

I cannot do justice to the friendly cooperation that I have enjoyed from Mary Hersov and Michael Wilson of the Exhibitions department. Their dogged determination to obtain what often looked like completely unobtainable paintings was truly admirable and I can only thank them for their amiable tolerance at my frequent outbursts of frustration when faced by apparently inexplicable refusals from galleries and museums, both in England and abroad.

The staff of National Gallery Publications Limited have put up with a lot of procrastination and inefficiency on my part and I would like to thank Suzie Burt and Felicity Luard for their support and encouragement. Edward Tilley has heroically followed up reproductions and picture references and has shown the most extraordinary patience when faced with sudden and totally unexpected additions to the illustrations. I would like to thank Valerie Mendes for her editorial services.

Chloë Alexander has come up with an elegant and imaginative layout whose beauties I could never have foreseen when I began to visualise this

book. I also owe a special debt of gratitude to Katya Ford not only for her imaginative picture research but for her cheerful willingness to sit through hours of sometimes constipated dictation. Finally, I would like to thank Neil MacGregor, Director of the National Gallery, for inviting me to undertake this exhibition and for the hospitality which he and his staff have shown me during the many months of its development.

Jonathan Miller
London, 1998

Nicholson The Silver Casket 1919

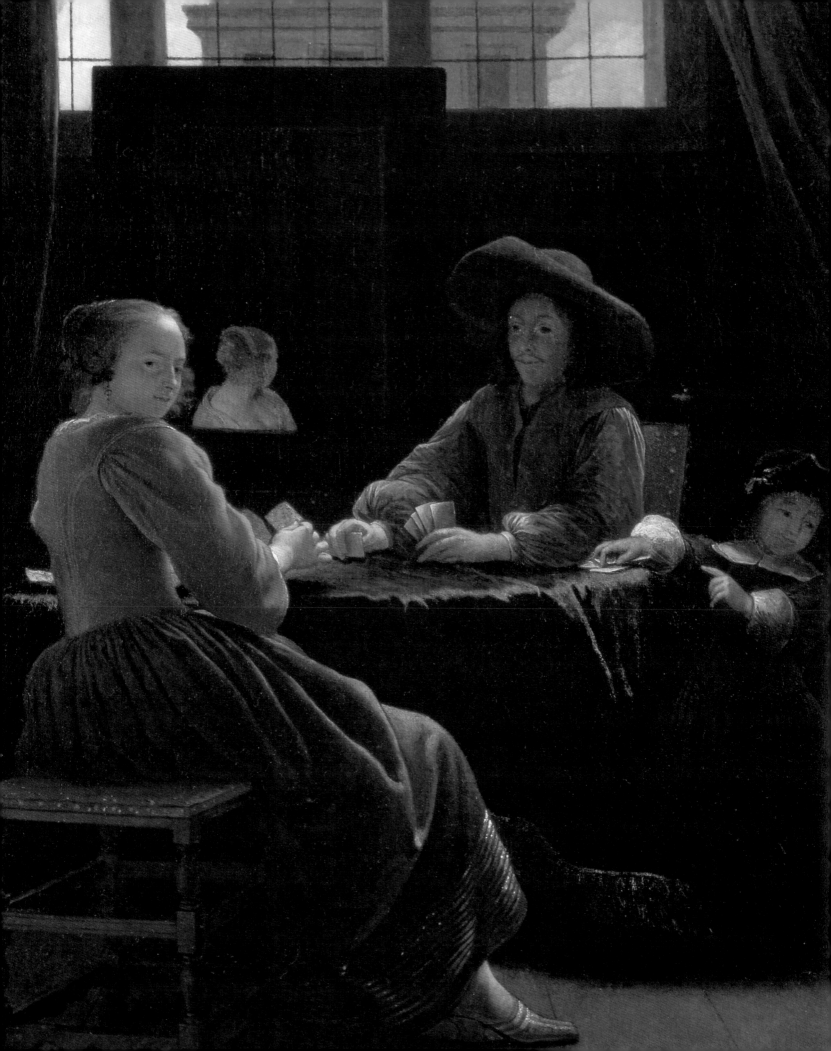

Contents

Sponsor's preface

THIS YEAR we celebrate the tenth anniversary of our partnership with the National Gallery by sponsoring *Mirror Image: Jonathan Miller on Reflection*. Perhaps appropriately this marks a new development after the very successful 'Making and Meaning' series which the Gallery has presented over the last five years. Previous Esso-sponsored exhibitions have opened the eyes of the visitor by putting into context paintings from the Gallery's own collection. This year Dr Miller continues this process by challenging our perceptions and assumptions about mirrors and reflections in art.

The National Gallery's success in increasing public understanding and appreciation of its collection is widely recognised and deserves rich applause. For Esso our association is particularly exciting because of the application of science to the exhibitions we have sponsored. Some two million people have visited 'Art in the Making' and 'Making and Meaning' exhibitions since 1988.

We are proud of the partnership and look forward to sharing in the success of *Mirror Image: Jonathan Miller on Reflection*.

K.H. Taylor
Chairman and Chief Executive, Esso UK plc

Foreword

OVER RECENT YEARS the National Gallery has mounted many exhibitions (mostly thanks to the generosity of Esso UK plc) on how pictures are made and what they were intended by the artist to mean. This exhibition (once again supported by Esso UK plc) and this book that accompanies it, are about something else: about how we look at paintings, how we decode not their meanings but the conventions of representation, how we negotiate the complex and often contradictory illusions that painters have conjured. How do we perceive pictures? Why do we read a flat painted surface as showing objects situated in real space? And how do we decide where we in reality stand in relation to their fictive location?

Jonathan Miller has taken as his theme one aspect of representation: reflections. But it is, of course, a particularly rich vein. From at least the time of Jan van Eyck, artists have exploited the opportunities mirrors offer for playing games with and on the spectator: in the *Arnolfini Portrait*, for example, we can see figures who must be behind us but we cannot see ourselves. The artist, while re-creating the world, has elided the viewer. What are the rules of this kind of visual game? How can the artist persuade us that we are looking not through a window at an object beyond the picture plane, but into a mirror?

Perceptual confusion rapidly becomes moral, and in this looking-glass world, language mirrors the ambiguities of looking. We no longer know where we stand — if indeed we stand at all. Mirrors are both symbols of vanity and emblems of prudence, and reflection both an insubstantial glistening and the process of rational thought which will let us re-assert control over our unreliable perceptions.

In this seriously ludic enterprise, there could be few better ring-masters than Jonathan Miller. He brings to the questions years of looking and a sustained interest in cognitive psychology. He can explain how human (as opposed to other) brains tackle the perceptual problems raised by the painting of reflections. And this he can locate in an intellectual history, a cultural landscape.

As a renowned director of plays and operas, Jonathan Miller has often robbed well-known works of their familiarity, giving them back their strangeness as well as their immediacy. In a sense, this book and exhibition are like a new production of a classic opera. Great works we thought we knew ask us unfamiliar and unsettling questions that go to the heart of our acquaintance with them.

With Jonathan Miller as a guide — or perhaps more accurately as an interrogator — we stand again in front of the pictures, looking longer at these inexhaustible and ungraspable things.

Neil MacGregor
Director

Introduction

MIRRORS, those reflective surfaces which produce an image of objects placed in front of them, recur as a pictorial motif in the history of Western art. Painters seem to have been intrigued by the relationship between the virtual reality which spontaneously appears in a mirror, and the one which they artificially create by marking an *un*reflective surface of plaster, paper or canvas. In both cases the observer sees something which is not where it seems to be, but in contrast to a painted image, which presupposes that the marked surface is visible, the vista which appears in a mirror requires that the reflective surface be *in*visible. When mirrors are represented in paintings, the situation becomes intriguingly complicated, because the virtual reality of the picture includes a second order of virtual reality in the form of a painted reflection.

The mirror, and reflections more generally, are the subject of this book and of this exhibition at the National Gallery, which houses perhaps the earliest and certainly one of the most striking examples of a painted reflection: the mirror in the optical centre of *The Arnolfini Portrait* by the fifteenth-century Netherlandish master Jan van Eyck. Yet it was not this famous picture which first aroused my own interest in reflections, but the behaviour of a familiar cat whom I watched some years ago from the front porch of my house.

An hour or so earlier, an unexpected downpour had left deep puddles of rainwater in the gutter. Normally the cat would have hurried across the street without pausing to examine the ground underfoot, but now it sat hesitantly at the kerbside, reluctant to go any further. From time to time it cautiously dabbled the surface with its paw and fastidiously shook off the droplets of water. After a while it crept along the pavement to a point where the gutter was dry. Here it scuttled across the road just as I had seen it do before. Evidently pawing the puddle had confirmed its suspicion that it would be risky to entrust its full weight to such a treacherously yielding surface. But why had the cat hesitated in the first place, and what prompted it to 'test' the puddle so cautiously? Something about the appearance of the puddle must have enabled the creature to distinguish it from the safely supportive surface of the gutter. What could it have been? One answer might be that, in contrast to the dry ground, the surface of the puddle was disconcertingly reflective. But what exactly does that *mean*? What does a reflective surface *look* like and how could a cat or anyone else distinguish it from a *non*-reflective one?

It was no good invoking physical optics, because that's how we *explain* the difference, not how we *experience* it. Cats know nothing about the physics of reflection, and neither do most human beings. So it must have been a

question of appearances, which is another way of saying that reflective surfaces just *look* different. In what way though? When you ask people to characterise a reflective surface, they usually insist that it looks *shiny*. But not in the way the sun shines: it's the *surface* which gives off the shine. But the more reflective the surface – a mirror being the ideal example – the harder it is to see it, and the more difficult to claim that it *looks* shiny. How can something invisible be said to have a *look*, shiny or otherwise? Yes, but ... it would be absurd to claim that the cat, looking at the puddle, had *seen* nothing. *Something* it had seen must have caused it to hesitate and *what* it had seen turned out to have a surface, as the cat soon discovered by dabbling its paw in it.

All right then, although the *surface* of a puddle, like that of a flawless mirror, is invisible, the *area* it occupies is not. Pools of water, like mirrors, afford the observer a 'view', though as we shall see, in contrast to the 'actual' view to be seen through a window or a door reflected views are 'virtual' or apparent: they are not where they *seem* to be. Looking at the puddle from the opposite side of the street I could see what *I* knew to be the reflected image of the cloudy sky above. I doubt if the cat saw it in those terms, and that it was disconcerted by seeing clouds and foliage where they had no business to be. Still, in all probability it must have experienced the puddle as a perplexing discontinuity in the surrounding dry ground, and although it may not have recognised what it saw as displaced sky, I suspect that it *did* see something at a disconcerting depth below the surface of the road. In other words, the cat reacted to the 'virtual' view of sky and branches *above* as if it were the 'actual' view of an illuminated cavity.

In that sense, the cat's behaviour was comparable to that of a human infant who will consistently refuse to crawl across the edge of a *trompe l'oeil* 'cliff' painted on the nursery floor. In fact, one of the most important functions of the visual system is to represent the mechanical supportiveness of the ground underfoot and to anticipate dangerous pitfalls. The ability to detect *watery* depths has the added advantage of protecting terrestrial mammals against the risk of drowning as opposed to merely stumbling.

In the natural conditions under which the visual system evolved, horizontal sheets of still water would have been the only surface whose reflectiveness represented an interpretative challenge. Upright surfaces of rock and vegetation are self-evidently opaque and readily identifiable as solid obstacles to be got round, or behind which prey or predators might be concealed. In nature there are no vertical surfaces offering deceptive views of a 'virtual' beyond. So the invention of *artificially* reflective materials complicated the scene considerably, and although human beings have learned to live in a world which now includes mirrored walls and plate-glass windows,

Vandivert *The Visual Cliff* 1984

it's easy to underestimate the perceptual problems created by surfaces which are reflective enough to provide misleading views. We take it for granted that the 'virtual' view to be seen in a mirror is automatically distinguishable from the 'actual' view through a doorway or a window, but the distinction requires cognitive work. One of the purposes of this exhibition and book is to bring the details to light, and to analyse how and why we make perceptual mistakes. As we shall see, it takes some time for the relevant skills to develop, and it's not until the second year of life that the human infant fully grasps the 'grammar' of reflection.

It is hardly surprising that artists, who deal in representational ambiguities, should have been attracted to the motif of the mirror, and exploited it in many different ways.

The mirror in Van Eyck's *The Arnolfini Portrait* is paradoxically shiny (!), its reflected imagery rendered in invisible brush strokes and turns our attention in the opposite direction to the 'actual' scene represented.

Velázquez, who would have been familiar with Van Eyck's painting since it hung in the Spanish royal collection in Madrid, developed the pictorial paradoxes of reflection still further. In addition to the *represented* mirror, he teasingly implies an *un*represented one, without which it is difficult to imagine how he could have shown himself painting the picture we now see, *Las Meninas*. For to reflect the appearance of the otherwise invisible self is one of the mirror's best-known functions.

Most things which appear in a mirror duplicate what can be seen in its immediate vicinity. And even when the reflected objects are temporarily invisible in reality because they are behind us, we can see them by turning around. But for each of us there is one item whose appearance is inescapably confined to the mirror, because there is no way of seeing it *except* in a mirror. Until we see ourselves reflected we haven't the faintest idea of what the most recognisable part of us looks like. And pools of water are less helpful in this respect than the myth of Narcissus implies. In order to see your face in the horizontal surface of water you have to crane over the top of it, and from such an angle the reflected image is compromised by what can be seen *through* the surface. Apart from the fact that mirrors are optically insulated, so that the reflectiveness of glass is not confused by its transparency, they can be set up to afford a more convenient and often full-length view, one which corresponds to the view which others have of us.

But in order to take advantage of this amenity, it is necessary to understand what we are looking at. Even if the polar bear illustrated on the frontispiece of this book could see himself from such an angle, it's unlikely that he would recognise himself. The chances are that, being a bear of very little

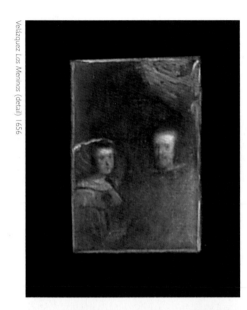

Velázquez *Las Meninas* (detail) 1656

Follower of Leonardo *Narcissus* c.1490–9

brain, he, like the equally dim-witted Narcissus, thought he was looking at someone else! As it is, human beings and chimpanzees appear to be the only animals capable of identifying themselves in their reflection. Which is what we might expect, considering how anomalous the experience must be. Although we soon become accustomed to it, there is something paradoxical about seeing ourselves from the viewpoint of another person, and in the first instance at least it must be difficult to accommodate the idea of being in two places at once. And yet by the time we are two years old we scarcely give it another thought, and, as many of the pictures in this book and the exhibition show, a significant proportion of human culture is based on the reflected visibility of the personal self. Apart from its obvious and indispensable use in monitoring and modifying our *facial* appearance – cosmetics and coiffure would be inconceivable without it – the skill of the ballet dancer depends on being able to see herself from the viewpoint of an independent observer, at least during rehearsal. For all these reasons, the mirror, in art as in life, has assumed complex metaphorical significance, epitomising both the vice of vanity and the virtue of prudent self-knowledge.

The surfaces which furnish such experiences are ideally invisible, since anything which can be seen *on* them gets in the way of what is to be seen *in* them. But there are other artefacts whose reflectiveness is deliberately contrived to draw attention to their surface, and although this may also reflect a recognisable image, that is not the point of the exercise. The reflectiveness of jewellery, armour, ornamental tableware and 'important' furniture is carefully enhanced, not to allow a view of something else, but because the resultant lustre is delightful in its own right.

The extent to which a surface reflects a recognisable image varies enormously, and in this exhibition and book I have tried to show the full range, from the diffuse sheen of burnished copper to the representational realism of silvered glass. The depiction of such variously reflective surfaces has challenged the virtuosity of artists for more than two thousand years, and the exhibition will, I hope, allow the visitor an unprecedented opportunity to reflect upon the somewhat neglected subject of reflection.

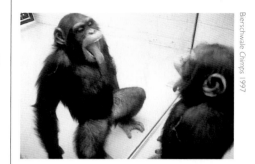

Bierschwale Chimps 1997

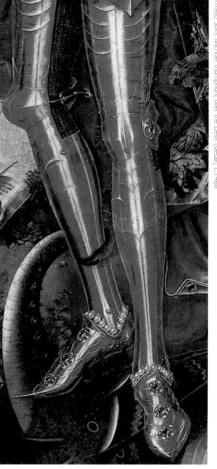

Bermejo Saint Michael triumphant over the Devil (detail) c.1468

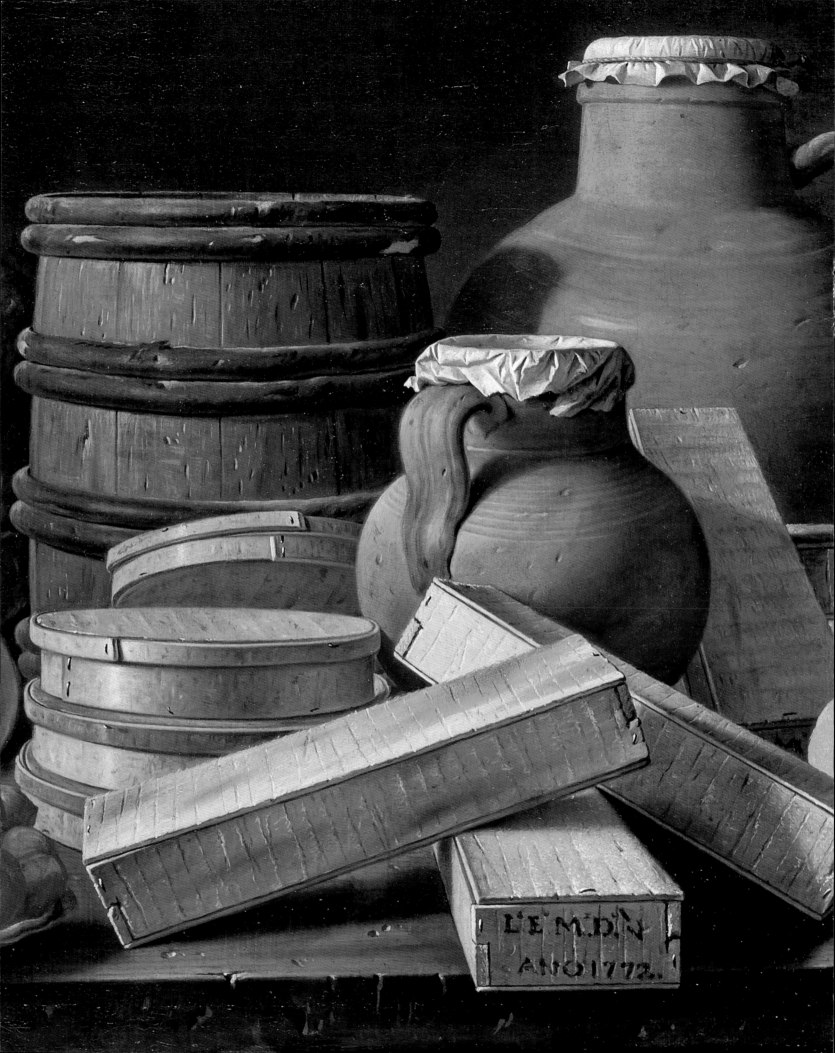

THE NATURAL WORLD reveals itself in borrowed light. With the exception of incandescent bodies such as the sun, whose high temperature causes them to emit light, the visibility of the environment depends on the radiant energy which it reflects from primary sources elsewhere. Although this is an undeniable matter of fact, it does not exactly correspond to our experience. It is not altogether how things *look*. What we see is an illuminated vista of physical objects and the reflected light to which they owe their visibility is not explicitly apparent. The reason is, that with certain important exceptions, the surface of physical objects is more or less densely pitted with microscopic irregularities from which the rays of incident light are reflected in optical disarray. Instead of preserving the parallel order in which they arrive, the rays are scattered in so many different directions that the reflected image of their source is confused beyond recognition and what we see instead is an illuminated panorama of variously coloured local textures.

But not all surfaces disrupt the incident light to the same extent. The amount by which they do depends on the depth and frequency or 'grain' of their optical imperfections. The smoother and less pitted a surface is, the more coherently the rays of incident light are reflected from it. And in the limiting case, such as the mirror or standing water, the coherence of the reflection so accurately reproduces the image of the source that it more or less precludes the visibility of the surface from which it rebounds. The result is that in contrast to a *matt* surface which displays nothing but its own local characteristics, the visibility of a *polished* one is almost entirely due to the imagery which it reflects.

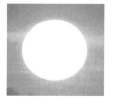
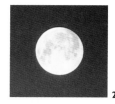

The configuration of shadows clearly indicates the direction from which this cluttered still life (**1**) is illuminated. But since the roughened surfaces of wood and terracotta scatter the incident light, the fact that the ensemble of objects owes its visibility to a barrage of reflected rays is not explicitly apparent.

The Sun (**2**) is a primary source of illumination, emitting light as a result of its incandescently hot gases.

The Moon (**3**), like the boxes and pots in Meléndez's picture, owes its visibility to the light which it reflects from the distant incandescence of the Sun. Dead and cold, it emits no light of its own.

A smoothly polished surface (**4**) reflects the rays of light coherently in one direction, at an angle which is equal but opposite to the one at which they arrive. The observer, however, 'sees' the reflected image along the line of its reflection and therefore, by illusion, *below* the surface. The rougher the surface (**5**) the more scattered and incoherent the reflection becomes so that the image of the light source becomes blurred and diffused, and the local characteristics of the surface become increasingly apparent.

Meléndez *Still Life with Oranges and Walnuts* 1772

Skidmore Boat 1977

As its optical properties approach that of a mirror (**1**) the visibility of the surface is increasingly replaced by the scene which it reflects. Try turning the page upside down and see if you can tell the difference between reflection and reality. In the Købke (**2**) it is only the ripples that give the game away.

When it comes to representing water, this is something which amateur painters frequently misunderstand. The critic John Ruskin, who was an accomplished artist in his own right, encourages the novice to use his eyes before putting pen to paper. He describes this in his lectures on *The Elements of Drawing* (1886):

Water is expressed, in common drawings, by conventional lines, whose horizontality is supposed to convey the idea of its surface.

In paintings, white dashes or bars of light are used for the same purpose.

But these and all other such expedients are vain and absurd. A piece of calm water always contains a picture in itself, an exquisite reflection of the objects above it. If you give the time necessary to draw these reflections, disturbing them here and there as you see the breeze or current disturb them, you will get the effect of the water; but if you have not the patience to draw the reflections, no expedient will give you a true effect. The picture in the pool needs nearly as much delicate

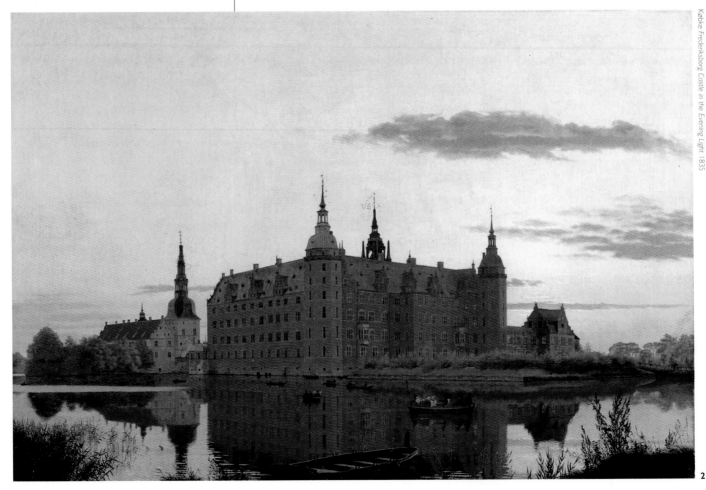

Købke Frederiksborg Castle in the Evening Light 1835

drawing as the picture above the pool; except only that if there be the least motion on the water, the horizontal lines of the images will be diffused and broken, while the vertical ones will remain decisive, and the oblique ones decisive in proportion to their steepness.

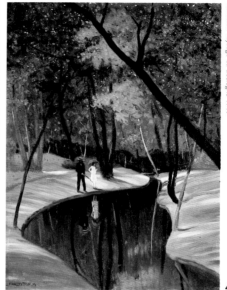

Vallotton Paysage du Boulogne 1919

4

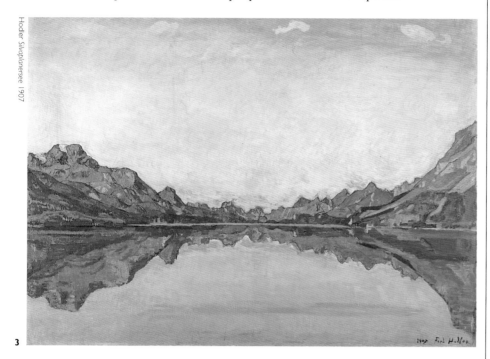

Hodler Silvaplanersee 1907

3

In the paintings by Hodler and Monet (**3**, **5**) reflection and reality are symmetrical about the axis of their respective waterlines. Try looking at the page sideways and see how much the two pictures look like Rorschach ink blots! (**6**)

Vallotton's woodland pool (**4**) is so shaded that it scarcely betrays the presence of its perfectly reflective surface.

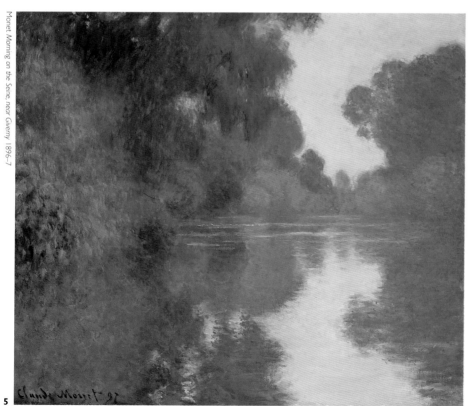

Monet Morning on the Seine, near Giverny 1896–7

5

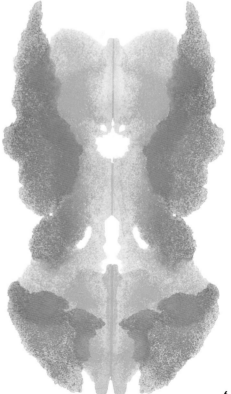

6

Light and lustre

Between the two extremes of matt and mirror there is a continuous series of intermediate forms, to which various familiar terms are applied – gleam, shine, flare, glimmer and of course lustre – and the appearance of any one surface depends on the extent to which it scatters the incident light, as opposed to reflecting it in a strictly rectilinear fashion. In surfaces with a relatively coarse microscopic texture, the proportion of scattered reflection is comparatively large, so that the light which is reflected in a more regular order is barely detectable as an indistinct gleam or highlight whose colour is similar to that of the source. If the surface is illuminated by relatively colourless daylight, the flare will effectively bleach the local colour of the surface. If the illumination is

The Delft School interior (**1**) is a veritable salad of differently reflective surfaces. The widely distributed sheen of the silk dress is alluringly reflected upside down in the polished floor, which in turn is anamorphically reflected in the globular fire-iron. Meanwhile the various vessels give off a glinting display of reflected highlights. The burnished leather on the back wall is just smooth enough to reflect a broad gloss. Only the mirror gives back a perfectly pictorial image – or is it a painting?

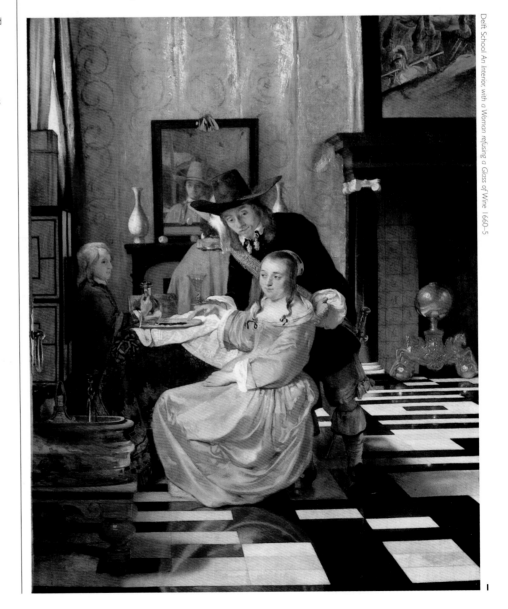

Delft School An interior, with a Woman refusing a Glass of Wine 1660–5

1

Zurbarán A Cup of Water and a Rose on a Silver Plate 1627–30

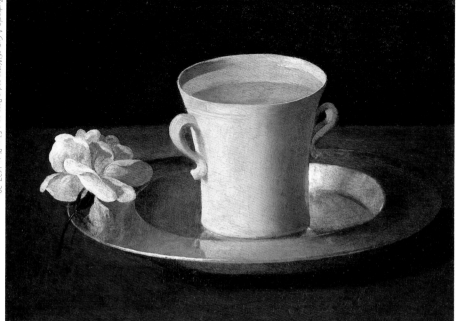

2

The matt surface of the cup (**2**) scatters and diffuses the incident light from the left, whereas the polished silver reflects a curved highlight and an almost perfect image of the blossom *and* the pottery.

A display of various lustres (**3**) each of which would shift with alterations of the observer's position. But on the flat surface of the canvas they remain constant, regardless of the viewpoint. You could say, but no one does, that in a good still life the gleams follow you around the room.

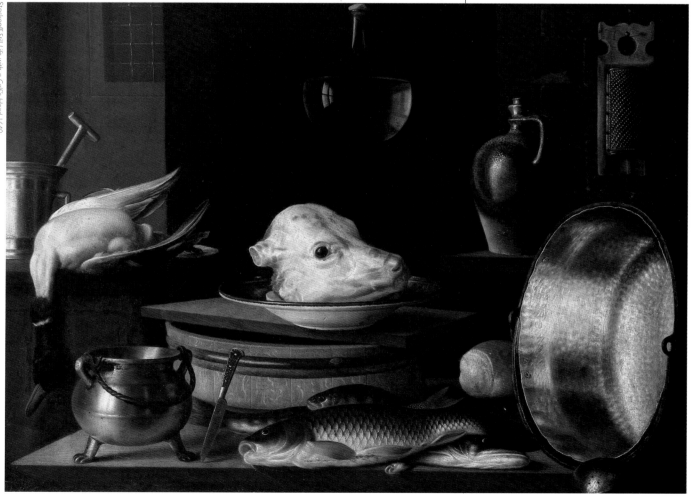

Stoskopff Still Life with a Calf's Head 1640

3

People *do* say that in a good portrait (**1**) the *glance* follows you around the room. It does nothing of the sort. If, as in the Titian, it happens to be a picture of someone looking at you, it is bound to go on doing so no matter where you see it from. It is flat, that's why. In fact, in this respect *glint* and *glance* obey the same rules. Since they are represented on a two-dimensional surface they cannot change their appearance as a result of the observer's movements in three-dimensional space. If you were moving around the room in which the objects represented by Kalf (**2**) were laid out, the glints and glimmers would change accordingly. And so would the windowed highlight on the postboy's leather peak cap (**3**). But in the art gallery these lustres are fixed forever and like the gaze in Titian's portrait they would seem to follow you around the room.

strongly tinted, the highlight will be dyed with the same colour. In contrast to scattered light, which rebounds in many different directions and is therefore visible from any viewpoint, the rays which are reflected in a more orderly fashion rebound in one direction only, and unless the observer happens to view the surface along the principal axis of this reflection, the highlight disappears. Leonardo da Vinci was one of the first artists to recognise the way in which the visibility of lustre varies according to the observer's viewpoint. He distinguished two forms of reflected light: so-called *lume* by which he meant randomly scattered light, and *lustro* which was responsible for the gleam which is to be seen 'on the polished surface of opaque bodies'. According to Leonardo the lustre 'will appear in as many different places on the surface as different positions are taken by the eye'.

The optical instability of lustre varies according to other factors, one of which is the size of the luminous source. When a surface is illuminated from a relatively small source — say a distant window — the visibility of the reflected highlight is critically dependent on the viewpoint, whereas if the scene is more

Titian *Portrait of a Man* c.1512

1

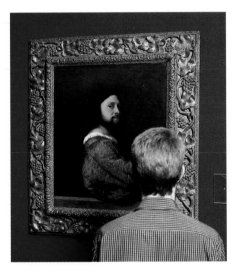

broadly illuminated — say from the sky — the reflected lustre is relatively widespread and the visibility is comparatively resistant to changes of viewpoint. Even so, the fact that a highlight is preferentially reflected at one angle rather than another means that the lustre unmistakably fluctuates when viewed from different positions. This is not observable, however, in pictorial representations, since the highlight is depicted on a two-dimensional surface and cannot vary as spectators change their position. The same applies to the legendary eyeline of a portrait which is said to follow the spectator around the room. It does no such thing, of course. The gaze, like the lustre, is represented on a flat surface and it cannot change its appearance with alterations in the observer's position.

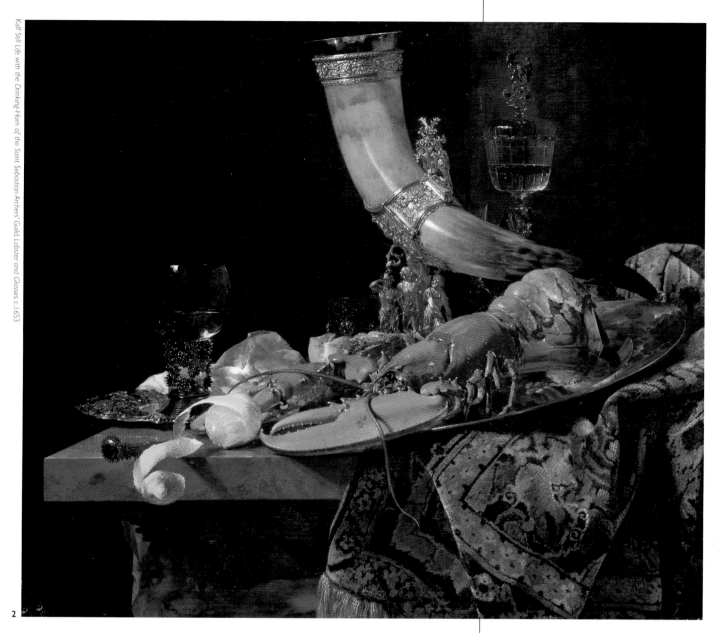

Kalf *Still Life with the Drinking-Horn of the Saint Sebastian Archers' Guild, Lobster and Glasses* c.1653

2

Another factor which influences the visibility of lustre or sheen is the curvature of the surface from which it is reflected. Highlights which are thrown off from sharply angled surfaces come and go with captivating abruptness, should either the object or the observer shift. This is why diamonds glitter or scintillate when twiddled in the incident light.

Another characteristic of lustre is the fact that it seems to hover somewhere below the surface in which it appears. In contrast to the local texture and colour of the object, which are coextensive with the plane of its surface, the sheen or gleam appears to be in the depths. Once again, this is less apparent in a flat picture than it is in three-dimensional reality.

Reiter *The Young Postboy* (detail) 1846

3

Taken out of context, the reflected skylight (**1**) does nothing for the surface in which it appears. Conversely, without the window, the granite looks dull and matt.

Highlights

In the examples cited so far the surfaces are just smooth enough to furnish a distinguishable lustre. But since the proportion of scattered light is still considerably greater than that of the more regular reflection, the highlight is not distinct enough to disclose an identifiable image of its source. As the optical smoothness improves, the resolution of the highlight increases to the point where we can often recognise a miniature representation of the light source itself. In Hummel's painting of *The Polishing of the Granite Bowl*, it is possible to make out a clearly reflected image of what must be the invisible skylight in the roof of the workshop. But since the obliquely incident light was too dim to illuminate the rest of the interior, the virtual images of the windows appear in puzzling isolation, looking for all the world like illustrated labels stuck on to the otherwise clearly visible surface of the splendidly polished granite. If the workshop had been brilliantly lit from within, as it might have been in a modern factory, the otherwise characteristic appearance of mottled granite would have been subordinated to a panoramic reflected image of the walls and rafters. By convenient coincidence, we can see this effect in Hummel's *The Granite Bowl in the Lustgarten, Berlin*. The brilliantly

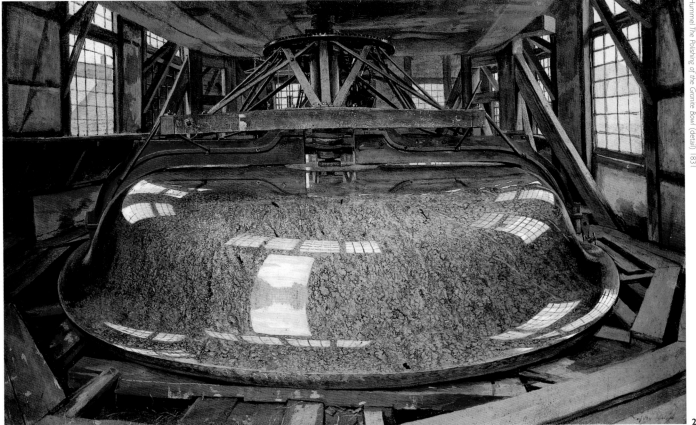

Hummel *The Polishing of the Granite Bowl* (detail) 1831

2

sunlit piazza is comprehensively reflected in the undersurface of the bowl, and over quite large areas the distinctive appearance of the granite is replaced by an upside-down image of the surrounding scene.

 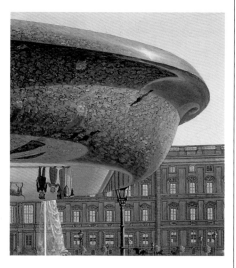

3,4

The bounce of secondary light (**3**) is reflected in a perfect upside-down picture of the park and the granite looks polished, though the surface as such is invisible.

The primary source of illumination (**4**) is barely reflected as a featureless gleam on the upwardly facing lip of the bowl.

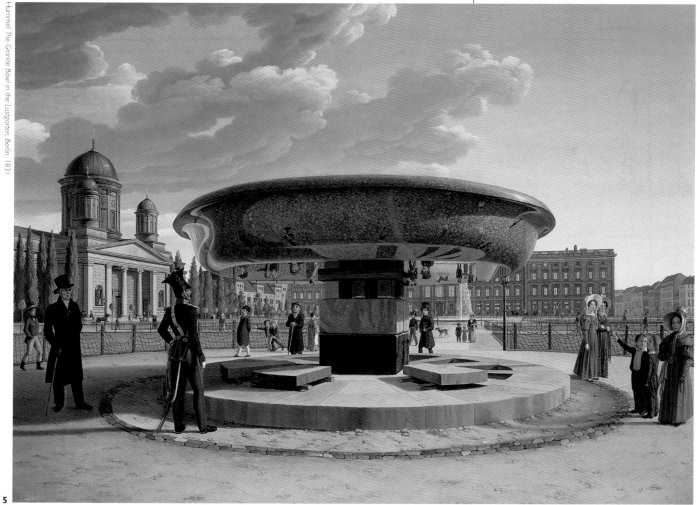

Hummel *The Granite Bowl in the Lustgarten, Berlin,* 1831

5

With unprecedented attention to minute detail Van Eyck (**1**, **2**, **3**) succeeded in rendering the subtle difference of lustre or *splendor*. He accurately captured the blurred shimmer of pearl, the wiry glint of gold thread, glinting metal and the mysterious lustre of faceted gemstones. The prismatic amethyst (**4**) is the acme of his display, with its accurately detailed reflection of what must be the chapel window.

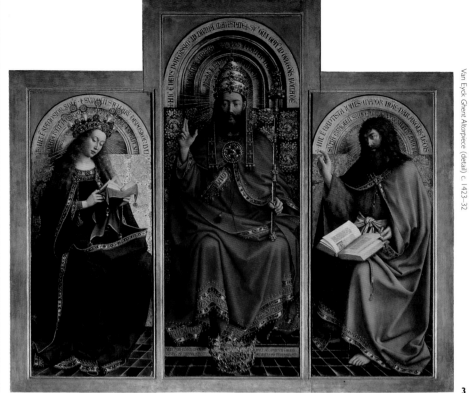

Van Eyck *Ghent Altarpiece* (detail) c. 1423–32

3

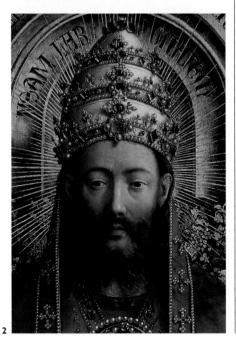

1

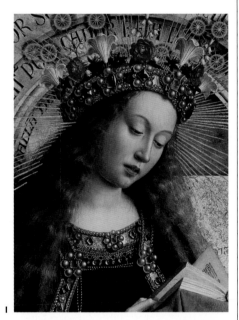

2

The windowed highlight which appears in Hummel's *The Polishing of the Granite Bowl* is a comparatively recent example of what was already a standardised convention for representing shiny surfaces. Jan van Eyck revelled in the display of such surfaces and with unprecedented virtuosity he captured the bewildering variety of surface lustre: the alluring sheen of pearls, the glisten of gold thread, the sharper glint of precious metals. In their discussions of light, medieval students of optics distinguished four recognisable categories. *Lux* referred to the brilliantly visible source of light emitted from incandescent bodies such as the sun, flame and white-hot metal. *Lumen* was the invisible form assumed by light in transit. When reflected, or rather scattered, from a matt surface it resumed visibility in a form which they identified as *color* (Latin). But when the light was reflected from a lustrous surface, it gave off *splendor* (Latin). For some reason, artists found it difficult to represent *splendor* pictorially, and they found it necessary to exemplify these materials with physical tokens such as gold leaf and coloured glass.

But by the time Van Eyck undertook the task of representing glamorous jewellery, this was no longer necessary. Because of his observational skill and the availability of transparent media, he could *depict* precious stones instead of *exhibiting* them; and in the large jewel to be seen on the breast of the chorister, (**4**) we can identify the triumphant culmination of this method. Van Eyck has whitened one of the facets with a recognisable image of the window by which the altarpiece must have been been illuminated.

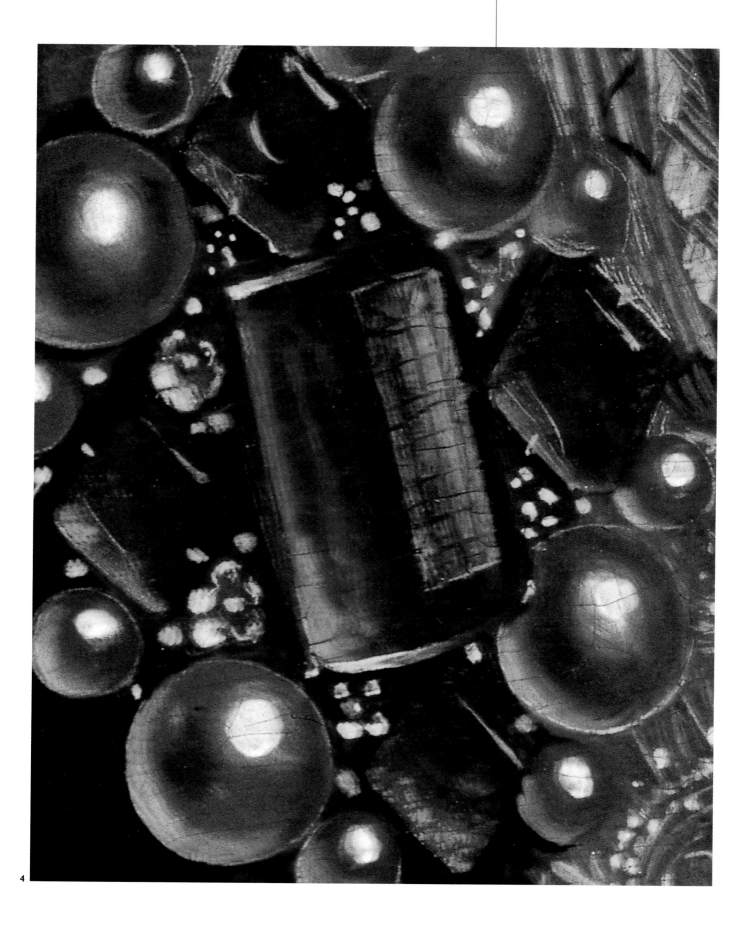

Transparent glazes may have *allowed* Northern artists to represent the varieties of surface *splendor*, but that doesn't explain why they made such a productive use of this opportunity.
I sometimes wonder whether it was a climatic difference. In the moist, rainy North shimmer and sheen are in the air, as it were.
They are much less conspicuous in the dry, dusty South.

In traditional accounts Van Eyck's virtuosity has been explained as the result of his skilful use of oil paint, but his mastery of *splendor* is just as much the result of his close observation of such phenomena.

Because they used tempera rather than oil, Van Eyck's Italian contemporaries were unable to compete with him in the representation of *splendor*, and as Professor Gombrich (1964) has pointed out, the surfaces which appear in Domenico Veneziano's *Saint Lucy Altarpiece* in the Uffizi in Florence are strikingly *un*reflective in comparison to the pictorial glitter of Northern panels.

Domenico Veneziano *Saint Lucy Altarpiece* (detail) 1445–50

1

Van Eyck Van der Paele Altarpiece (detail) 1436

In the overall panorama of reflective *splendor* it is easy to overlook the windowed highlight which appears in the magnificent amethyst. But in Northern art at least Van Eyck's reflected window spawned a multitude of pictorial offspring. For more than two hundred years the reflected window recurs as a conventional motif signifying the polished smoothness of the surface in which it figures. Its appearance differs according to several independently variable factors:

• the local properties of the reflective surface. If the surface is *coloured* it will tint the highlight accordingly. The *texture* may blur the highlight, and the *curvature* of the surface may disfigure it

• the size of the window which provides the illumination

• the intensity of the circumambient light – the extent to which the incoming light brightens other features of the interior.

In the Delft School interior (**1**), the *colour* of the metal tints the reflected scene, the *imperfections* of the surface blur it ever so slightly and the spherical *shape* disfigures its geometry.

The almost imperceptible window reflected in the arm of the chair in which Monsieur Bertin is seated (**2**) indicates the gloss of the surface.

Delft School *An Interior, with a Woman refusing a Glass of Wine* (detail) 1660–5

1

Ingres *Bertin l'Aîné* 1832

2

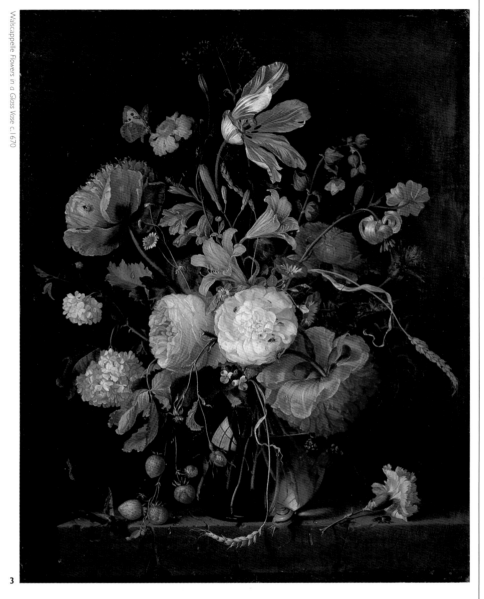

If it were not for the splendidly warped reflection peeping through the flowers in Walscappelle's still life (**3**, **4**), the voluminous transparency of the vase would be almost invisible. As it is, the vessel bulges unmistakably by disfiguring the window which illuminates the scene.

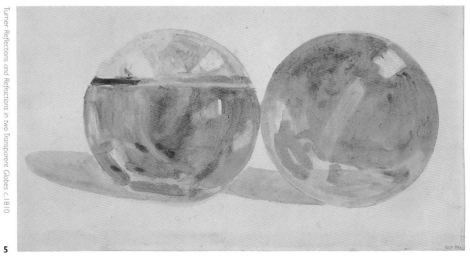

Turner executed several exercises in the optics of reflection. From the systematic curvature of what we know to be a row of rectangular windows we can virtually feel the globular transparency of these glass spheres (**5**). They are also reminiscent of the 'vile jelly' of the eye itself, as if we were looking through the vitreous humour of the eyeball to the projected image on the retina. The mirror in Van Eyck's *The Arnolfini Portrait* on page 30 also seems to represent vision itself, consciously seeing what it reflects!

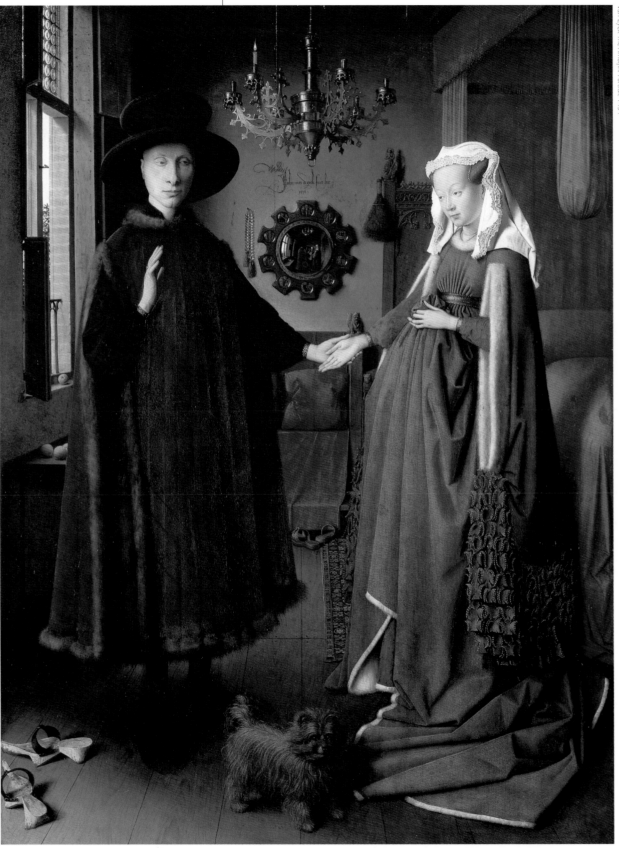

If, as in Hummel's picture on page 22, the reflective surface has strongly marked local colours of its own and if the incident light is comparatively dim, the window appears in isolation, superimposed upon the green complexion of the stone. But if the window admits enough light to illuminate the interior quite brightly, and if, in addition, the reflective surface is colourless, the image of the window visibly occurs in its setting. One of the earliest examples of this is the legendary mirror on the back wall of Van Eyck's *The Arnolfini Portrait*. Although the window is the brightest feature in the reflected scene, and its presence is undoubtedly what helps to give the mirror its gleaming lustre, the room and its inhabitants are clearly visible. The effect is so striking, so visually seductive, that it was emulated by several of Van Eyck's contemporaries. The long tidal wave of its influence can be seen four hundred years later.

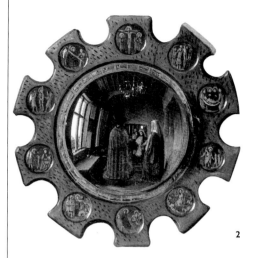

2

The human gaze will often direct our attention to something which we, looking elsewhere, must turn to see. Van Eyck's mirror (**1**, **2**) actually reveals what would be seen by looking at the couple from behind. In Orpen's painting (**3**) the relationship between looking and seeing is made even more explicit. Like a 'thinks' bubble in a cartoon strip, the mirror shows what the young woman is seeing. It is as if we were looking at the inside of her mind!

Van Eyck's mirror was such a striking cultural mutation that it almost immediately replicated itself with variations in the work of his contemporaries. It pops up like a disembodied Cyclops in Petrus Christus' *Saint Eligius* on page 32.

Orpen *The Mirror* 1900

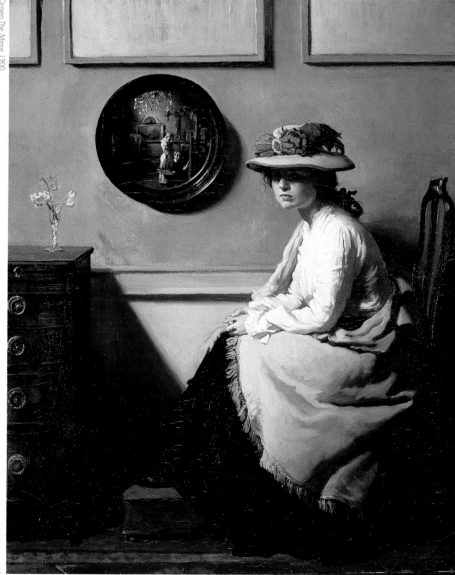

3

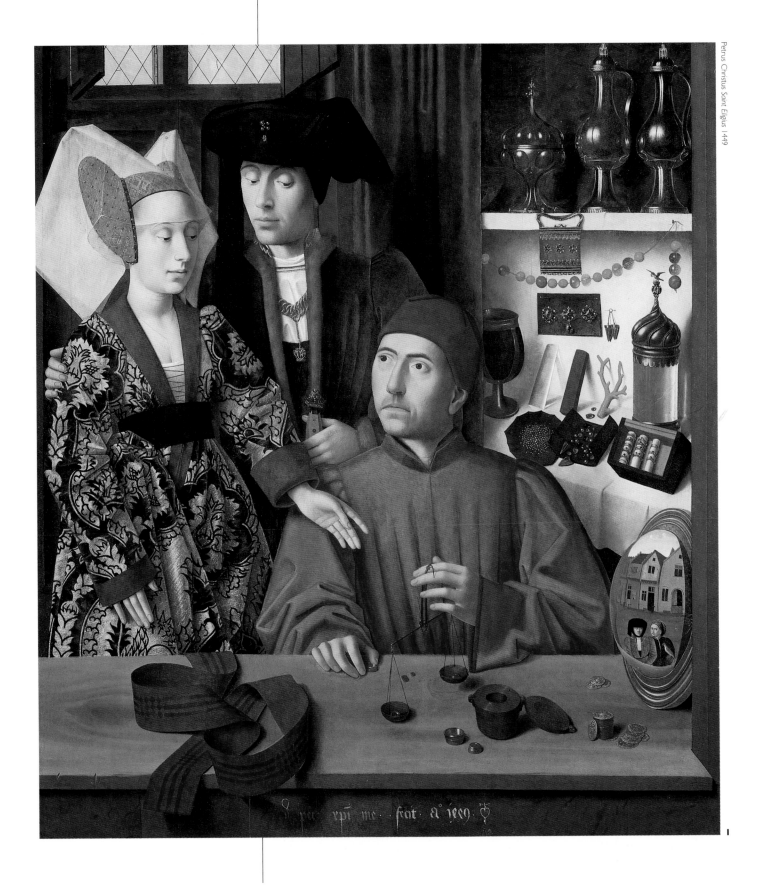

Petrus Christus Saint Eligius 1449

I

Campin *Werl Altarpiece* (detail) c.1438

In Robert Campin's *Werl Altarpiece* (**2**) the immaculate lustre of Van Eyck's mirror is almost pedantically reproduced. But in the context of the representation of Saint John indicating the Lamb of God, it somehow emphasises the Baptist's order to 'behold' the sacrificial animal. The mirror represents the attentive gaze which is required.

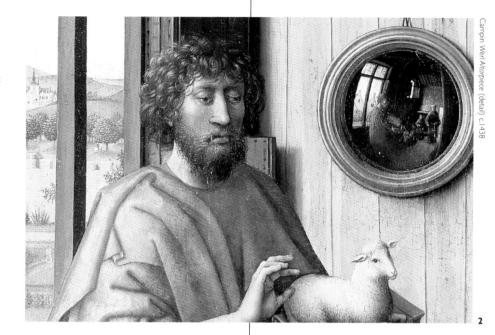

2

Massys *The Moneychanger and his Wife* (detail) 1514

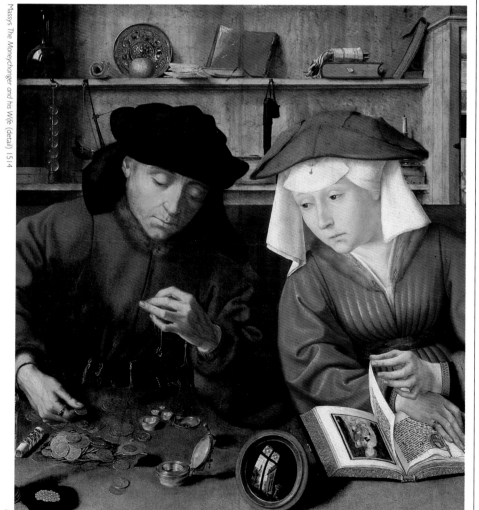

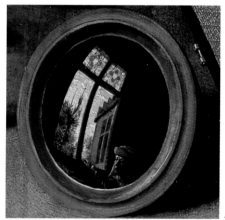

4

As with so many mirrors, the tiny 'monocle' leaning on the moneychanger's counter (**3**) directs our attention to something which would otherwise be invisible from our point of view. It looks for all the world like a frog's eye (**4**), but since there is no frog's brain to receive what it reflects, its imagery is conspicuously unnoticed – except by us.

3

Miller Florence Window 1996

The transparency of the window pane folded back against the wooden shutters (**1**) affords a clear view of the grain of the timber, but since the surface of the glass reflects the otherwise invisible piazza outside, the campanile looks as if it were made of wood.

Reflective glass

In all three of the previous examples the reflectiveness of the mirror depicted was carefully enhanced by backing it with colourless foil, so that all the incident light was pressed into the service of detailed reflection. In the absence of such optical insulation, reflection is complicated by the fact that it appears on the front surface of a medium whose transparency affords the observer a relatively uncompromised view of everything behind it. If, on the other hand, the background is either featureless or too faintly illuminated to be visible, the reflected window may be the only clue from which to read the presence of the transparent medium. Stoskopff's goblets are a dramatic example. The configuration of highlights betrays the existence of what might otherwise be invisible glass. In Grancel Fitz's photograph the reflected flare is the only clue to the existence of the cellophane held up by the young woman.

Fitz Cellophane 1928-9

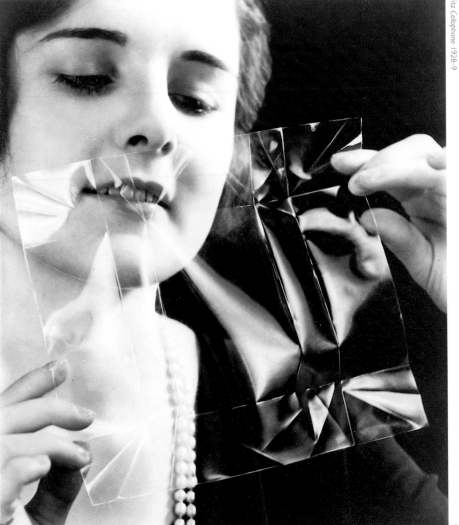

Stoskopff *Still Life with Glasses and Pâté* 1630–40

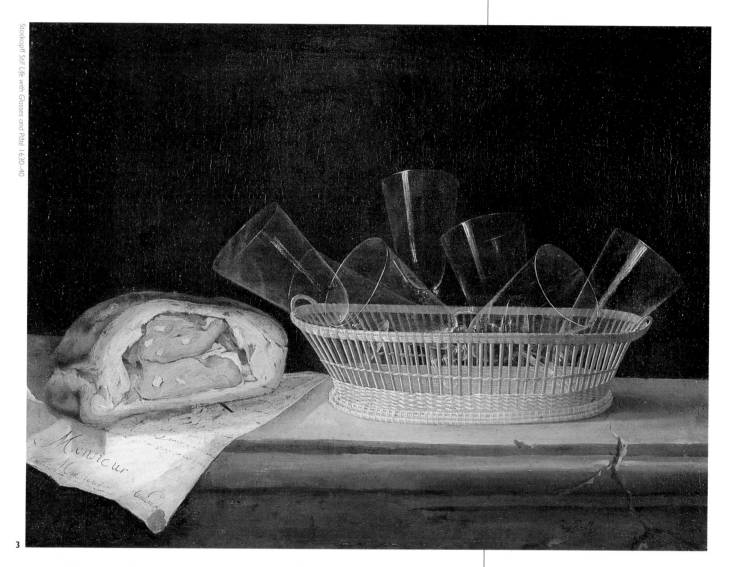

3

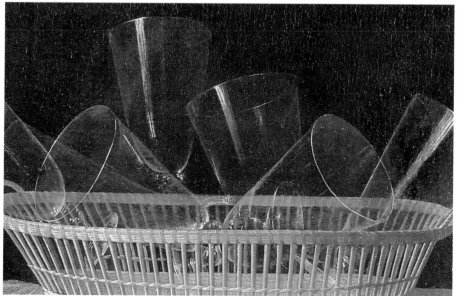

4

In contrast to the meat and the wickerwork which scatter the incident light and reveal their colour and texture (**3**), the surface of the transparent glass is almost invisible against the dark background. And yet the intersecting pattern of highlights allows the observer to analyse the array into a collection of seven separate crystal vessels (**4**).

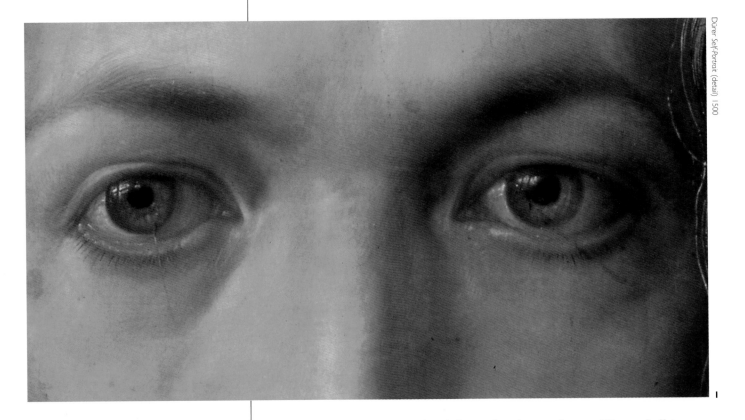

Dürer Self-Portrait (detail) 1500

1

Behind the reflective surface of the two eyeballs in Dürer's *Self-Portrait* (**1**) there is a brain, whose owner actually *perceives* the window whose existence *we* can only infer from its miniature representation on the otherwise invisible dome of the glistening cornea (**2**).

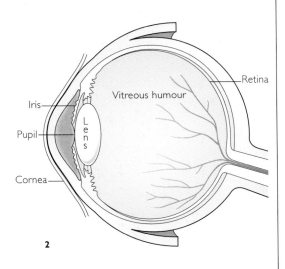

2

An even better example of this is the glint in the eye. The eyeball is a hollow sphere, perforated at the business end by an adjustable aperture known as the pupil. This is protected by an elastic transparent dome called the cornea. Since the eyeball is to all intents and purposes a camera obscura, which admits light but allows none to escape, the cornea as such is invisible. But because its outer surface reflects a small proportion of the light, most of which it otherwise transmits to the interior of the eyeball, the cornea betrays its presence by the highlight which gleams on its domed surface. Although this reflected gleam is a purely optical phenomenon, it is consistently visualised as an expression of the personal vitality of the sitter, and an artist who wishes to convey the attentive liveliness of his subject is somehow obliged to reproduce the glint in the eye. This is usually achieved by a pair of white flecks, an effect which appears in some of the earliest known portraits. When viewed in isolation each of these white dots seems quite opaque and nondescript, but when they are seen in context they confer the unmistakable gleam upon the otherwise invisible transparency of the cornea. If the subject happens to be facing a brightly lit window, the glint in each eye will be seen to consist of a small but recognisable image of the window. Few artists have bothered to represent the highlight in such exact detail, but in some of his portraits Dürer did so, and it has been suggested that the image has a metaphorical function, symbolising the idea that the eye is the window of the soul.

Said to be from er-Rubayat, Egypt *Portrait of a Man c.110–30 AD*

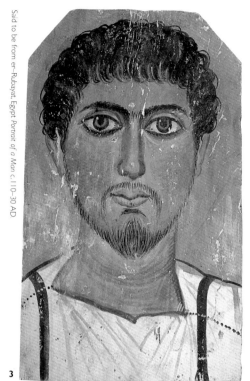

3

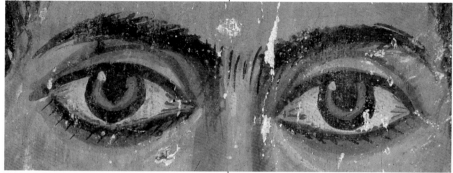

4

Thirteen hundred years before Van Eyck and his contemporaries mastered the art of representing the varieties of surface *splendor*, Hellenistic artists in Egypt (**3**, **4**) recognised the importance of showing the reflected lustre in the human eye. Without such specks of white the gaze of the subject would seem dead and inattentive.

Ignore the skull which Escher has inserted into his close-up of a human eye (**5**), and look at the clues from which we infer the presence of the otherwise invisible cornea. From the fact that its

curvature is different from that of the iris, we can tell that the white 'rectangle' is reflected from the domed surface of a transparent medium lying just in front of it. And because we can see eyelashes reflected in the brightest part of the gleam, we can also tell that the eye is illuminated by a window at the top left. The differential illumination of the eyelid confirms this, as does the little highlight on the caruncle in the right corner.

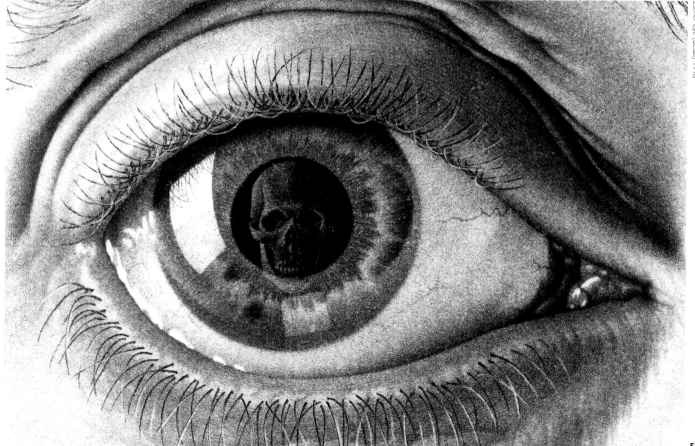

Escher Eye (detail) 1946

5

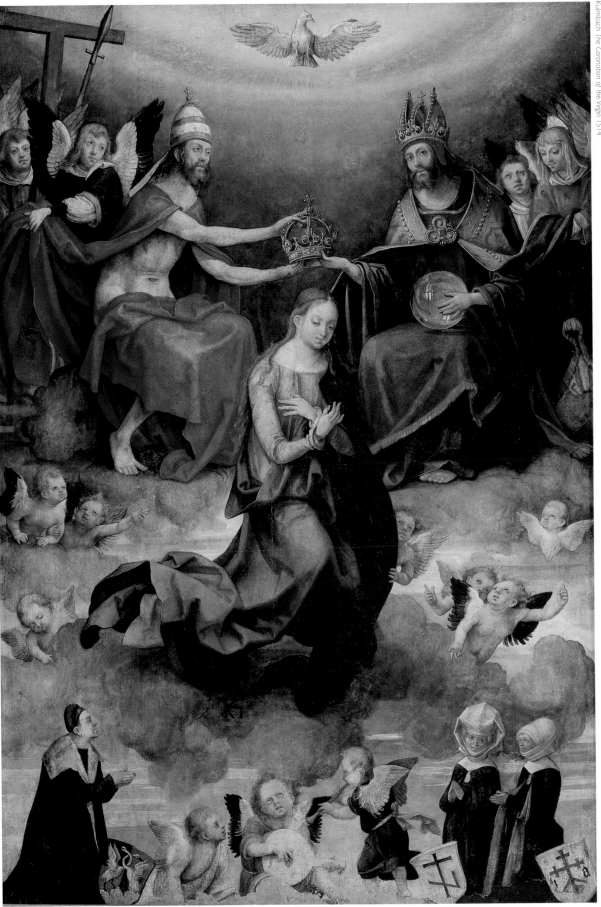

1

There are some intriguing examples in which the introduction of a windowed highlight is pictorially inconsistent rather than unnecessary. In Kulmbach's painting *The Coronation of the Virgin*, God the Father is seated in the vault of Heaven. But in the crystal orb which he holds in his left hand it is possible to make out the unmistakable reflection of a mullioned window! The same image recurs in the London National Gallery's panel by the Master of the Saint Bartholemew Altarpiece, in which Saint Peter, standing on what seems to be the outside steps of the church, holds a pair of spectacles whose lenses clearly reflect yet another non-existent window. It is as if the pictorial motif of a reflected window has taken on a life of its own.

<div style="text-align: right">**2**</div>

<div style="text-align: right">**4**</div>

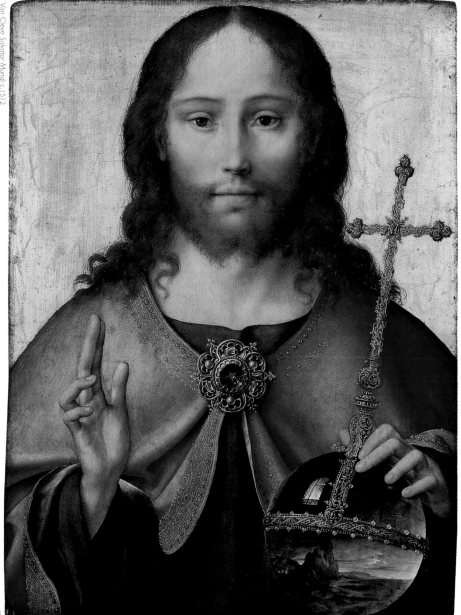

<div style="text-align: right; writing-mode: vertical">Van Cleve *Salvator Mundi* c.1512</div>

<div style="text-align: right; writing-mode: vertical">Master of the Saint Bartholomew Altarpiece *Saints Peter and Dorothy* (detail) c.1505–10</div>

3

At first sight these reflected windows (**1**, **2**, **3**, **4**) seem inconsistent with the outdoor setting of the pictures. But perhaps they have an allegorical function, symbolising the idea that the universe itself is a church. On the other hand, they *do* look like windows in the artist's studio.

Whatever symbolic function they might have had in the previous paintings, the windows reflected in these examples (**1**, **2**, **3**) are no more than pictorial clichés representing lustre without implying the existence of what they seem to reflect. We perceive the sheen without necessarily 'seeing' the window which represents it.

This is certainly the case in popular graphic art. Most readers are familiar with the barred window that appears in the polished boots of comic characters and in the photograph below (**2**) I was amused to notice that the fuzzy reflection of my own photographic flash in the window of the pharmacist's shop is less convincing than the highlight inscribed on the snowman's glossy red nose!

Miller Neutrogena Advertisement 1996

2

Millais Bubbles (detail) 1886

1

Vero Soap Bubbles 1985

3

Höch Glasses 1927

4

5

When it figures in a line drawing (**5**) the
reflected window is no longer legible as a
representation of glassy lustre and Picasso
has taken no interest in the anamorphic
transformation from which we might have been
able to read the bulging shape of the vessel.
In Hannah Höch's painting however (**4**) she has
taken self-evident delight in representing the
sheen of the glass and the voluminous bulge
of the vessel.

In each of these examples (**1**, **2**, **3**) the distortion of the reflected scene allows us to 'read' the curvature of the reflective surface. But as well as showing the geometrical characteristics of what *can* be seen, the reflection bears witness to what would otherwise be invisible. It is as if we had acquired eyes in the back of our heads.

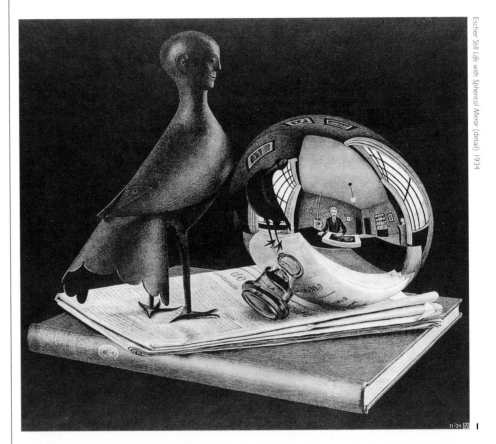

Escher *Still Life with Spherical Mirror* (detail) 1934

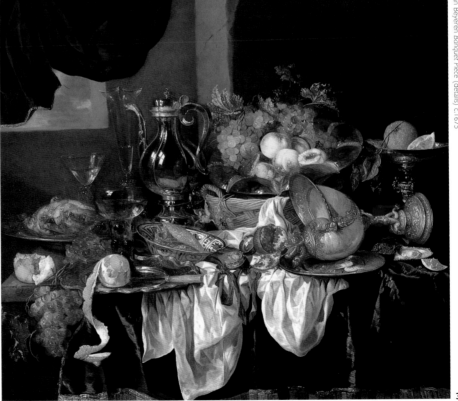

2

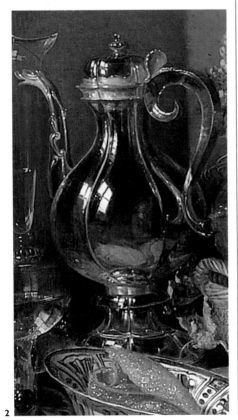

Van Beyeren *Banquet Piece* (details) c.1675

3

In most of the examples I have described, the curvature of the surfaces in question exerts a strong but lawful influence over the shape of their reflected imagery. In contrast to a plain or flat surface, which faithfully reproduces the proportions of whatever it reflects, a curved surface systematically disfigures it. When the objects in question have a relatively simple geometrical shape, it is easy within limits to make an allowance for the distortion of their reflection and the observer may even discount it altogether. Architectural features such as doors and windows are known to have a regular rectangular shape, so when their reflected image is bulged out of shape the effect is not necessarily disconcerting. On the contrary, if the observer has the opportunity to compare the actual shape of the object in question with its reflection, the anamorphic distortion actually conveys a great deal of useful information as to the curvature of the reflective surface. This can be seen quite clearly in Campin's *Werl Altarpiece* in the Prado in Madrid.

The 'surface' of the mirror (**5**) in Campin's painting (**4**) deserves its inverted commas because objectively speaking there is nothing to be seen except the reflected vista. But because the view is regularly distorted we know that what we can see is reflected in a convex mirror and therefore that it must have a surface, which we cooperatively supply.

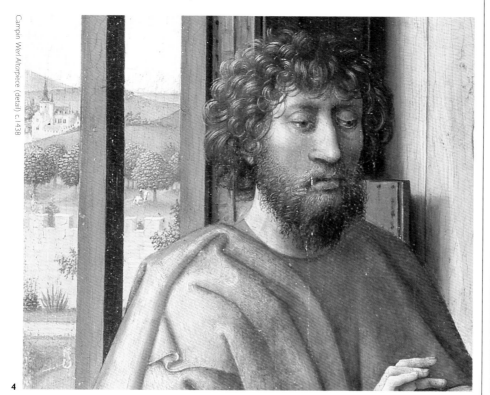

Campin *Werl Altarpiece* (detail) c.1438

4

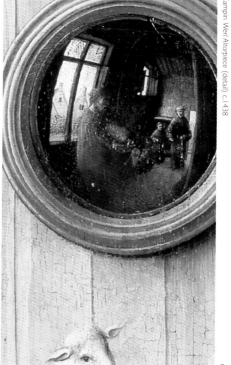

Campin *Werl Altarpiece* (detail) c.1438

5

The rectangular shape of the window is represented in the same picture as its curvilinear reflection in the mirror so that the convex surface of the mirror is immediately apparent. But the same calculation can just as easily be made if the real window happens to be excluded from the picture: windows are known to have a rectangular format, so that a reflection which systematically deforms this arrangement automatically expresses the curvature of the reflective surface.

To make this point more vividly, imagine an otherwise featureless sheet of rubber on which a rectangular grid has been inscribed. The rubber membrane is stretched tightly over a wooden sphere and securely fastened at each corner (**2**). The once rectangular grid is systematically deformed as the rubber membrane bulges over the now concealed sphere. But the regularity of the deformation accurately records the shape of the hidden object under the rubber.

In the Delft School interior (**1**) the artist has successfully recreated the globular lustre of the brass fire-dog by copying what he sees in paint. The same effect can be achieved by supplying a computer with unambiguous mathematical specifications as to the three-dimensional definition of a cylinder, a sphere and a cone respectively (**3**). The optical characteristics of the surfaces are similarly specified. The checkerboard floor is defined in exclusively geometrical terms. The 'description' runs on the hardware and by completing the algorithm, a virtual reality springs into visibility from something 'described' but never actually seen. The programme must have included an optical specification of the reflectiveness of the floor, since we can see a glossy image of the three solids reflected in it.

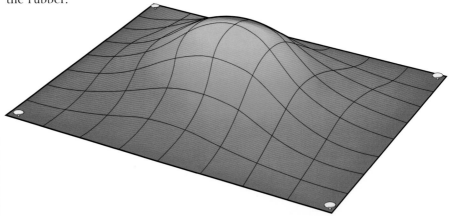

2

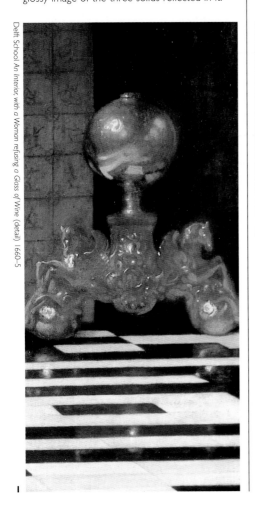

Delft School An Interior with a Woman refusing a Glass of Wine (detail) 1660–5

1

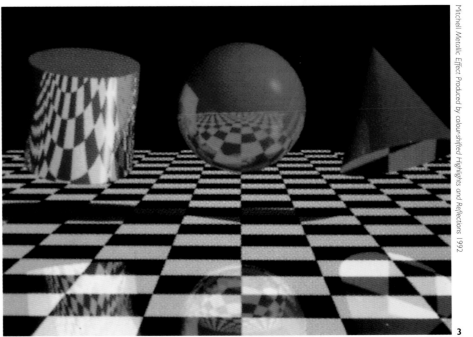

Mitchell Metallic Effect Produced by colour-shifted Highlights and Reflections 1992

3

As long as the reflected object has a simple geometrical format it is relatively easy to discount or at least make an allowance for the deformation which it undergoes when reflected in a curved surface. For that reason the anamorphic reflection of architectural features is relatively undisturbing. But when the reflected object has complicated and irregular curves of its own, the effect is much less legible and in the case of the human body the deformation

Parmigianino *Self-Portrait in a Convex Mirror* 1524

4

With configurations such as the human body (**4**, **5**) it is difficult to read the shape or curvature of the reflective surface from the often confusing distortion of the reflected image. What we *see* is what we sometimes *feel* when the subjective image of the body is disturbed by fever or neurological disease. The point is that in contrast to anything *else* that we might see reflected in a mirror, we have direct, non-visual experience of our own physique and when the reflected image conspicuously contradicts this feeling the effect is quite disconcerting.

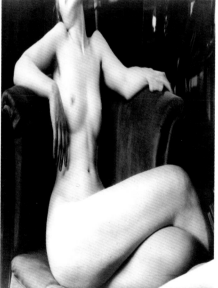

Kertész *Distortion No. 6* 1932

5

is often disconcerting. For example, in Parmigianino's *Self-Portrait*, which is painted on a convex panel to imitate a mirror of the period, the reflection of his own hand has a curiously monstrous appearance. And if the reflective surface is conspicuously irregular into the bargain, the experience is both illegible and bewildering.

When it comes to transparent media such as unsilvered glass, the visibility of whose surface is seriously compromised by what is seen behind it, the distorted reflections they afford are virtually the only source of information about their three-dimensional shape. What is more, the cognitive utility of such highlights does not depend on their being pictorially recognisable. The patches of reflected lustre which appear on the otherwise imperceptible surface of a glass vessel rarely assume the recognisable form of a window. In Stoskopff's still life on page 35, highlights which are represented in the glass have no identifiable features apart from their tell-tale curves – but from these alone, the observer can reliably infer the shape of the almost imperceptible glasses.

But the reflectiveness of a transparent medium is not always an advantage. In most situations, the incidental reflectiveness of glass compromises its intended purpose: to allow the observer a clear but protected view of what

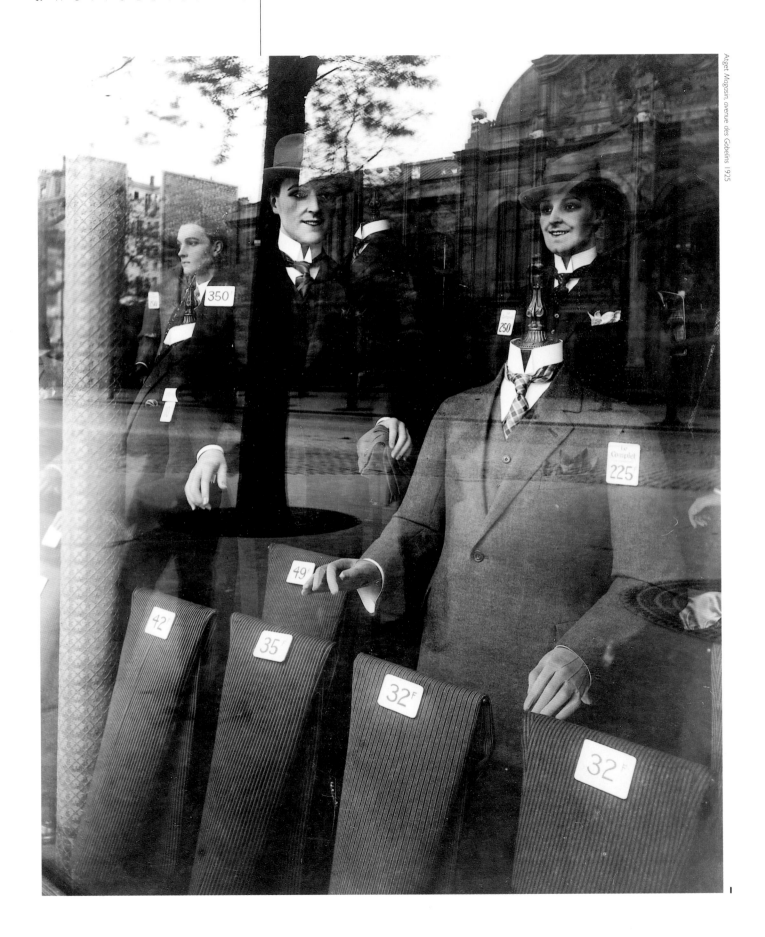

Atget *Magasin, avenue des Gobelins* 1925

1

lies behind. This is why window-shoppers are often to be seen with their noses pressed to the glass, using both hands to shutter off the light which is responsible for the distracting reflection. In art galleries, where such a procedure is justifiably forbidden, visitors can exploit the alternative strategy of shifting their gaze from left to right. One reason for doing this is that the offending reflection may be fainter from one position than it is from another. But even if it is not, as the viewpoint shifts, the imagery reflected from the front of the glass moves in the opposite direction to the imagery behind it, and although this differential movement may be quite slight, it recognisably enhances the intelligibility of the picture *behind* the glass.

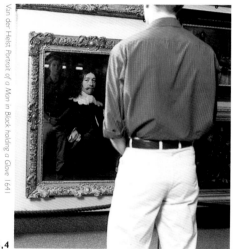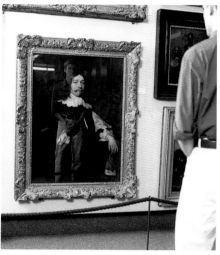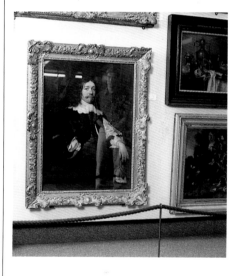

Van der Helst *Portrait of a Man in Black holding a Glove* 1641

2, 3, 4

The explanation of this is quite simple although the cognitive mechanism is still somewhat obscure. As the viewpoint shifts, each configuration moves as a coherent whole, so that the overlying details of one, which might otherwise have been confused with the underlying details of the other, are now assigned to the appropriate scene. In certain cases, when the balance of illumination is favourable, observers can alternate their perception and, without moving their head, see either the reflection or the underlying picture, simply by *deciding* to do so.

It is easy to describe this, but much harder to explain it. What exactly do we mean by *deciding* to see this to the exclusion of something else? How is such a decision implemented? This question is closely related to another problem which has exercised the ingenuity of experimental psychologists: the so-called 'cocktail party' problem. In a crowded room filled with chattering guests you are doing your best to listen to what someone is saying. Suddenly you hear the fragment of a more interesting conversation elsewhere. If you are irresistibly drawn to what you overhear, you somehow cease to listen to the previous talk. Or conversely, by making a courteous effort, you can resist the

When a substance such as glass or water is both transparent *and* reflective, the visibility of what is to be seen *through* it may be compromised and confused by the scene which it reflects from elsewhere. The one is superimposed upon the other and, as in Atget's Parisian shopfront (**1**), the observer may find it difficult to 'separate' the two layers of the perceptual sandwich. If the background is strongly illuminated, the superimposed reflection may be overlooked, but conversely if the reflected scene is brightly lit it may be difficult to distinguish what is on the other side. This effect can be seen in most art galleries in which pictures are exhibited behind glass – although highly varnished paintings display the same effect. The visibility of the painting can be enhanced by lowering the illumination of the room, when the reflective surface will have less to reflect (**2**, **3**, **4**).

distant conversation and attend to the one near at hand. But you cannot do both at the same time. The acoustic alternation is quite clearly analogous to the optical one. In both cases psychologists refer to the achievement as a mental act rather than a physical one. What they mean by this is that it is the result of making a decision and not necessarily the consequence of making a physical movement. By making an *effort* I can listen to the distant conversation without turning my head to favour its reception. And by the same token without betraying any movement of my head, I can decide to inspect the contents of the shop window, or just as inconspicuously attend to the reflection of someone skulking on the other side of the brightly lit street.

In both cases this achievement is often described in terms of filters, but it is difficult to imagine what sort of filter could do the job. Acoustic filters operate on frequencies, favouring high ones, say, at the expense of lower or deeper ones – or vice versa. But it is the *topic* of the conversation I am attending to, not its *pitch*. How would we design a filter sensitive to interesting topics? The same principle applies to the shop window, although there are some interesting differences. As it happens, the light reflected from a glass surface is detectably polarised and by introducing a polaroid filter it is possible to eliminate or at least reduce the distracting imagery. But the 'filter' which allows the observer to alternate between smartly dressed mannequins and less fashionably clothed men in the street does not work like that. It is a question of differential *interest* – and once again it is difficult to imagine an apparatus whose differences of interest could result in such mutually exclusive differences in visual perception.

Presumably, each of the conversations going on in this crowded scene (**1**) make sense to the participants. But it is only possible to listen to one at a time. Listening and looking both require the ability to discriminate between the din and the topic.

Williams (*The New Yorker*) *The Reception* (detail) 1948

1

Shading and shining

One of the most interesting achievements in the field of artificial intelligence was Terry Winograd's computer programme SHRDLU. In the effort to identify the grammatical rules that determine shape recognition, Winograd created a notional table-top world, variously piled with virtual cubes, cones, cylinders, pyramids and rectangular blocks. The arrangement of these items was represented by a simple line drawing 'taken' from a fixed viewpoint. For each of the solid tokens Winograd wrote into the programme an unambiguous definition. He also listed specific definitions of certain simple operations such as 'pick up', 'put on top' and 'replace'. The programme was also equipped with definitions of spatial relationships, such as 'in front of', 'behind', 'to the left of'. With these axiomatic specifications written into the programme, Winograd instructed the computer to make certain rearrangements to what it could 'see'. 'Pick up the cylinder on top of the cube on the far right and put it in front of the rectangular block with the cone on top of it' and so on. In spite of the fact that some of the objects 'occluded' the outline of some of the others, the machine successfully 'parsed' the pattern of lines and obeyed the instructions. The fact that it could do so in a world represented by nothing but outlines might lead us to suppose that natural vision is furnished with much more information than it needs. But of course it is not and the reason is almost trivially obvious.

The automatic ease with which we can see this diagram (**2**) as a three-dimensional scene blinds us to the complexity of the perceptual task which it involves. What the eye is presented with is a complicated *two-dimensional* pattern of intersecting lines. But the brain computes the network of forks, arrows and angles (**3**) and unerringly 'extracts' an assembly of boxes, cylinders and pyramids. In the 'natural' world the task is made easier by the systematic distribution of light and shade.

3

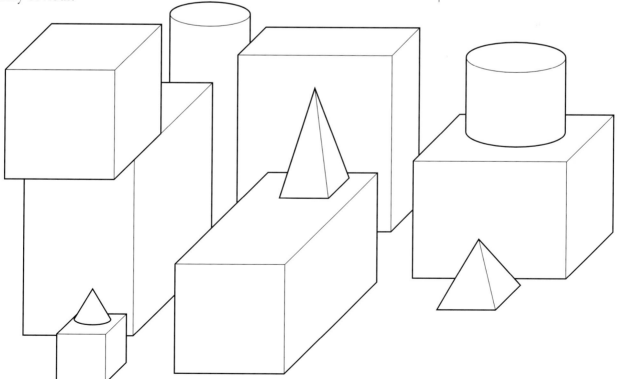

2

In the real world whose contents defy unambiguous definition and in which actions are not confined to pickings-up and puttings-down, we cannot dispense with the visual details which are so conspicuous by their absence from Winograd's table-top world. They are the very features by which the living organism recognises the ecological hospitality of its surroundings. And for all practical purposes one of the most significant pieces of information in any given scene is the pattern of light and shade which plays across its irregular surfaces. In addition to conveying the overall layout of the scene — its slopes, its valleys, its bulges and its promontories — the way in which a particular surface is *shaded* may be the only reliable information about its three-dimensional shape. The mechanism by which this optical information is computed is still under consideration but it is generally accepted that the derivation of shape from *shading* is one of the most significant functions of natural vision.

In real life the abstract skeleton of lines and edges is covered with a 'skin' of variously shaded surfaces (**1**, **2**). The observer may not be consciously aware of it, but the brain computes the distribution of shadows, and extracts a reliable account of the textured solidity of the scene.

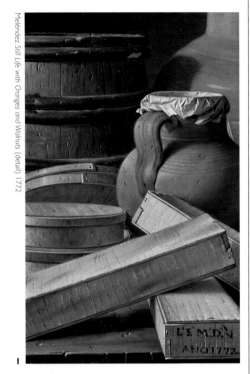

Meléndez Still Life with Oranges and Walnuts (detail) 1772

1

Miller Rocks 1996

2

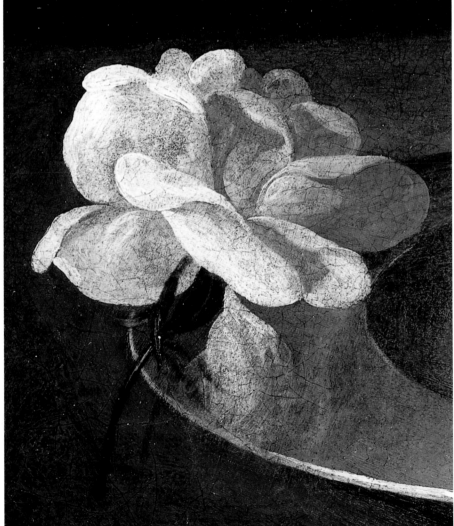

3

Zurbarán A Cup of Water and a Rose on a Silver Plate 1627–30

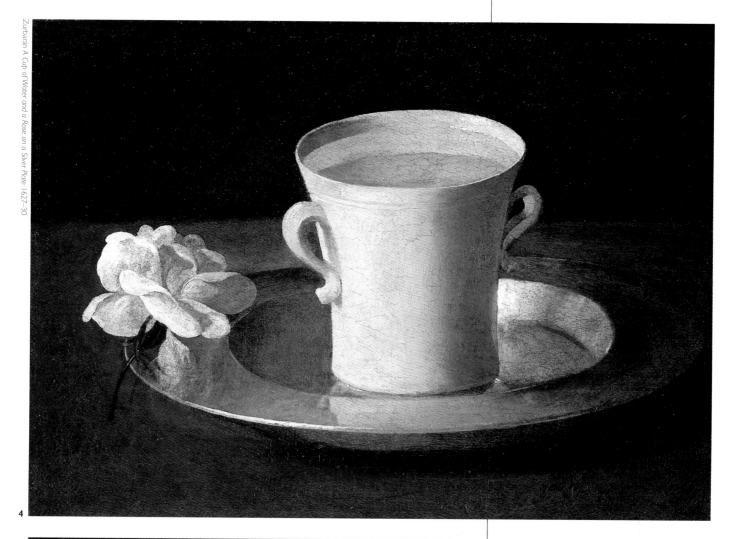

4

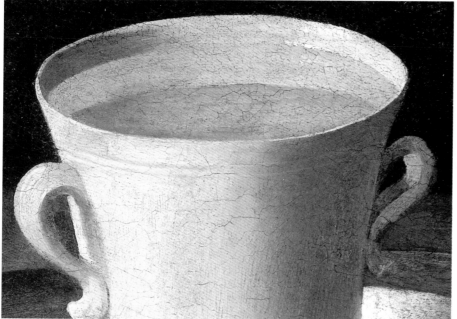

5

The three-dimensional shape of cup, plate and blossom (**3**, **4**, **5**) would undoubtedly be legible if represented in a line drawing similar to the one which appears in Winograd's SHRDLU table-top world. But the solidity of the scene is much more insistent when the artist represents the differential pattern of shading. The overlapping rose petals are unambiguously legible in terms of line alone but the shadows give the flower as a whole a complex volume which would be missing from a line drawing.

When it comes to subtly curved surfaces whose three-dimensional structure cannot be rendered in terms of edges and corners, the softly graded 'wash' of shadows provides an essential source of perceptual information (**1**, **2**, **3**). Using coarsely textured paper and a black Conté crayon, Seurat created a mysteriously sooty medium for rendering the play of light across the gentle convexities of the human body.

Seurat Study for the Bathers at Asnières (detail) 1883–4

1

Seurat Study for the Bathers at Asnières 1883–4

2

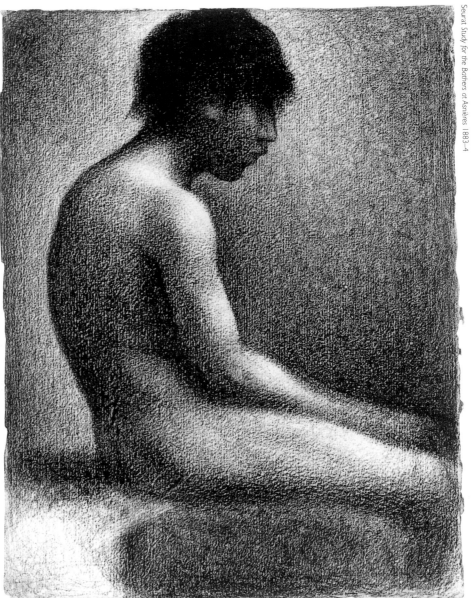

Stoskopff Still Life with a Calf's Head 1640

Seurat Study for the Bathers at Asnières 1883–4

3

4

When some of the surfaces are recognisably reflective, the highlights often provide additional clues about shape. Although the complicated shapes of the pots and pans in Stoskopff's *Still Life with a Calf's Head* would be quite legible in terms of shading, the fact that they happen to be made of polished metal lends a helpful sheen from which it is much easier to read the shape. And the more reflective a surface is, the more significant its lustre becomes, because the shinier a surface is, the more clearly it affords the observer a view of something else. By the same token the form which that view of 'something else' takes becomes increasingly significant as a clue to the shape of the reflective surface in question.

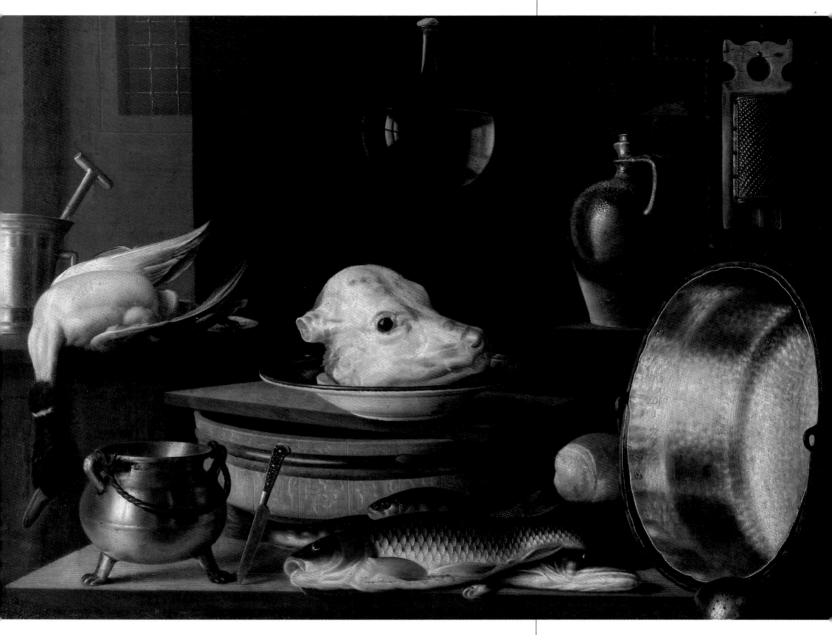

Although the shape of the metallic vessels in Stoskopff's still life would be legible in terms of shading alone (**4**, **5**, **6**) the fact that they have an explicitly reflective surface lends an extra clue to the visible structure, and the pattern of lustre is yet another aid to reading the hollows and bulges of the scene.

5, 6

The 'real' peaches in the foreground (**1**) provide a standard by which we can judge the geometry of the reflective surface of the silver tray. But since everyone *knows* what real peaches look like, we do not need to see them to detect the flatness of the tray. Try covering the foreground and you will see what I mean.

Thus, in Desportes' wonderful still life, the only clue to the existence of the tray's surface is the image of the peaches which it reflects. But since the reflected peaches have exactly the same proportions as the real ones in the bowl just in front, we can see that the silver surface in which they are reflected must be flat. Whereas in the Delft School interior, the anamorphic reflection in the brass globe standing by the fireplace tells us that it is spherical. As with the transparent examples cited earlier, our ability to derive the shape of a surface from the configuration of its reflection does not depend exclusively on

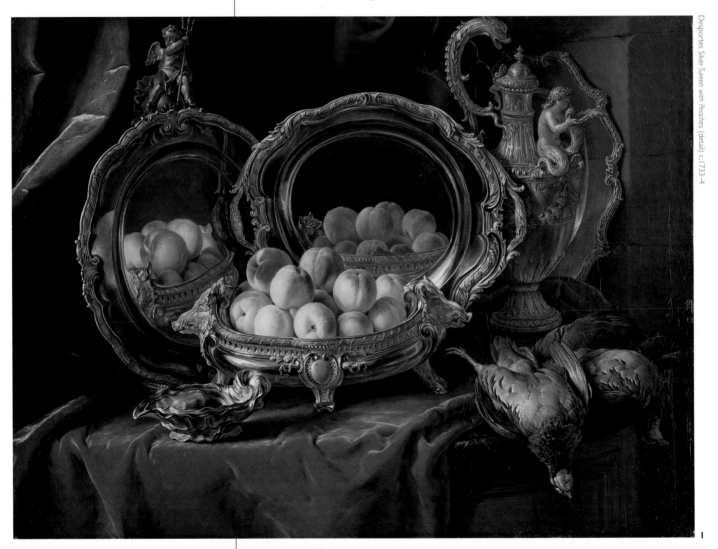

Desportes *Silver Tureen with Peaches* (detail) c.1733-4

recognisable imagery. A non-figurative highlight can be just as informative. The parallel bands of lustre on the brass surface of Arnolfini's candelabrum vividly express its cylindrical shape. The same goes for the broad highlights which shine on the surface of Konrad Witz's armour, although in none of these is there a recognisable image of the light source.

Delft School *An Interior, with a Woman refusing a Glass of Wine* (detail) 1660–5

The deformation of the reflected scene (**2**) tells us that we are looking at a spherical surface. If it were a disc rather than a globe, the scene would appear undistorted, though tinted by the local colour of the brass.

We can often get an accurate sense of the shape of an object (**3**, **4**) from the way in which its surface shapes the reflected lustre, even when the highlight is non-figurative.

Witz *Abishai before David* (detail) c.1435

Van Eyck *The Arnolfini Portrait* (detail) 1434

2

3

4

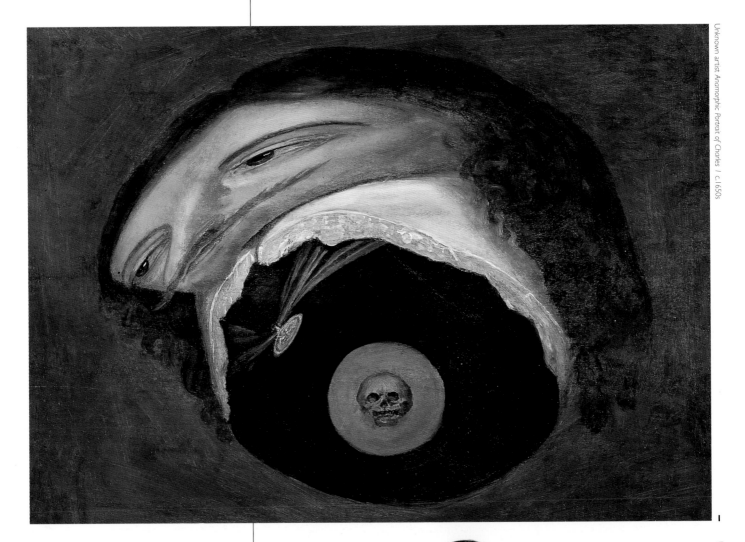

Unknown artist Anamorphic Portrait of Charles I c.1650s

1

Since there is a straightforward mathematical function that relates the proportions of a real object to the proportions of its reflected image on a surface of known curvature, we can artificially construct a two-dimensional image of an object as it would appear in the three-dimensional surface of a polished cone or sphere (**1**, **2**, **3**, **4**, **5**). Such images are closely related to the so-called Mercator projections by which geographers transpose the image of the continents as they appear on a sphere on to a flat sheet of paper. By constructing such anamorphically-deformed images we can then restore them to their correct proportions by reflecting them in a surface whose three-dimensional shape corresponds to the one that would have created such a distortion in the first place.

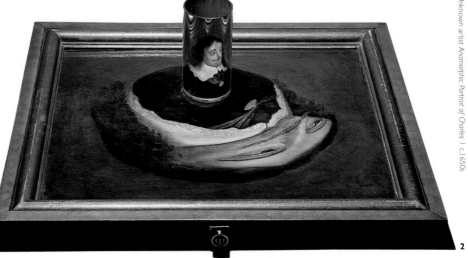

Unknown artist Anamorphic Portrait of Charles I c.1650s

2

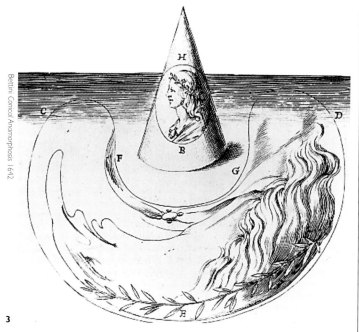

Bettini *Conical Anamorphosis* 1642

3

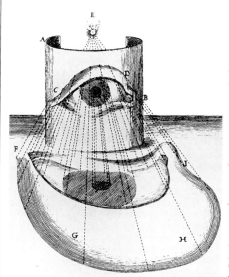

Bettini *The Eye of Cardinal Colonna, Anamorphosis in a Cylindrical Mirror* 1642

4

Unknown Artist *Anamorphosis of a Ship Model with Cone Mirror* c.1770

5

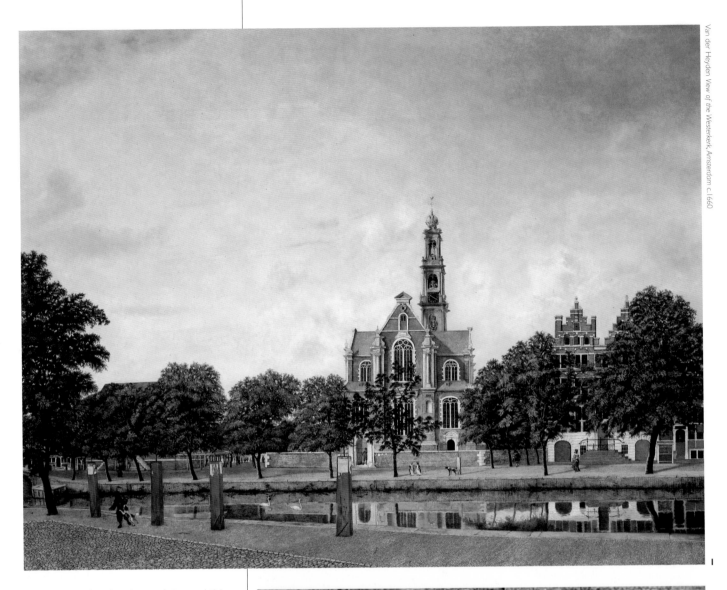

Van der Heyden View of the Westerkerk, Amsterdam c.1660

In spite of the fact that the canal shows nothing but the reflected images of the houses on the opposite bank, the observer gets the overwhelming impression of a shiny surface at right angles to the vertical lines of the reflected buildings (**1**). But when you crop the picture to exclude everything *but* the reflection (**2**), the reflective surface vanishes.

Virtual surfaces

In previous sections I have argued that the visibility of a surface is inversely proportional to its reflectiveness and that the more it discloses in the way of reflection the less it reveals itself as a surface. This claim needs to be expanded and qualified.

In one sense it is unarguably true that when a surface approximates to the condition of a perfect mirror it is no longer to be seen as a surface. Nevertheless, as long as observers have good reason to identify what they see *as a reflection*, they 'see' the surface notwithstanding the fact that there is nothing visible to justify such a perception. In van der Heyden's townscape (**1**) there is nothing to be seen between the banks of the canal apart from the reflected imagery of the houses opposite. And yet, subjectively speaking, the horizontal surface of the water is strongly visible.

The glassy surface of the lake is an illusion (**3**). See what happens when you mask off the frieze of real girls, or turn the page upside down.

Burne-Jones *Study for the Mirror of Venus (detail)* 1867–77

3

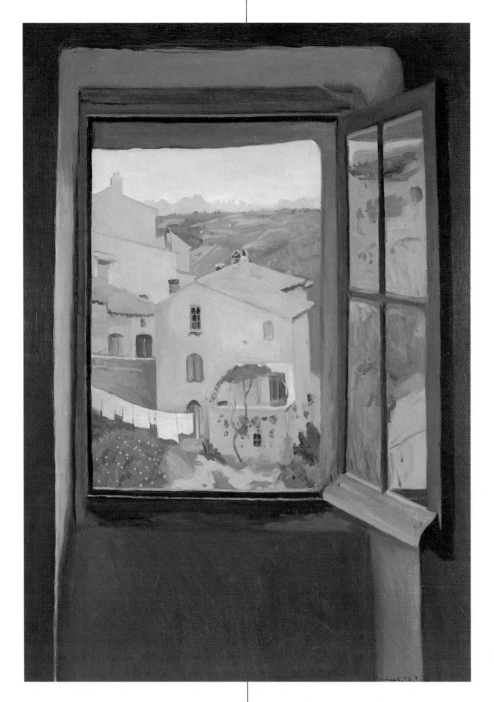

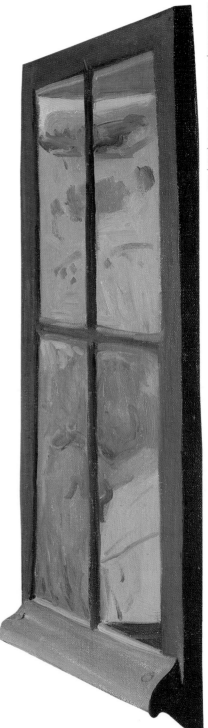

Vallotton's picture (**1**) discloses three distinct types of virtual reality. Because it figures in a painting, the 'view' through the casement is represented rather than actual. The landscape reflected in the window pane is a *second order* of virtual reality since it is the painted representation of the reflection of a view.

And because we have good reason to know that it *is* a reflection, we 'see' the invisible surface of the window pane. If we isolate the window from the 'real' view, the evidence in favour of it being a reflection is seriously reduced and it is difficult to avoid the impression that we are looking *through* the glass to a view beyond.

The windows which are thrown back against the wall in Vallotton's painting of a view in Provence disclose what is unmistakably a reflection of the scenery beyond. But in seeing this imagery as a reflection we get the irresistible impression of seeing the glass in which it appears – it even seems to glitter! In other words by displaying its virtual *imagery* the glass has acquired a virtual *surface*. A simple experiment proves that this is an optical illusion. If all but one of the window frames are masked off so that it is impossible to tell what, if anything, it is a reflection *of*, the window pane undergoes a remarkable change in appearance. What previously looked like a reflection on the glass is now seen as a view *through* it, and as a result the virtual surface vanishes as if by magic. What seems to be happening is this. Under normal circumstances windows afford a *view*. That is to say we normally see things *through* them. But in the context of Vallotton's picture they are understandably prevented from serving their normal function of affording a view through, so that the landscape which they disclose *must* be reflected and the glass which supports the reflection becomes virtually visible as a result. When the evidence in favour of this theory is eliminated, the observer reverts to the more probable theory: that being a window – which is what it looks like – it affords a view of something beyond. And the reflective surface disappears. Hey presto!

The same principle applies to Desportes' still life. The oval format in which the peaches are so beautifully reflected has no visible features apart

Everyone is familiar with the idea that seeing is believing. What is less well known is the part that belief plays in the experience of seeing itself. Because we have reason to believe that the heap of peaches in the background of this picture (**2**, overleaf) is the reflected image of the real peaches in the foreground, we credit the oval area in which the reflected peaches appear with a shiny metallic surface.

Overleaf
Desportes *Silver Tureen with Peaches* (detail) c.1733–4

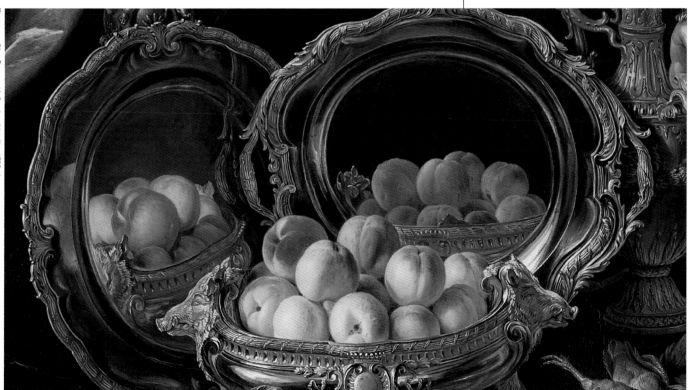

Desportes *Silver Tureen with Peaches* (detail) c.1733–4

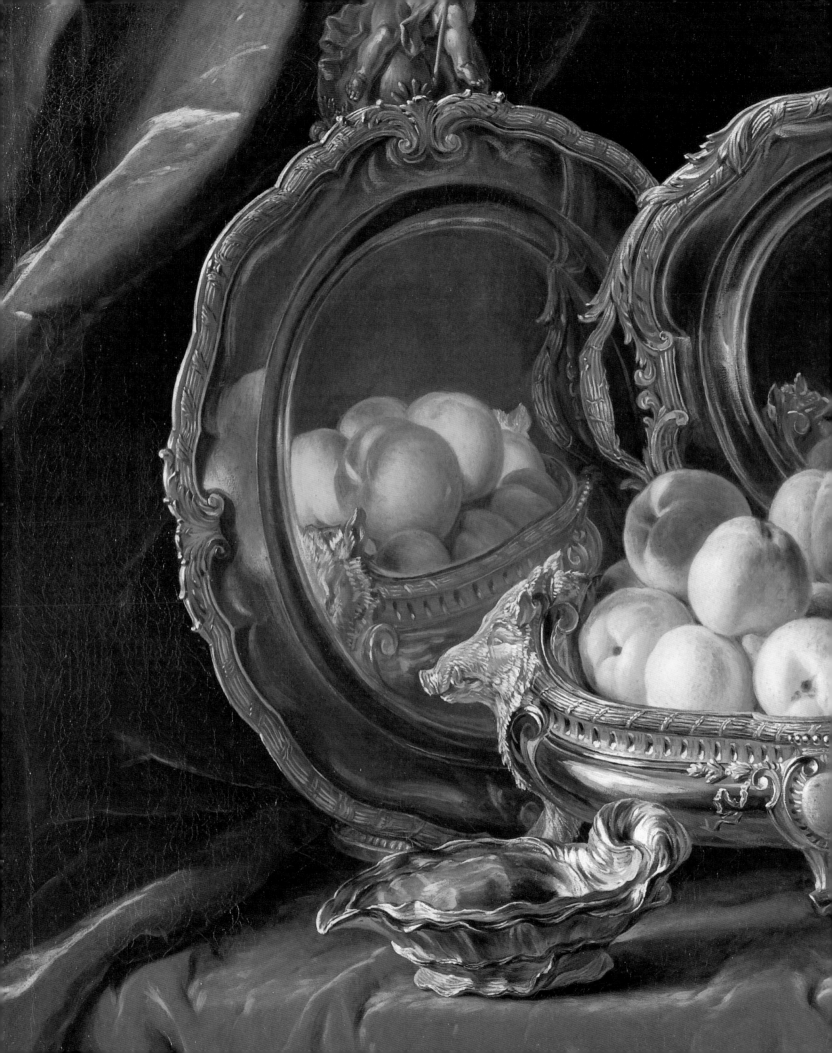

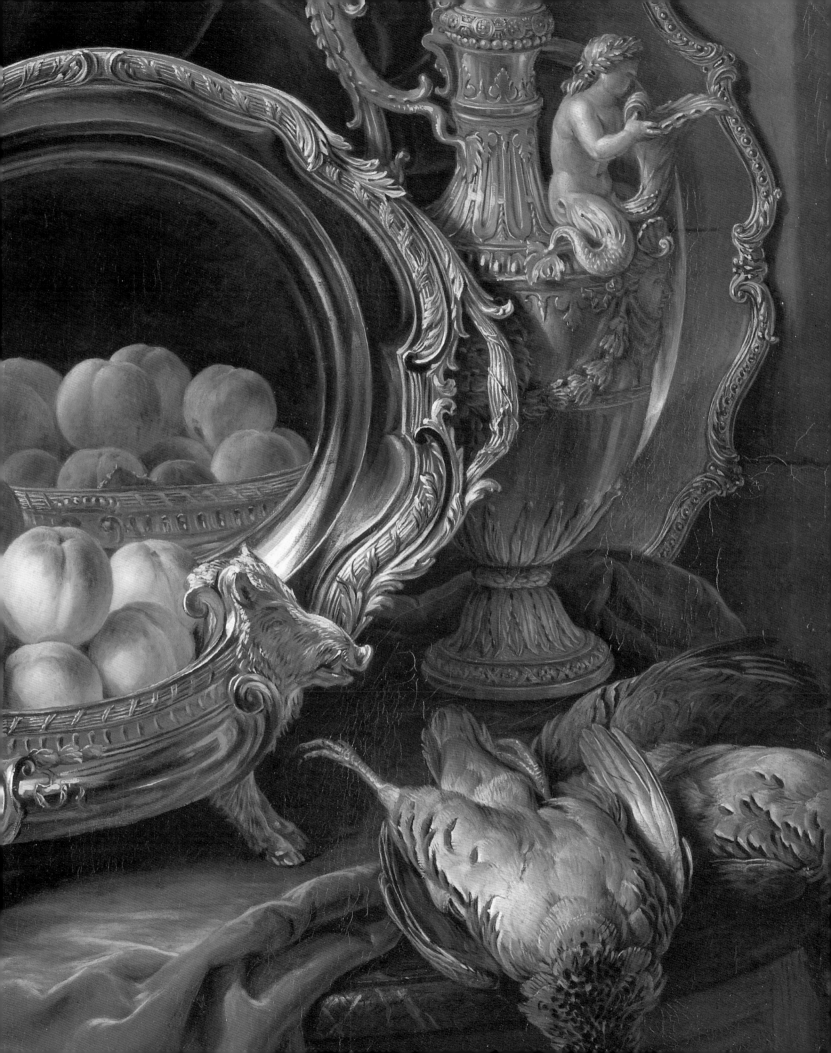

from the images of the fruit which it reflects. And yet the observer detects a silvery sheen on the reflective surface of the tray. But if, as before, we mask off everything except the reflected images, eliminating the actual peaches in the foreground, not to mention the tell-tale decorative frame of the tray, the virtual peaches become real and the reflective surface disappears.

If we systematically deconstruct the picture (**1**) and mask off any evidence in favour of our belief that we are looking at a reflection, the 'surface' of the metal is no longer apparent.
All we can see is peaches.

Desportes Silver Tureen with Peaches (detail) c.1733-4

1

Cartier-Bresson's photograph of a man jumping over a puddle illustrates this principle very clearly. Objectively speaking the puddle has nothing to show apart from the upside-down image of the athletic workman. But the surface has a spectacular watery sheen. If the picture is turned upside down, however, the shiny surface now appears in the equally featureless sky.

In all these examples we are witnessing the operation of what seems to be a perceptual rule. The rule is that if something is recognisable as a reflection, the surface which affords it becomes subjectively visible. And yet we are not conscious of operating such a rule. We don't say to ourselves: 'What I see is a reflection, there must be a surface in which it appears, so I'll see it just to keep the record straight.' As with other optical illusions the calculation is made at a level well below consciousness, so that its perceptual results are immediately experienced without any sense of their having been 'arrived at'.

The Italian psychologist Gaetano Kanisza has convincingly demonstrated some closely related illusions, each of which illustrates the astonishing 'creativity' of the visual system. In configuration (**4**) many subjects see a large white triangle, each of whose three vertices seems to overlap and occlude one

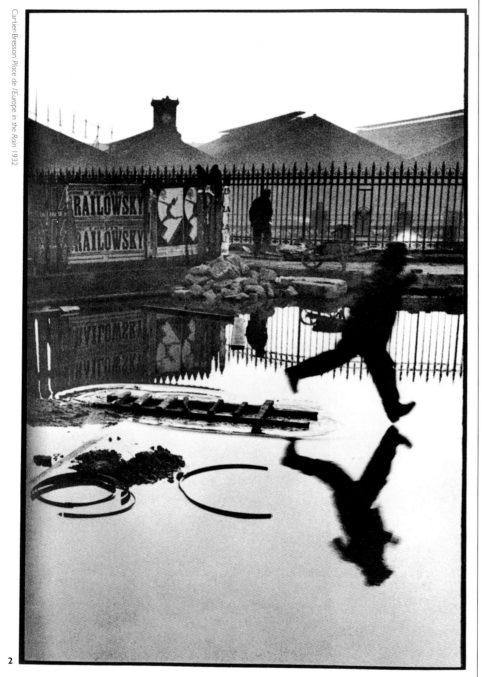

Cartier-Bresson *Place de l'Europe in the Rain* 1932

2

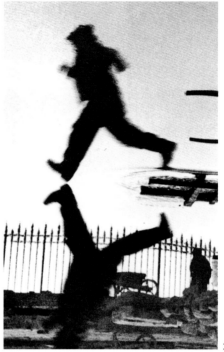

3

Apart from a few specks of floating dirt, there is nothing to justify the irresistible impression that we are looking at a watery surface (**2**). Nothing, that is, apart from the duplicated image of the leaping workman. But the composition of the photo supports the belief that we are looking at an unruffled puddle and as a result of this belief we perceive its reflective but otherwise invisible surface. See how it looks when we turn the picture upside down (**3**). The sky looks shiny!

The effect is comparable to the illusory contours of the non-existent triangle in Kanisza's well-known figure (**4**). We conjure the white triangle into existence as if to 'explain' the gaps and interruptions in the other parts of the diagram.

of the three black discs. For those who 'see' it, the illusion of the triangle is so insistent that it actually seems whiter than the background. In other words its invisible contours appear to stand out against the white paper. And yet objectively speaking there *is* no such triangle. The paper is uniformly white. There are three angles and three discs, each of which has an angular 'bite' taken out of it. But the bites have been cunningly arranged so that the most plausible explanation of what otherwise might seem to be their independent orientation is the existence of a triangular white mat overlying the intact black discs.

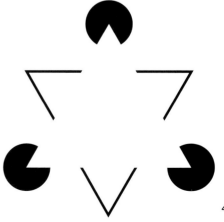

4

French Tapestry *La Dame à la Licorne* c.1490–1500

See how a tapestry artist of the fifteenth century intuitively exploits Kanisza's principles to create the illusion of a diaphanous sleeve (**6**). As with the abstract diagram (**1**), the artist has instructed the weaver to maintain the continuity of the contours which pass beneath the gauzy folds of the sleeve. A slight disruption in this continuity would have cancelled the fabric's subtle transparency.

Again, the word 'explanation' is somewhat misleading since it suggests that we consciously make up our minds to such an effect. As it is, the illusory contour is simply *seen* and the subject is blissfully unaware of weighing the evidence in its favour. An even more striking example is the illusion of transparency created by the appropriate arrangement of differently tinted geometrical figures (**1–5**). Given the appropriate arrangement of four completely opaque areas the observer will receive an irresistible impression of transparency. But if the components are even slightly misaligned, the illusion is shattered.

The mechanism which is responsible for these two illusions is altogether obscure. Although psychologists now tend to describe it in terms of 'perceptual hypothesis', it is difficult to say what this really means. Because the concept of hypothesis is so closely associated with that of conscious thought, it seems like a contradiction in terms to claim that such a thing can be entertained without the subject being aware of it. Nevertheless the notion of conjecture and the calculation of probabilities seems inescapable, because the

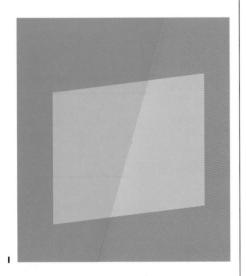

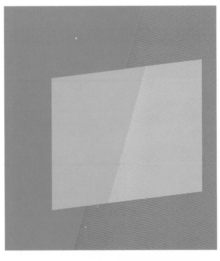

1

2, 3

The illusion of transparency can be created by juggling four opaque components (**1**). 'Two of the four areas have to be unified in a single visual object – that is, the object that has to appear transparent and, thus, to be located in front. This condition obviously implies that these two areas have some of their contours in common. Furthermore, the other two areas must also be in contact in order to constitute a bicolour region – that is, the region that has to appear opaque and thus to be located behind, and seen through, the first one' (Kanisza, 1979). If these rules are broken, as they are in **2**, **3**, **4** and **5**, the illusion is shattered.

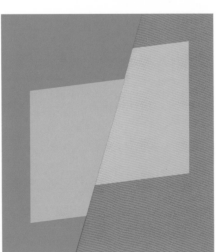

4, 5

6

way in which these illusions can be deconstructed shows that the concept of evidence and judgement is not altogether irrelevant.

However we choose to describe it, the process which is responsible for Kanisza's experimentally contrived illusions is probably related to the one which furnishes the spontaneous illusions of reflective surfaces, since they too can be deconstructed by removing or tinkering with the evidence in their favour. The inescapable fact is that these illusions are demonstrably sensitive to the composition of the picture in which they appear and, as such, they display

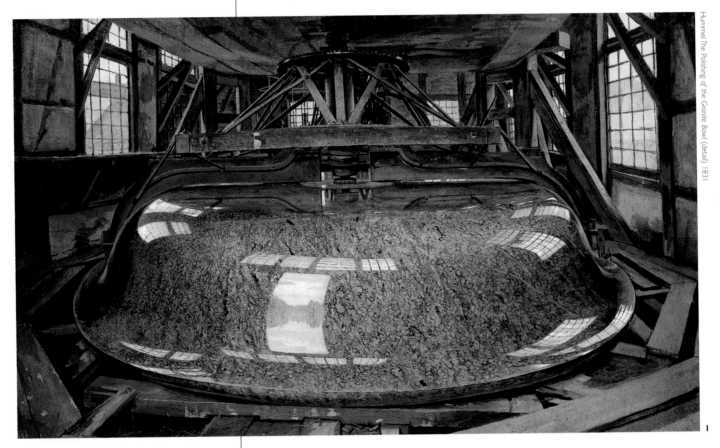

Hummel *The Polishing of the Granite Bowl* (detail) 1831

The irresistible illusion of stony sheen is a compositional effect (**1**). To all intents and purposes the observer *creates* the sensation of smooth gloss, by inferring its existence from what he assumes to be the windows reflected in the surface of the granite. If they *are* reflected, and the scenic context implies that they probably are, the observer unconsciously concludes that the surface which affords such imagery would be smooth to the touch. The subjective experience is supplied by the observer whose visual system computes into existence something that is more than the sum of its pictorial parts.

a peculiar form of reciprocity. In Hummel's *The Polishing of the Granite Bowl*, for example, the windowed highlights confer an illusory sheen on the rest of the granite surface, and if they are blotted out the mottled stone looks quite nondescript. But on the other hand it is only because they figure in such a setting that they are recognisable as highlights. If we mask out the granite surface, the now isolated highlight looks at best like an odd sort of window. So it is the highlight which gives the granite its sheen and the granite which gives the highlight its identity.

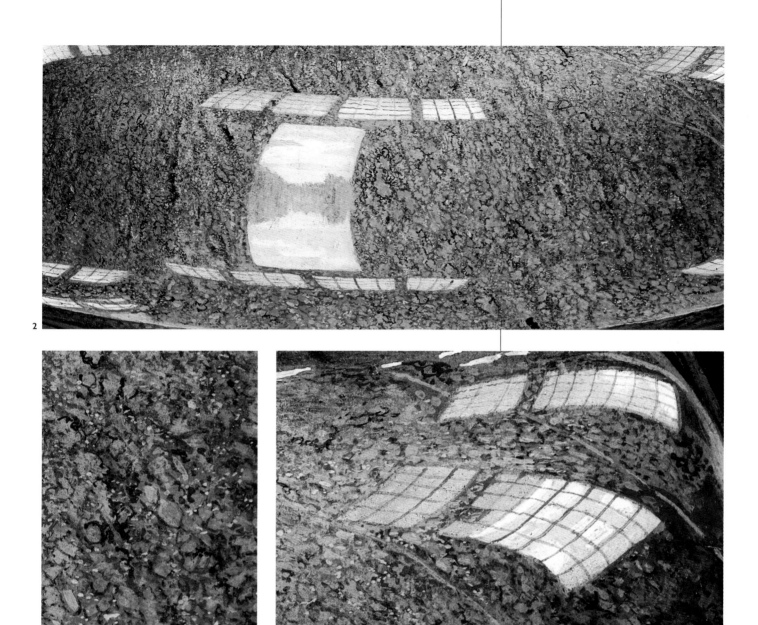

2

3

4

5

By systematically deconstructing the composition we can analyse the way in which the pictorial elements interact. By zooming in to exclude the information which tells us that we are looking at a bowl (**2**), the convexity of its surface is almost illegible and the reflective identity of the 'window' becomes ambiguous. When a patch of the granite is seen on its own (**3**) the very nature of the substance is uncertain and when the 'windowed' highlights are completely isolated their reflective pedigree is annihilated (**4**, **5**).

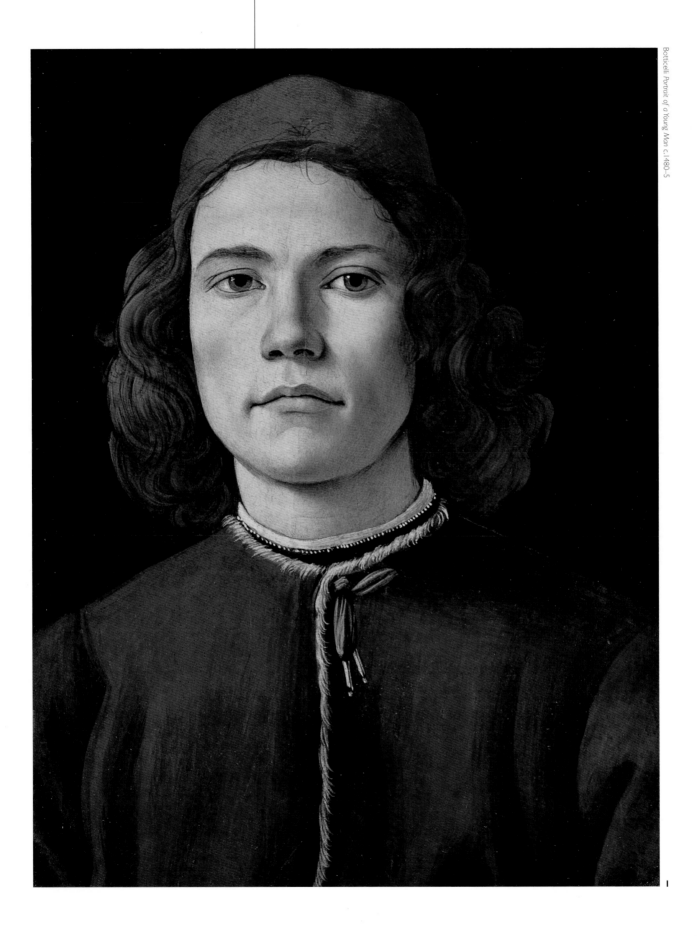

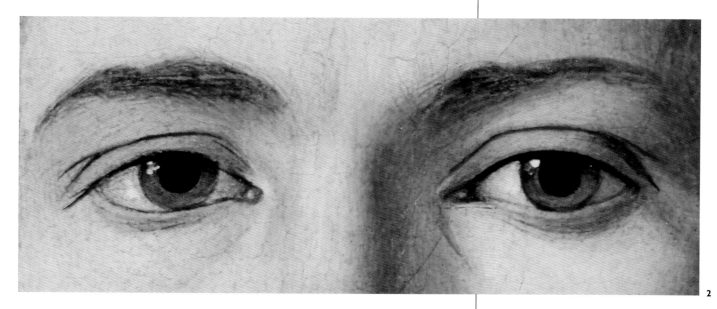

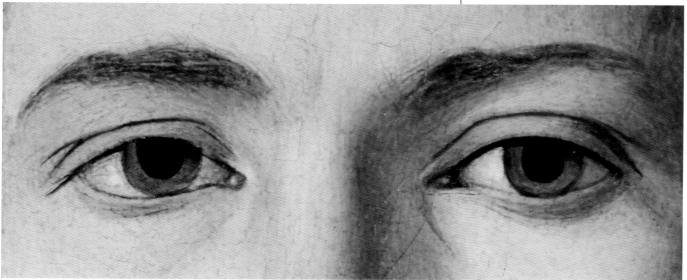

The mutual dependency is more dramatically pronounced if the highlight happens to be non-figurative: if it does not *look* like anything. As we have already seen, the introduction of a featureless white speck gives lustre and shape to the darkened transparency of the human cornea. If this gleam in the eye is carefully blotted out the virtual surface disappears. Conversely, though, if the identifiable setting is masked off, we now see the highlight for what it is: a non-committal speck of opaque white paint.

Although we do not perceive it consciously, the tiny white speck in each eye (**2**) lends an energetic sense of attentiveness to this portrait by Botticelli (**1**). It is like the spark of consciousness and without it the gaze seems almost dead (**3**). What is more the eyeball loses its bulging rotundity. Conversely, without its anatomical setting, the white speck loses its identity as a glistening highlight (**4**).

Even when the pictorial format is diagrammatic the observer can 'read' the curved white patches as highlights (**1**) and as a result, 'sees' the waxy bulge of the ripe fruit. As with the gleam in the eye, the effect can easily be deconstructed. Take out the highlight (**2**) and the fruit goes flat. If its shape is inconsistent with the cross-sectional curve of the apple (**3**), the highlight is not recognisable as such and the fruit looks flat, just as it does *without* the highlight. If the curvature of the highlight is consistent with that of the apple but happens to have the price written on it (**4**) it is difficult to see it as a highlight so that the shine goes but the bulge of the apple remains. And yet the white patch does not signify anything if it is seen against a featureless coloured background (**5**), without any other information as to the possible identity of the real object on whose surface it appears.

A slightly more complicated effect is to be seen in this example (**1–5**). By including a conventionally curved highlight in the simplified logo of a Washington State apple, the commercial artist has successfully represented both the *rotundity* of the apple and the waxy lustre of its skin. When the highlight is taken out, the fruit looks both flat and matt. If the highlight is reintroduced, but this time with its curvature contradicting the circular outline of the apple, it does not look remotely like a highlight. As a result the skin of the apple does not look waxy at all. On the other hand we can preserve the consistency of the curvature and deny the identity of the highlight by overprinting it with the price so that it now looks like a label and, once again, the gloss vanishes. It is as if we read the pictorial composition like a sentence. When it happens to include grammatical mistakes, the meaning becomes ambiguous.

However, the analogy with grammar gives a misleading impression as to the character of pictorial composition. Because while there is an unarguable sense in which pictures can be said to be *composed*, since they can be *de*composed with some of the results we have just seen, the composition as such does not consist of discrete representational units. The fleck of white which confers visibility and shape on the transparency of the cornea does not do so by virtue of some representational property comparable to the lexical meaning of a word. When a word is introduced into a sentence, the meaning it gives to the sentence is to a significant degree the result of the meaning it has in the dictionary. I say 'to a significant degree' because a word may have several different meanings, only one of which is apparent in any particular sentence. In the phrase 'I cashed a cheque at the bank', the riverside meaning of the word 'bank' is suppressed by the mention of cashing money. Nevertheless, the fact that the word has a meaning prior to its use in any particular sentence makes it fundamentally different from the fleck of white paint which does not mean anything at all until it is introduced into a picture. In fact the fleck of paint

3

4

5

does not even exist until the artist flecks it into existence. It is created by making a brushstroke not by choosing it from a box of flecks. Besides, when a word occurs in a sentence it functions in the sentence by retaining its identity as a word; whereas the dab of paint which results from making a brushstroke often loses its identity in the paintwork to which it is added. In that sense the painted fleck is an atypical example, for the simple reason that it is separately visible against the dark background of the pupil. In most cases, the result of making separately countable brushstrokes does not consist of correspondingly countable dabs of paint on the canvas but rather an area of paintwork.

So when we talk about the composition of a painting we are not referring to an arrangement of pre-existing representational units, because there are no such units. By the same token, when we decompose a painting for the purpose of elucidating its illusionistic effects, it is not a question of taking it apart at the joints, because there are no joints. By a process of trial and error we eliminate first one area and then another and discover the pictorial evidence that supports this or that particular visual effect. As with any experimental enterprise we start the investigation with a certain hypothesis and then tinker accordingly.

In the case of the illusion of reflective surfaces that we have already discussed, it seems likely that a *necessary* condition for our perceiving them is the recognition that the imagery is reflected – why else would we credit the area in which they occur with a surface? In which case, the next step is to see what happens if we blot out the pictorial evidence of its *being* a reflection. And in pictures which happen to include a duplicate representation of the objects in question, and if there is good reason for thinking that one of these configurations is the reflection of the other, it would seem reasonable to start the analysis by blacking out that part of the picture which includes what is obviously the *real* object, and see what happens to what we think is the

Campin *Werl Altarpiece* (detail) c. 1438

reflected one. So, in Robert Campin's *Werl Altarpiece*, it is easy to distinguish between the real window on the left-hand side of the wall and its glistening reflection in the spherical mirror. But as it happens, eliminating the section of the picture which includes the real window is not by any means sufficient to abolish the sheen of the mirror in which it is reflected. And that is because there is still enough evidence to identify the image of the window as a *reflected* one, and the observer automatically credits the circular area in which it

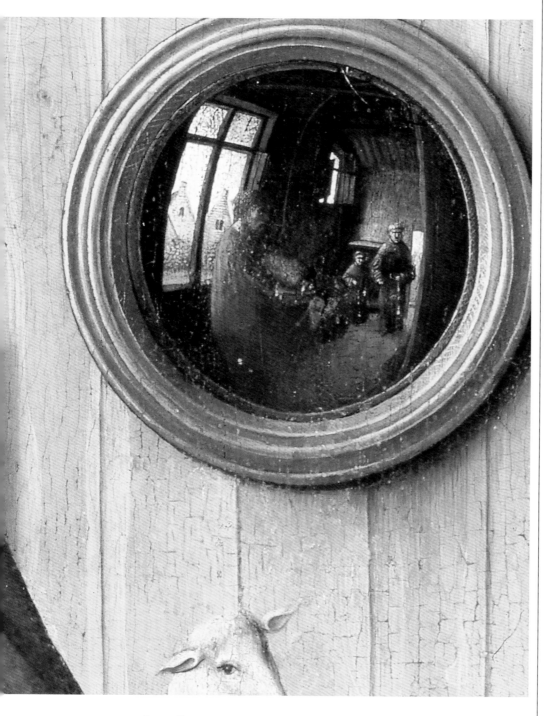

In contrast to the apples on pages 72 and 73, whose surfaces have a strong local colour, Campin's mirror (**1**) shows no objective signs of having a surface at all. What it reveals is what it reflects, so that by looking at it we *see* something else, and the objectively non-existent surface unarguably shines. We *know* that if we reached out to touch it, our finger would meet mechanical resistance and that we might even leave a fingerprint suspended between us and the 'view'.

appears with a reflective surface. So how do we know it *is* a mirror? By its frame perhaps. How about masking that out? The forlorn image of the window still seems obstinately reflected. And if it does, the only remaining evidence in favour of its being a reflection is the anamorphic distortion of the image. Real windows don't *look* like that, but since windows reflected in convex surfaces do, then it seems reasonable to assume that we are, after all, looking at a reflection, and the surface which affords it therefore remains apparent. Or at

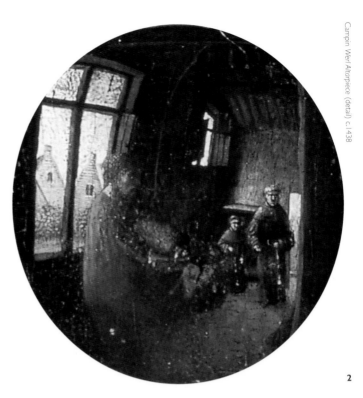

1

2

The illusory gleam in Campin's picture owes a lot to the brightly reflected window, and if you hold your hand over that part of the picture, the lustre of the surface is undeniably diminished. However, the glimmering frame helps to reinforce the belief that this might be a mirror after all – though it *could* be a circular painting or tondo, in which case there would be no reason to credit its surface with lustre!
Take the frame away (**1**) and then correct the anamorphic distortion (**2**) and see how little reflective gleam is left.

By the middle of the seventeenth century it was possible to manufacture flat, as opposed to blown, convex mirrors, so that the reflected imagery was no longer distinguished by tell-tale signs of anamorphic distortion. In *Las Meninas* (**3**) Velázquez has cunningly deprived us of some of the *other* assurances as to this being a mirror. There is no window reflected, and the real couple, of whom this *might* be a reflection, are enigmatically unrepresented!

least it does to some observers. So how about eliminating what seems to be the only remaining evidence in favour of it being a reflection? By exploiting the versatile capabilities of computer graphics, we can 'morph' the curved image into the form that it would have in a flat mirror. When *that* happens there is no evidence left in favour of the image being a reflected one, and the illusory surface vanishes once and for all.

This, I suspect, is the reason why Velázquez felt it necessary to 'brush in' the sheen which we can see quite clearly on the mirror on the wall of *Las Meninas*. The Royal couple, of which this is assumed to be a reflection, are conspicuous by their absence from the full picture, since they are presumably standing where we are. And since the frame of the mirror is indistinguishable from those of the surrounding pictures, there is no firm evidence in favour of the figures being reflected. In contrast to Robert Campin's mirror, Velázquez's glass is flat so that we have no anamorphic evidence in favour of reflection. Velázquez therefore cannot leave it to us to provide the necessary illusion of reflective sheen. He, the artist, has to *supply* it, which he does by lightly scumbling the pictorial surface with an uneven film of white paint. If Velázquez had slightly enlarged the format of his great painting to include even a partial rear view of the Royal couple, then we, the spectators, would recognise the framed image as a mirror and Velázquez's painterly effort to give it a sheen would be quite unnecessary because we would supply it for him!

Velázquez *Las Meninas* 1656

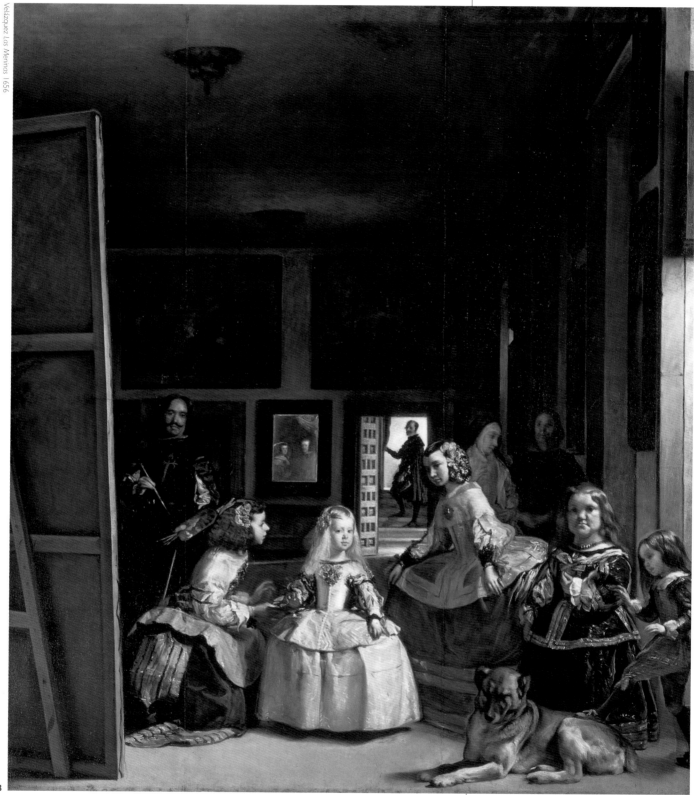

3

Looking at and looking through

Unlike the Arnolfini mirror which surveys the scene which it reflects in splendid isolation, the Velázquez looking-glass takes its place on a wall which is literally crowded with picture frames, each of which, as we shall see, employs the eye in a recognisably different way. Although Velázquez has helpfully 'silvered' its otherwise invisible surface, adding suggestive gleams at the bevelled edges, the most important way in which the mirror betrays its

1

In contrast to the featureless surface of the Flemish mirrors, there is an unmistakable glassy flare in the lower right corner of this example (1, 2). Presumably it is the light from the invisible window at the far end of the room glancing off at an oblique angle, and as with anything that betrays the otherwise invisible presence of the surface, the flare compromises the visibility of the reflected image. What are we to make of the blurred features of the Royal couple (4)?

It is unlikely that it has anything to do with the optical imperfection of the mirror, which would, in reality, have displayed a focused image of the King and Queen. Perhaps Velázquez was trying to represent our experience of looking at the *real* scene, because in order to see the figures in the foreground clearly, we would have 'pulled' focus and lost the definition of the background.

And yet ... the silhouetted courtier who stands in the same focal plane as the mirror (3) is sharply outlined. Hmm!

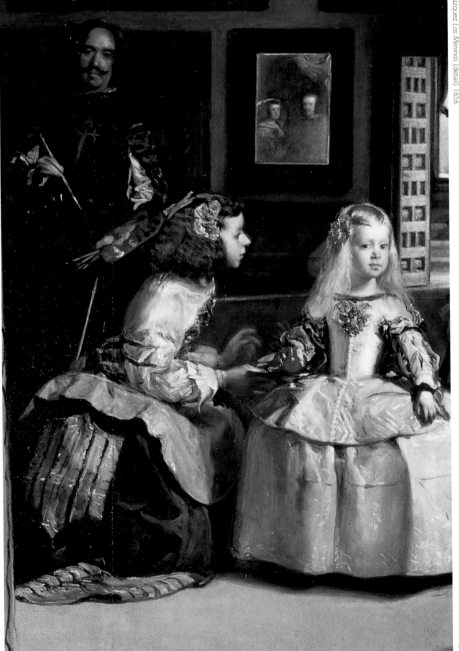

Velázquez *Las Meninas* (detail) 1656

2

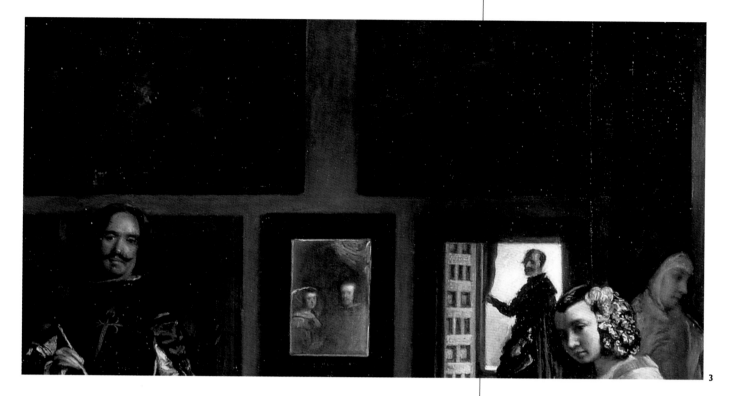

3

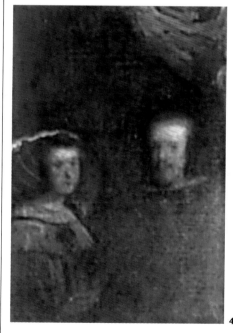

4

identity is by disclosing imagery whose brightness is so inconsistent with the dimness of the surrounding wall that it can only have been borrowed, by reflection, from the strongly illuminated figures of the King and Queen, who must have been standing pictorially unrepresented in the invisible foreground. As soon as we identify this luminous image as a reflection we recognise that it is something categorically different from the figure standing in the adjacent frame. Because in contrast to the silhouette which is unarguably that of a *real* person standing just beyond what is self-evidently a *real* doorway, the Royal couple, conspicuous by their *actual* absence, are represented by their reflected deputies, who stand in a virtual space behind the mirror's invisible but nonetheless impenetrable surface. And whereas the enigmatic courtier is genuinely looking downstage towards us, the mirror reflects a gaze which is actually, although invisibly, pointed in the opposite direction. And if only we could see the mythological subjects in the barely discernible paintings above, we would recognise imagery of yet another sort; just as virtual as that which appears in the mirror, but in a totally different way. Instead of *reflecting* what they represent, paintings *depict* it and, as such, we are required to exercise a different type of perceptual effort from the one we bring to the recognition of a reflection. Because in contrast to the mirror, the perception of whose imagery requires us to *ignore* its surface – the more we can see *on* a mirror the less we can see *in* it – the imagery which appears in a painting is actually constituted by the visible brushstrokes on its opaque surface.

This is what Richard Wollheim (1968) means when he refers to the dual requirements of representational seeing. According to him, looking at a representational painting engages not one but two types of visual activity. If the painting is to succeed as a depiction, we must recognise what it depicts, but this requires us to see the paint by means of which the depiction is achieved. Thus in looking at a still life by Cézanne we see apples but can only do so by seeing them in the *paint*. There is no such requirement when it comes to seeing something in a mirror, since the surface which affords its reflection contributes nothing visibly to its appearance. There are of course certain pictures whose brushwork is so reticent and which are so cunningly exhibited that we see what they depict without being consciously aware of the painted

If, as it seems to be, this is a picture of apples (**I**), the surface is notionally invisible. We 'see' the apples through what looks like a completely transparent window. And yet the 'window' through which we see the fruit is thickly painted with almost palpable layers of unmistakably opaque pigment. So what *are* we seeing?

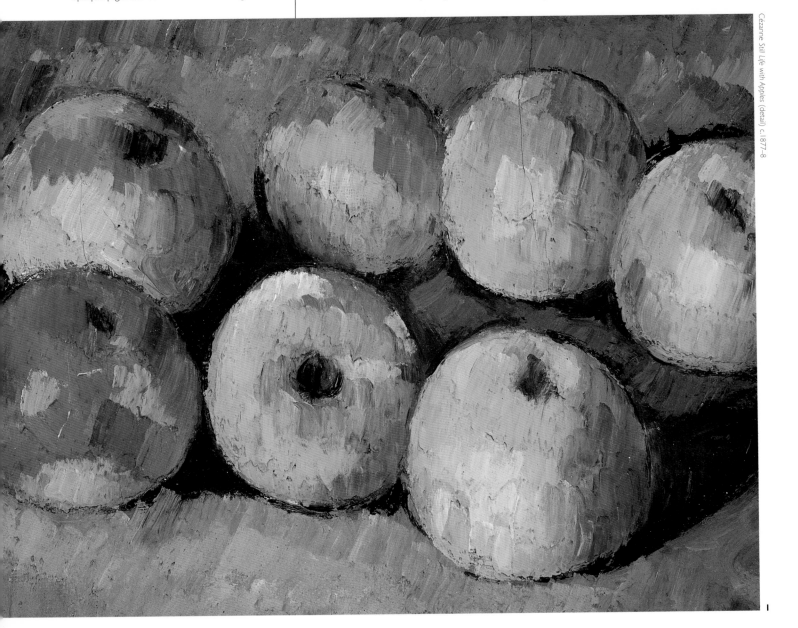

Cézanne *Still Life with Apples* (detail) c.1877–8

Hoogstraten *A View down a Corridor* (detail) 1662

2

The paintwork by means of which we get the sense of seeing something beyond is not always as juicily apparent as it is in Cézanne. When the point of the exercise is to deceive the observer as to the reality of what is represented, the artist must efface any signs of his own brushwork (**2**). Even so, there are practical limits to such reticence, and closer inspection invariably reveals the medium of the representation (**3**). The surface of a mirror reveals nothing of the sort.

3

The more coherently a surface reflects the incident light, the more insistently its appearance nudges the observer's attention in another direction. Although it is not smooth enough to resolve a recognisable image of the light source, Stoskopff's saucepan (**1**), attentively tilted like the dish of a radio telescope, gives off a vivid metallic flare, whose brilliance alone indicates that of the distant Sun.

The mirror on the opposite page (**2**) provides much better reception. In contrast to the all too evident texture of the saucepan, the silvered glass is so flat and so perfectly polished that the only evidence in favour of its existence is the reflection of an otherwise invisible scene nearby.

surface. But even with such successful *trompes-l'oeil* we can be *made* aware of the paintwork which does the trick. Whereas there is no imaginable way of seeing how a mirror does it. You can look at your own reflection until you are blue in the face and still see nothing but your own discoloured features.

Although reflected imagery does not, as painted imagery does, require the observer to recognise the existence of something which mediates its appearance, it could be argued that for all practical purposes it has dual requirements of its own; if only because the usefulness of a mirror presupposes that as well as recognising what is in it, we must understand that what we see is, after all, a *reflection* and that what it shows is not where it seems to be. This is what is meant by reflection: something bent back from somewhere else. From the most indistinct highlight to the most recognisable scene, a reflection directs our attention to the existence of something elsewhere — and in many cases it refers to something out of sight.

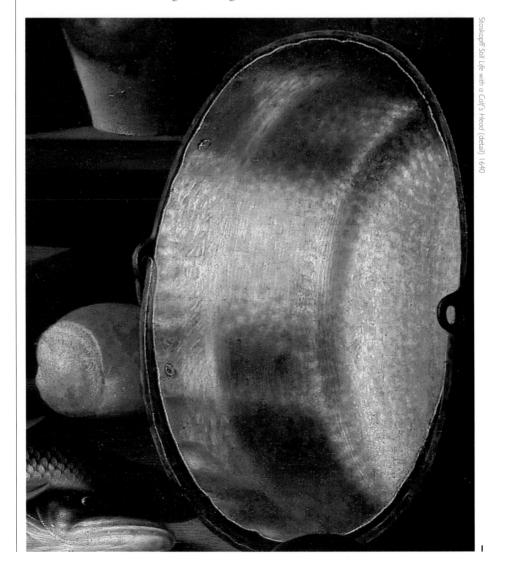

Stoskopff *Still Life with a Calf's Head* (detail) 1640

1

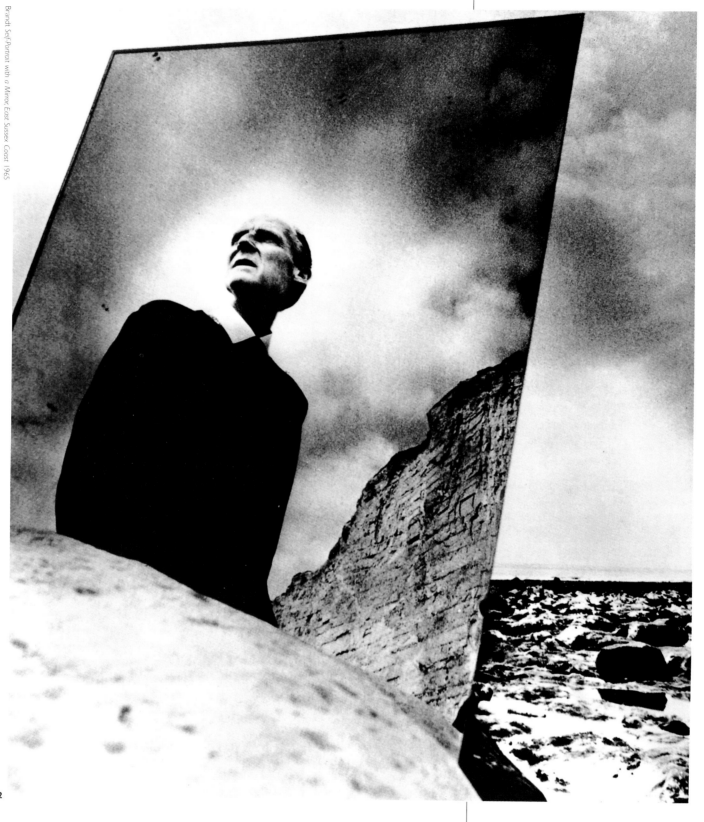

Brandt Self-Portrait with a Mirror, East Sussex Coast 1965

2

The polished brass sphere (**1**) disfigures and discolours the scene which it reflects. Its convexity warps the regular pattern of the chequered floor, and the brass stains the scene slightly yellow. The reflective lustre of the object is composed of these features and little else.

Delft School *An Interior, with a Woman refusing a Glass of Wine* (detail) 1660–5

1

How then does a reflection betray its identity? How do we tell the difference between a reflection and the real thing? One answer, though by no means the only one, is that reflected imagery just *looks* different. Because of the surface in which it appears, the *quality* of the imagery may be unmistakably characteristic. It may be tinted by the colour of the reflective surface. It may be blurred by the local texture of the surface. Or it may be disfigured and distorted by the curvature or the irregularities of the surface. Such imagery wears its reflected identity on its sleeve.

The geometrical regularity with which the unmistakably upside-down image of a tree is intermittently serrated (**2**) indicates that we are looking at a woodland scene reflected in a pool of water, whose surface has just been disturbed by two droplets falling from the overhanging branches. Escher has deliberately simplified the representation as if to show how little is required to give the impression of watery sheen. Once again it is the observer who supplies the sensation of there being a surface. Apart from the ruffled imagery there *is* no surface to be seen.

By using coloured paint rather than black ink, Caillebotte (**3**) provides extra information as to the local hue of the reflective surface.

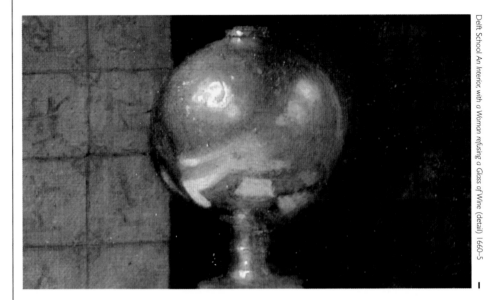

Escher *Rippled Surface* 1950

2

Caillebotte L'Yerres in the Rain 1875

3

Desportes Silver Tureen with Peaches (detail) c.1733-4

Even at a glance, it is easy to tell that the avalanche of peaches in Desportes' still life (**1**) is divided into two distinct groups and that the heap which is almost separately framed by the oval format in the back of the picture is the reflected image of the fruit in the foreground. But unlike the child on the opposite page (**2**), whose reflected face is unmistakably different from the back of his head, the mirror image of the peaches is almost indistinguishable from the front surface of the real thing.

But when the reflective surface is smooth, flat and colourless, the images which appear in it are qualitatively indistinguishable from the real thing, so that the only way of telling that they are or might be reflections is purely circumstantial. That is to say it depends on something other than the quality of the imagery itself. If something visibly duplicates the appearance of something which is to be seen in its immediate vicinity, the chances are that the relationship between the two is one of reflection, especially if one of the two images appears in a decorative frame. In Desportes' still life the peaches which appear in the oval format of the silver tray are self-evidently reflections of the ones heaped in the nearby bowl. As far as their intrinsic appearance is concerned, there is, as we have seen, nothing to choose between the reflected peaches and the real ones, so that it can only be their partnership which gives the game away.

But duplication as such is not sufficient, or to be more precise it is not sufficient unless it is correct. In Romney's portrait of *Mrs Russell and Son*, the duplicated image of the child is perfectly acceptable as his reflection – just as it

Human beings are conspicuously asymmetrical fore and aft so that we can tell without having to look twice that Magritte's *La Reproduction Interdite* (**1**) is optically impossible, whereas Bedoli's *Anna Eleanora Sanvitale* (**2**) is correctly reflected. But since peaches do not have readily distinguishable aspects, it is difficult to visualise the Magrittian equivalent of Desportes' still life!

Magritte *La Reproduction Interdite* 1937

1

is in Bedoli's painting (**2**). Whereas in Magritte's notorious portrait of Edward James (**1**) it just as obviously is not. But why are we so certain? The laws of optics, according to which reflected images are necessarily reversed, are not exactly common knowledge, and yet everyone can tell that there is something unacceptably wonky about Edward James' appearance in the mirror. So wonky, in fact, that we are tempted to cast around for an explanation which does not require it to be a mirror. What if the frame over the mantelpiece encloses a hole in the wall and Edward James is looking at his identical twin who happens to be facing at the same direction next door? No such luck! Magritte carefully forecloses this explanation by including a perfectly orthodox reflection of the book on the mantelpiece immediately in front of the mirror. So it is a mirror after all, and we are back where we started with the problem of how it is that this particular duplication is so glaringly unacceptable as a reflection.

2

This is a convenient place to consider the old chestnut about mirrors reversing things from right to left while reflecting them the right way up. If this superstition were *literally* true, we would expect the reflected imagery to

The relationship between one individual and his reflection can be imitated by two separate individuals facing one another. Apart from the obvious difference in their clothes, the male and female figures in Norman Blamey's painting (**1**) are almost, but not quite, mirror images of each other. The relative positions of their corresponding limbs are not quite right. Still, there is an uncanny sense of reflected reciprocity.

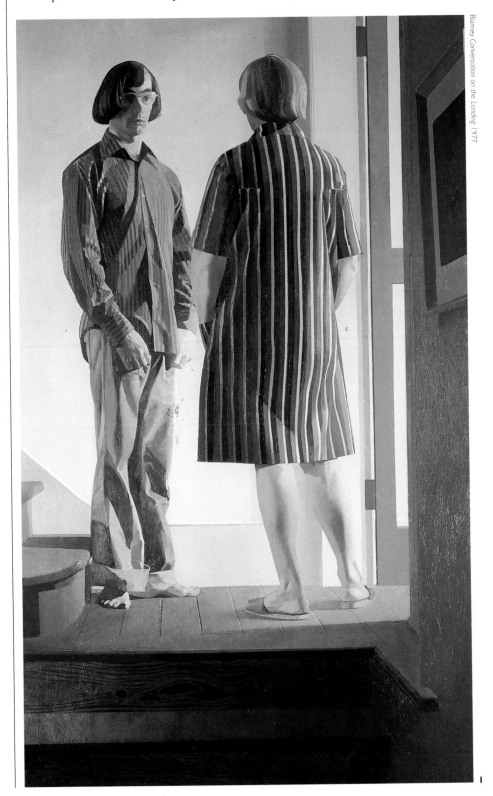

Blamey *Conversation on the Landing* 1977

1

undergo a visible change in orientation as the mirror was rotated about its centre. As it is, *nothing* changes at all, so that the reversal has nothing to do with the optical properties of the mirror as such. The problem is that even if we accept the uncontroversial claim that mirrors invariably reflect things the right way *up*, the sense in which they could be said to reflect things the wrong way *round* is not altogether clear. Even in what seems to be unmistakable examples of reversal – such as lettering – careful analysis shows that the role of the mirror is much less mysterious than it's cracked up to be.

In certain respects it's factually incorrect to insist that mirrors reflect things the wrong way round. If I stand facing myself in the mirror with my arms stretched out east and west, whenever I waggle the eastward hand I can't help noticing that it's the eastwardly extended reflection which waggles *its* hand. And vice versa. So there is *no* reversal from side to side. But wait. Although there is no visible reversal within the two-dimensional plane of the mirror, as soon as we take the *third* dimension into consideration there *is* a reversal – only we are so accustomed to it that we don't notice. In facing the mirror, which I have to do if I want it to reflect my front, my nose points due north, whereas my *reflected* nose is pointed in the opposite direction – due south. And *this* is where the apparent reversal from right to left happens. Looking at my reflection, I 'see' it as a real person facing in the opposite direction to me, at the same distance *behind* the mirror as I'm standing *in front* of it. Now, if I *imagine* myself facing in the same direction as my reflection *seems* to be facing, I have to rotate my imagined self through 180 degrees, and when I do so, my *right* hand is now on the same side as my reflection's left. Hey presto – reversal!

But this is *not* the result of some optical magic inherent in *mirrors*. On the contrary, it's the straightforward, though sometimes puzzling, consequence of the fact that in order to see the reflection of what we call the *front* of something, it must be rotated about its vertical axis so that its recognisably different front now *faces* the reflective surface, which then gives back an image of that aspect.

In an object which is symmetrical right and left, the rotation which is required to bring its front surface to face that of the mirror causes no visible reversal. And in certain respects at least, the human body is sufficiently symmetrical about the so-called sagittal plane, for the rotation to be visibly unnoticeable. In fact it is only because right and left *feel* different that we pay any attention to its *reflected* reversal.

But when it comes to configurations which are conspicuously and unmistakably asymmetrical from left to right, the rotation required to bring it face-to-face with the mirror causes unmistakable reversal.

Sagittal plane **2**

Sagittal plane **3**

The mirror image of ourselves (**2**) is identical to our actual appearance with one obvious difference: it's facing in the opposite direction, so that our right hand is on our left and vice versa. Nevertheless (**3**) the reflected hand waggles opposite the waggling real one.

If we could – but of course we can't – get in back of our own reflection (**4**), *our* right hand would be behind *its* left. And that's all there is to it.

Sagittal plane **4**

The face undergoes the same reversal. But since we have never seen our own features other than in a mirror, we are unaware of the fact that they are flipped over. But when we see the reflection of someone *else* we are often startled to discover how lopsided they look, because of their *unreflected* appearance as a comparison.

Clementina Lady Hawarden *Clementina and Isabella Facing One Another* 19th century

1

Because human beings display bilateral symmetry, which is another way of saying that the left side of a person is, externally at least, the mirror image of their right side, any one individual can act as the reflection of any other. All they have to do is to face one another as they are doing in Lady Hawarden's photograph (**1**). The more they each resemble one another the more convincing, if disconcerting, such a partnership can be. In the case of identical twins the partners may deliberately exploit one another's reflections: 'Stand over there so I can see what I look like'!

The reflection in the Picasso (**2**) is a decorative exercise in symmetrical duplication. But the darkness of the mirror image hints at the possibility of the woman's alternative self.

The theme of human duplication, as represented by twins, doubles and mirrors, is so persistent that it suggests a certain anxiety as to the uniqueness of the personal self. The possibility of there being an exact replica of oneself is understandably disturbing. Apart from the fact that it introduces the not always amusing risk of

social confusion, such a possibility raises existential doubts: 'If there are two of me, which of them can claim to be *really* me?'

In the Romantic literature of the nineteenth century the hero is frequently haunted by a darker and often shameful version of his public self. In the works of writers such as E.T.A. Hoffmann, James Hogg, Nathaniel Hawthorne and Robert Louis Stevenson, the main character is subverted and usurped by the misdeeds of his diabolic 'double'.

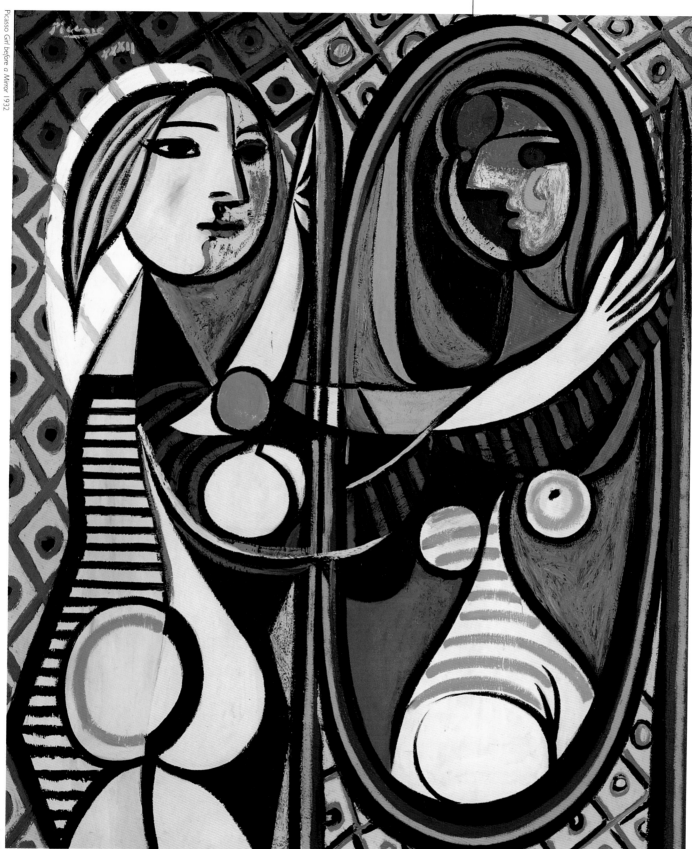

Picasso Girl before a Mirror 1932

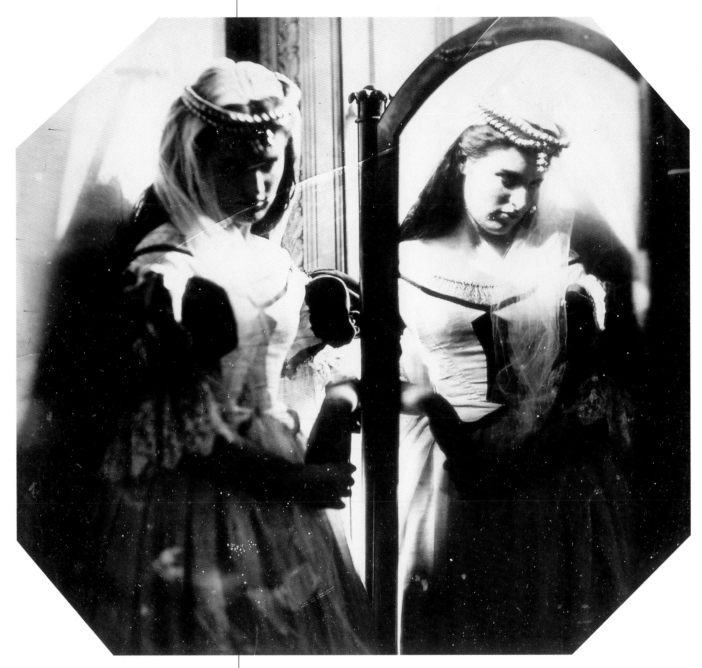

Clementina Lady Hawarden Clementina by a Mirror 19th century

1

Clementina, Lady Hawarden was obviously intrigued by the pictorial possibilities of human duplication (1) and in most of the published examples of her work the doubling is realised by optical reflection. But in many cases the same effect is created by posing two more or less identical figures next to or opposite one another.

It is difficult to say whether or not these tableaux express a psychological interest in duality. It seems just as likely that they represent a delight in the purely decorative effect of reduplication.

If I write the word R E F L E C T I O N in capital letters on the opaque surface of a strip of paper, the only way I can see it reflected is to turn the paper over so that the writing faces the mirror. The reflection is unmistakably reversed, in spite of the fact that the initial R is still directly opposite the reflected R and so on. The reason is that, with the exception of the characters T, I and O, each of the individual letters is asymmetrical about its vertical axis, so that in reversing the paper so that the inscription faces the mirror, the letters are turned the wrong way round, thus.

If I write the same inscription, however, on a strip of transparent cellophane and hold it up to the mirror *without* rotating it, I can read the word R E F L E C T I O N the right way round both on the cellophane *and* in its reflection in the mirror!

With alphabetical characters their susceptibility to reversal depends on their symmetry about the mid-line.

REFLECTION ИOITƆƎⅎƎЯ
ЯƎⅎⅼⅇƆꓕIOИ

1

axis of symmetry

Reflection is not confined to mirrors. The ornamental patterns above and below (**1**, **2**) are examples of the same geometrical principle. In each case, the right and left half of the format are mirror images of one another. The bilateral symmetry of the overall pattern is achieved by replicating the configuration on one side and flipping the copy through 180 degrees as if it were still attached along one of its side margins.

You can see the mechanics of the process by slowly opening the book at this page. When the volume is closed the two halves of the William Morris design (**3**) are accurately superimposed. But as you open the book along the axis of the spine, the single *asymmetrical* pattern unfolds to form a symmetrical image.

2

axis of symmetry

3

Morris Honeysuckle Printed Cotton 1876

Griesbach Gothic Ornament 19th century

axis of symmetry **4**

Riegl Corinthian Capital 1893

axis of symmetry **5**

Mirror imagery is one of the most important
features in the grammar of ornament and the
principle is consistently obeyed in the creation of
architectural decoration (**4**, **5**). It's as if we
project the image of human bilateral symmetry
on to the objects of our own making.

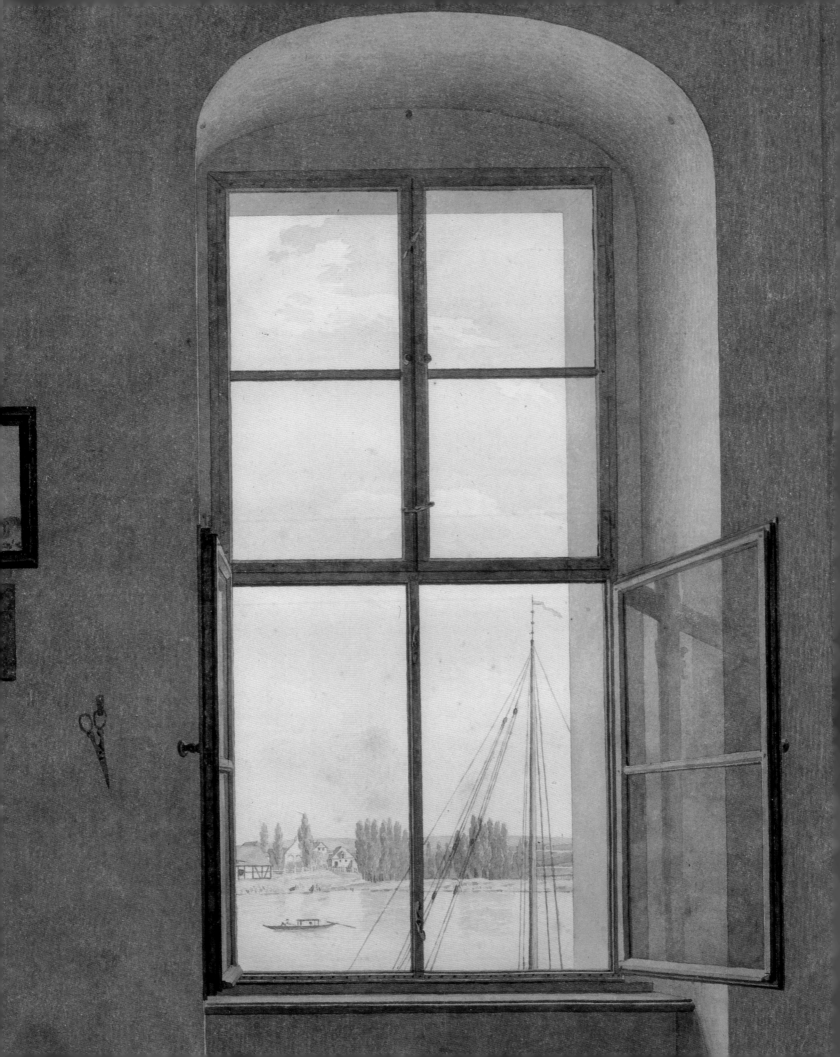

Seeing backwards

Friedrich *View of the Artist's Studio, Right Window* (detail) 1805–6

Miller *Window in Bologna* 1995

2

The brightness, scale and pictorial content of the imagery framed by Friedrich's window (**1**) is so coherently discontinuous with that of the surrounding wall that we read it as part of a larger scene, at a daylit distance beyond the dimly illuminated façade of the foreground interior. When it comes to looking from outside in (**2**), the complementary view that we might have had of the interior is often compromised by the reflective surface of the window panes. In this situation, the imagery framed by the window is pictorially inconsistent with what we would expect to see inside a house, so that instead of perceiving it as something on the *far* side of the frame, we take it to be the displaced representation of something in the opposite direction to our line of sight.

Recognising that something is a reflection does not necessarily depend on the visible presence of whatever it happens to be a reflection of. Even in the absence of its 'parent' object a reflection will often betray itself by virtue of its otherwise inexplicable relationship to its immediate surroundings. The photograph above is a good example. Because of its lighting we can recognise this as the outside view of a building in which the brilliant sky, framed in what is undeniably a window, is out of place. It is incongruously ectopic and unless we assume that it is an unsolicited Magritte it must be a reflection of the building on the opposite side of the street! A panel of imagery identifies itself as a reflection of something out of sight, by looking for all the world like a skin-graft transplanted from elsewhere.

However, the mere fact that a section of imagery is visibly out of joint with its immediate surroundings is not necessarily an indication that it is *reflected*. Doors and windows also disclose scenery which is visibly at odds with

1

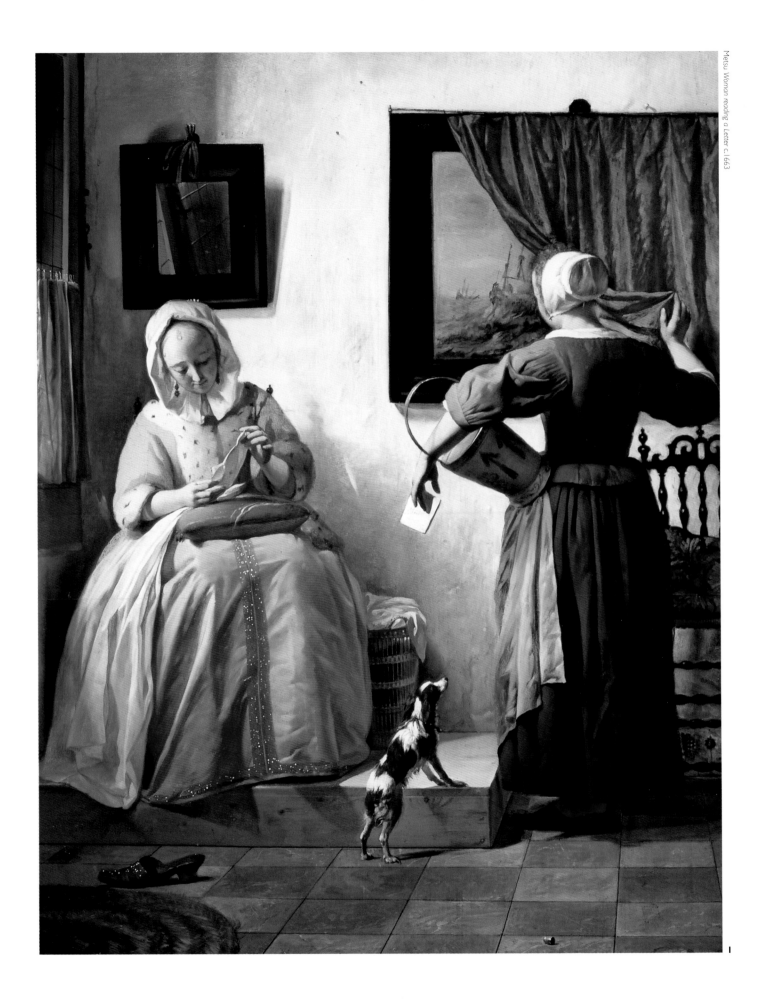

Somov *Matin d'Eré* 1932

2

Bonnard *Le Tub (Effet de Glace)* 1909

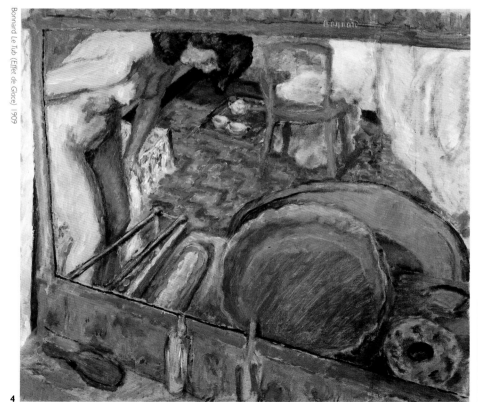

4

Købke *Portrait of the painter Frederik Sødring* 1832

3

In contrast to the riverside view which can be seen directly through the window in Friedrich's painting on page 98, the half-curtained seascape in Metsu's painting (**1**) is a different type of vista altogether. Instead of being an *actual* window it is, as the Renaissance theorists of perspective insisted, a *virtual* one, represented in paint, on an opaque flat surface. This means that in order to see the view the servant girl must look at the paint.

The almost unintelligibly abstract imagery in what is presumably a mirror, just above the seated woman's head, is also virtual. But since it is reflected we know that it represents something just out of sight on the near side of its surface.

The same sort of displaced imagery can be seen in the three examples on this page. In Somov's *Matin d'Eté* (**2**), the dog's gaze directs our attention to the absent nude who is so evidently delighted by her own canopied reflection. Similarly, the subject of Købke's portrait (**3**) looks towards a scene of which *we* can see no more than an ectopic fragment in the mirror above his head. Perhaps it isn't a mirror though. It could be an improbably early example of Danish Constructivism.

Almost the whole of Bonnard's canvas (**4**) is taken up by a reflection of something which would otherwise be invisible. Why is the mirror image of this scene so much more intriguing than the real thing would have been?

Vallotton Landscape in Provence – The Window (detail) 1920

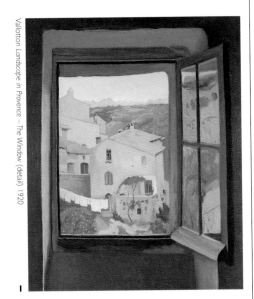

1

Since they are arranged to make a scenically intelligible whole, the adjacent panels of transparent and reflective glass in Dahl's painting (**2**) are readily distinguishable from one another. Notice that in both Dahl's and Vallotton's (**1**) pictures the windows thrown back against the casement reflect so much of the *external* scene that it is impossible to see the surface of the internal wall behind; whereas in Friedrich's painting on page 98 the reflection is visibly superimposed on what can be seen *through* the transparency of the glass. Kersting (**3**) juxtaposes transparency and two different types of reflection – the *deliberately* reflective surface of the mirror and the *incidentally* reflective surface of the window pane.

the adjacent detail. But in most cases the view identifies itself as something *beyond* and the observer is not tempted to look around for anything corresponding to it on the *near* side of the frame. Windows, for example, usually give on to landscape, the nature and scale of whose detail betrays the fact that it is something further beyond and that we are looking therefore at a view rather than a reflection. The open casements which recur with such insistent frequency in nineteenth-century German paintings are good examples. And as if to emphasise their distinguishable traits, artists such as Dahl and Kersting often put windows and mirrors side-by-side, as if to demonstrate the difference between something reflected on the hither side of the frame as opposed to something seen on the far side of one.

Dahl View of Pillnitz through a Window (detail) 1823

2

Kersting *Before the Mirror* 1827

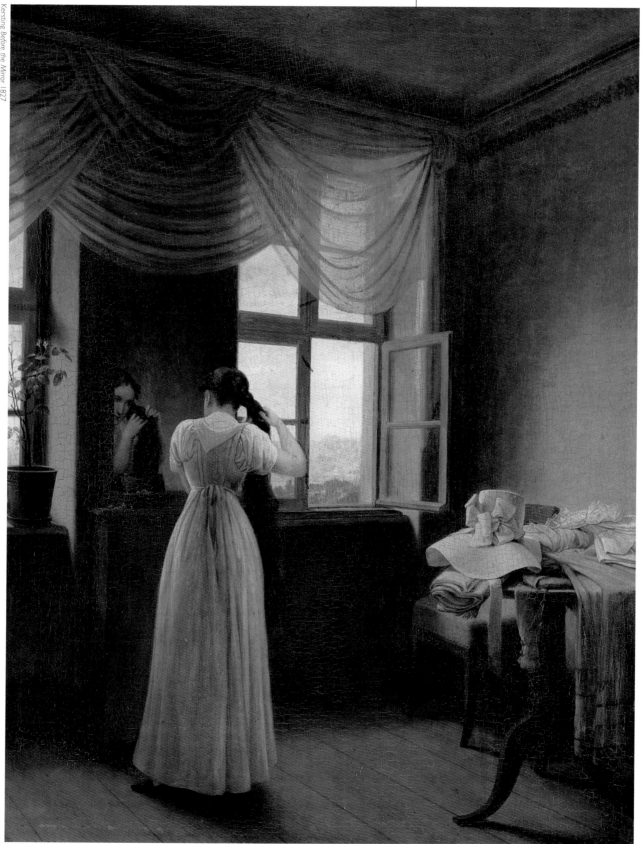

3

Parmigianino *The Mystic Marriage of Saint Catherine* c.1527–31

1

The most spectacular demonstration of this is to be seen in Samuel van Hoogstraten's box of delights in the National Gallery in London. Through an invisible peephole on one side of this long box we are inconspicuously let into a Dutch interior which is a virtual panellage of windows, mirrors, half-open doors and paintings, each one of which unambiguously discloses its particular form of view, virtual or actual. But perhaps the most remarkable feature of this boxed vista of vistas is the very thing which cannot be shown: the eye 'that sees not itself'.

For a moment it is difficult to tell whether the rectangular 'form' in the centre of Parmigianino's *The Mystic Marriage of Saint Catherine* (**1**) is a mirror or a doorway.
Hoogstraten (**2**) has a field day with such questions!

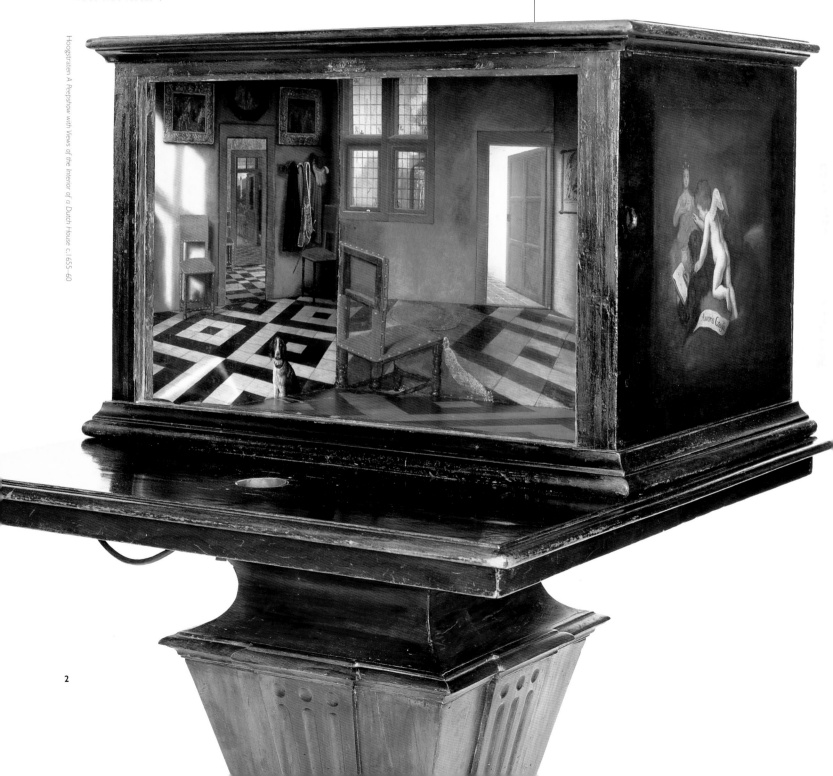

Hoogstraten *A Peepshow with Views of the Interior of a Dutch House c.1655–60*

2

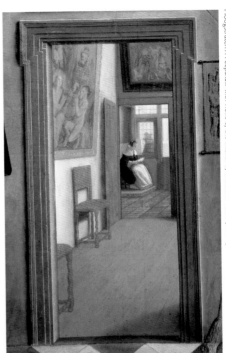

Hoogstraten A Peepshow with Views of the Interior of a Dutch House (details) c.1655–60

In a composition which in some respects is a representational Mondrian, Samuel van Hoogstraten creates a tessellated pattern of geometrical forms from which the observer constructs a pictorially coherent picture of a Dutch interior, intriguingly penetrated by windows, doors, pictures and mirrors (**1**, **2**, **3**, **4**).

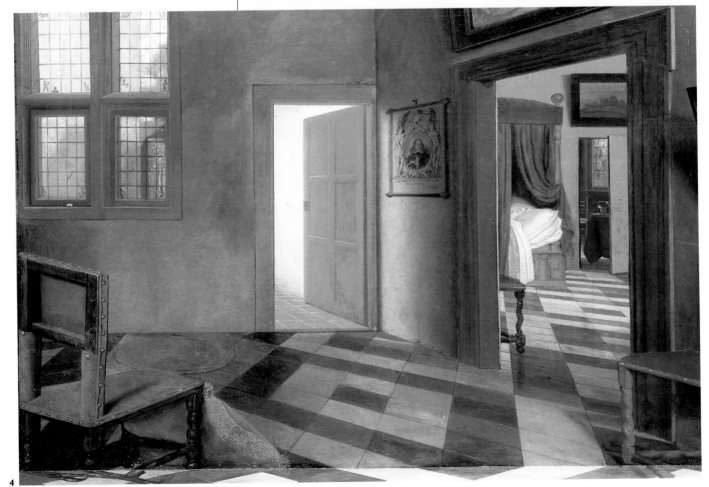

Van Eyck The Arnolfini Portrait (detail) 1434

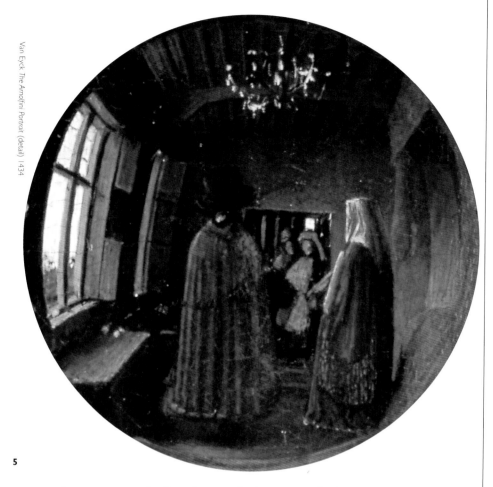

5

With its circular outline and convex surface, Van Eyck's mirror (**5**) would seem out of place in the conspicuously rectangular décor of Hoogstraten's interior. And the anamorphically distorted imagery seems to express a sensibility altogether different from that expressed by the well-proportioned reflections seen in seventeenth-century Dutch mirrors.

In contrast to the Royal gaze which commands the scene in *Las Meninas*, the monocular stare of the peeping viewer is not reflected. It reflects unobserved. And yet we have seen it before, though elsewhere and elsewhen. It is the unblinking eye, surveying what it reflects from an identical position on the back wall of *The Arnolfini Portrait*. In fact if we could pierce the centre of this convex mirror and look through its invisible pupil, what we would see would correspond to what it anamorphically reflects: that very part of the room which would otherwise remain invisible from the viewpoint chosen by Van Eyck to represent the young couple. Whatever symbolic purpose it serves – and its inescapable panoptic stare suggests it might be a representation of the all-seeing eye of God – Van Eyck's mirror epitomises the fact that reflection refers to something elsewhere and that it allows the artist to overcome the limitations of having eyes in the front of his head.

However, because of the technical limitations in the craft of fifteenth-century mirror-making, the rear view which the glass affords is disconcertingly unlike the one we might have had by peeping through the centre of the mirror. Since the reflective surface is convex, it furnishes a view not unlike the one provided by a modern fish-eye lens. Although this has the advantage of taking in a wide angle, so that if we look closely at the mirror we can see a large part

It is almost by accident that we discover the mysterious reflection of the Heavenly City in the polished breastplate of Bermejo's victorious Archangel (**1**). When the picture is viewed as a whole (**2**) the reflected scene vanishes into the bewildering glitter of the armoured figure. It is easier to identify the pictorial details in Van Eyck's mirror since there is nothing else to distract the eye from its intended purpose. Still, in the overall context of Van Eyck's *The Arnolfini Portrait*, the mirror seizes our attention as a magnificently rendered Gothic bauble.

of the otherwise invisible back end of the room, the perspective is disturbingly steepened and the reflected images become tantalisingly small as they recede into the distance. So much so that if the painting is viewed from a position which allows us to see the two principal figures at full length, the mirror dwindles to the size of a jewelled miniature and its ornamental lustre is much more noticeable than the Lilliputian scene it almost illegibly reflects.

An analogous conflict between lustre and picture is to be seen in Bermejo's painting of the triumphant Saint Michael in the National Gallery, London. Close inspection of the gleaming breastplate reveals an unexpected reflection of the Heavenly City, which we might see if we happened to look behind us, but when the picture is viewed from the standard distance, the glittering figure of the victorious Archangel is so striking that it is easy to overlook the minuscule scenery reflected in the polished armour. And yet the reflected imagery is one of the most important factors responsible for the impression of metallic lustre. The same principle applies to Hummel's *Granite Bowl in the Lustgarten, Berlin*. It takes a perceptual effort to recognise that the surface owes its seductively shiny appearance to the vista which is reflected upside down on its under-surface. If and when we do attend to the reflected scenery, our perception of the many-peeplia-upsidedownia prevents our seeing the granite lustre.

1

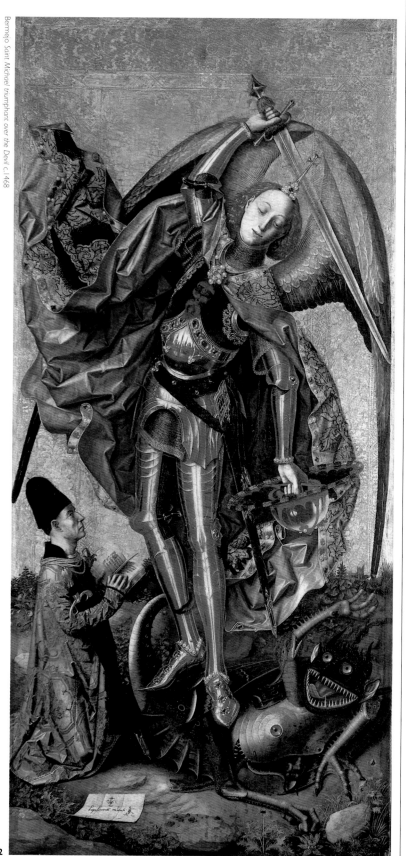

Bermejo *Saint Michael triumphant over the Devil* c.1468

2

Although Bermejo's Archangel is a devotional figure (**2**), the kneeling donor could just as easily be admiring a newly acquired example of figurative metalwork which blazes with Gothic virtuosity, looking for all the world like the most valued item in a ducal treasury.

The reticent domestic lustre to be seen in Claesz.'s still life (overleaf) is in sharp contrast to the apocalyptic splendour of Bermejo's altarpiece.

Overleaf
Claesz. *Still Life with a Turkey Pie* (detail) 1627

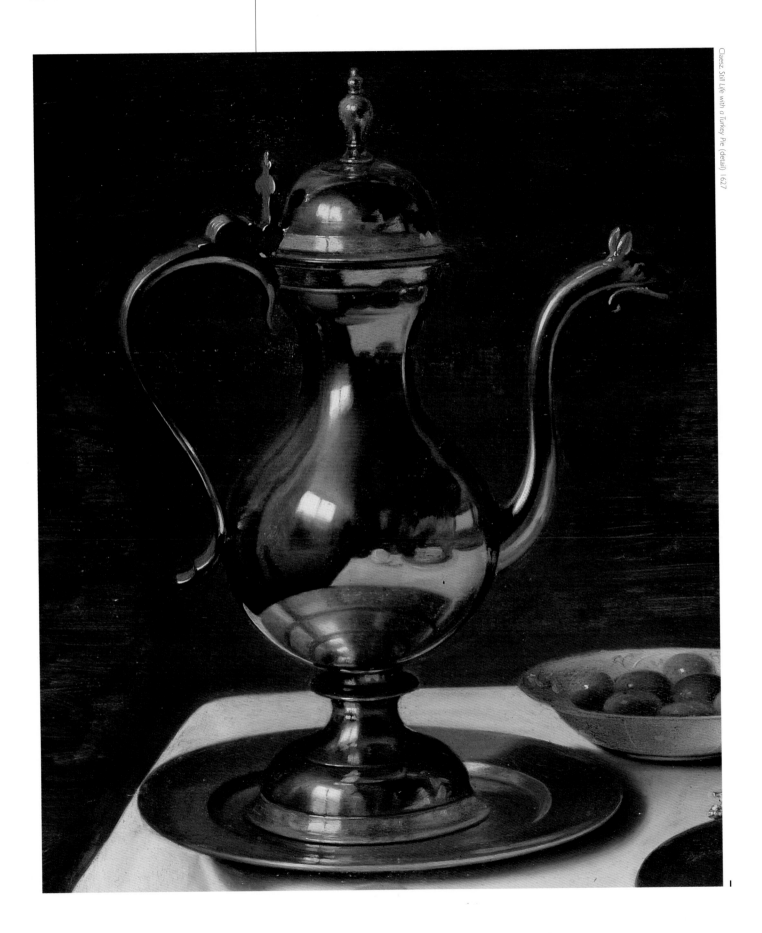

Claesz, Still Life with a Turkey Pie (detail) 1627

Pieter Claesz.'s still life in the Rijksmuseum, Amsterdam, is yet another example. The coffee-pot on the left of the picture owes its spectacular sheen to an anamorphically reflected view of the loaded table. To all intents and purposes the silver vessel is made visible by what it reflects. And yet, in some mysterious way, its identity as a coffee-pot takes perceptual precedence over the view its surface affords. In each of these examples the perceived lustre is caused by the imagery of something reflected in the surface of the object in question. And yet the visibility of the reflection is subordinated to that of the object itself, so that what we consciously see is a lustrous object, apparently unaware of the fact that the lustre itself is composed of recognisable imagery. What we are witnessing here is the perceptual competition between two recognisable objects or scenes and the impossibility of seeing two things at one and the same time. The situation is comparable to the famous duck/rabbit picture cited by Wittgenstein (1953). In one and the same configuration it is possible to see either a duck or a rabbit but the seeing of one precludes the recognisability of the other.

Admittedly there is an undeniable difference between the Arnolfini mirror on the one hand and the other three examples. The difference is that the reflections which appear in the armour, in the granite bowl and in the coffee-pot, are incidental to the identity of these objects, whereas the reflections which appear in the mirror define its identity. Nevertheless, because of its relatively small size and distortingly curved surface, the rear view which Van Eyck intended his mirror to provide is easy to overlook and therefore makes a negligible contribution to the three-dimensional composition of the picture.

Whatever its allegorical significance might be – and some art historians claim that such cluttered table-tops should be read as pious intimations of human mortality – there is an unmistakably Northern preoccupation with the representation of commonplace objects and materials (**1**). Instead of the *splendor* of angelic regalia, though, Claesz. revels in the almost self-effacing lustre of the tableware. The metallic surface of the coffee-pot is observed and rendered with wonderful accuracy: its modest sheen is to all intents and purposes composed of the scene which it reflects.

Jastrow's duck/rabbit figure (**2**) is cited by Wittgenstein as an example of the way in which we can perceive mutually exclusive 'aspects' of the same ambiguous configuration. Seeing something under one description precludes our seeing it under another description. When we see the duck 'aspect' of Jastrow's figure it is impossible to recognise its rabbit 'aspect'. We can see only one 'aspect' at a time. Perceptually speaking, the 'aspects' of such an equivocal figure take it in turns to seize, and then monopolise, our attention.

Wenzel Rabbit or Duck 1979

2

Invisible mirrors

With the discovery that molten glass could be rolled and moulded into large flat plates, the visibility of the mirror became much less noticeable than the lifesize images which were reflected in it. In Savoldo's *Portrait of a Man*, said to be that of Gaston de Foix, the mirror in which the otherwise invisible rear view of the young warrior is so prominently reflected is barely distinguishable as an object in its own right and the foreshortened glass on the left is equally

Savoldo *Portrait of a Man* (detail) c.1521

1

reticent. The result is that in contrast to the mirror in Van Eyck's *The Arnolfini Portrait*, whose visibility as a distinguishable object is so much more conspicuous than that of the scene it reflects, the pictorial effect created by Savoldo's barely perceptible mirrors is impressively three-dimensional.

It has been suggested that Savoldo's portrait was an attempt to emulate what one of his contemporaries was said to have achieved a few years earlier. According to Vasari (translated by G. Bull, 1965):

> Giorgione is said to have once engaged in an argument with some sculptors at the time when Andrea Verrocchio was making his bronze horse. They maintained that sculpture was superior to painting, because it presented so many various aspects, whereas painting only showed one side of a figure. Giorgione was of the opinion that a painting could show at a single glance, without it being necessary to walk about, all the aspects that a man could present, while sculpture could only do so if one walks about it. He offered in a single view to show the front, back and two sides of a figure in one painting, a matter which greatly excited their curiosity. He accomplished this in the following way. He painted a nude figure turning its back; at its feet was a limpid pool of water, the reflection from which showed the front. On one side was a burnished corselet which had been taken off. This reflected a side view because the shining metal reflected everything. On the other side was a looking-glass showing the other side of the figure. A beautiful and ingenious work proving that painting shows from a single view more than a sculpture does.

The mirror was not the only way in which painters could compete with the three-dimensionality of sculpture. In his *Martyrdom of Saint Sebastian* Pollaiuolo created a carousel in which he rotated the four executioners, thereby disclosing different aspects of the same figure. And the traditional motif of the three Graces renders the same pictorial service. In any case, in their sketchbooks, artists often display the same figure from several different aspects without having to resort to explicitly reflected images.

The painting to which Vasari refers is now lost but the composition of Savoldo's portrait, with its strikingly reflective piece of armour, confirms the suspicion that it was inspired by Giorgione's example. But since only one of the reflections is clearly recognisable, the picture does not altogether achieve the effect Vasari describes. Still, to someone unacquainted with the traditional dispute between painting and sculpture, the fact that Savoldo's reflections fail to show '*all* the aspects that a human figure shows' is neither here nor there.

Wittgenstein's use of the word 'aspect' is somewhat idiosyncratic, though as long as we understand that it refers to the visual *experience* of the observer, it is a perfectly useful term. The problem is that the word 'aspect' can also refer to one of several *views* of a three-dimensional object. When it is used in this sense, the word 'aspect' is comparable to the architectural term 'elevation' (a building has front, rear and side elevations). When we use the word 'aspect' in *this* sense, it has nothing to do with what we see something *as*, but quite simply, where we see it *from*. In the case of a sphere, the point of view from which we see it makes no difference to its appearance. A sphere does not *have* distinguishable 'aspects'. But when it comes to the human figure, with its many distinguishable 'aspects', the painter who works on a two-dimensional surface is limited to the representation of one aspect at a time; unless as Savoldo does (**1**), he exploits the pictorial device of a mirror. An alternative method is to distribute the different aspects of *one* figure among several of the same sort (**2**). Three Graces or Three Goddesses are a convenient device for rotating a three-dimensional figure on a two-dimensional representational surface.

Rubens: *The Judgement of Paris* (detail) c.1632–5

2

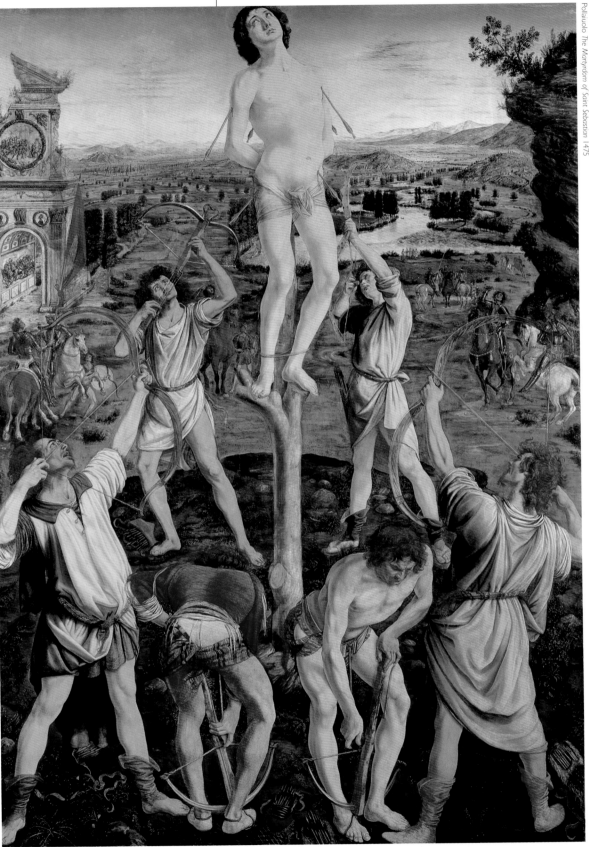

One of the two mirrors unarguably shows an aspect of the young warrior which could not otherwise be seen, and anyway the reflections effectively redesign the overall composition of the picture in a way that Van Eyck's mirror does not. Because instead of being clearly defined objects *within* the pictorial space, Savoldo's mirrors mysteriously enlarge the represented space without asserting their own identity. The same effect can be seen in Bedoli's *Portrait of Anna Eleonora Sanvitale* on page 89. As well as furnishing a rear view of the young lady, the mirror opens up a mysterious vista down which the reflected noblewoman retreats, Alice-like, into infinity.

In both these paintings the apparent deepening of pictorial space is incidental to what seems to have been the intended purpose of the mirror: to provide a rear view of someone portrayed from the front. Although the space is undeniably enlarged it is not all that easy to recognise the direction of the enlargement. On the contrary, if it were not for the self-evidently reflected images of each of the two subjects, there is little to indicate that we are looking at a mirror and that therefore the space represented in it corresponds to the otherwise invisible space behind our own backs.

The pictorial effects of reflection can be captured without having to use a mirror. Pollaiuolo's several executioners (**1**) might as well be one and the same man rotating around the central axis of the impaled martyr.

In the privacy of his unpublished sketchbooks the artist can compete with the sculptor without having to resort to any scenic device whatever. All he has to do is to draw the same figure from as many aspects as he cares to (**2**).

Gargiulo *Six Studies of Females* 17th century

2

The photo on this page (1) does not altogether convey the impression described in the text. I framed it rather carelessly, so that you can see certain features which give the game away. Unfortunately you can see the bottom edge of what, when viewed from lower down the stairs, looked exactly like a doorway. And the light reflected in the lower right corner is another irritating giveaway! All the same, it was the appearance of my own image a moment later which convinced me I was looking at the reflection of something behind my back.

Miller Staircase in Ferrara 1995

1

The same principle sometimes applies in real life. As the following story shows, the ability to identify one's own reflection can often play a crucial part in distinguishing a doorway from a mirror. Some years ago I visited a small palazzo in Ferrara. I entered the vestibule and stood at the bottom of a grand staircase, on the first landing of which I saw what seemed to be a framed doorway leading to the back of the house. As I mounted the staircase I was surprised to find that my own image appeared in what I immediately

understood to be the surface of a large mirror. What I had taken to be the framed entrance of a corridor leading ahead of me turned out to be the reflection of the vestibule behind me. To all intents and purposes, my seeing it as a rear view was the result of my recognising it as a reflection and this, in turn, seemed to require the appearance of an image I could identify as mine.

As soon as I knew it was a mirror, I became aware of other tell-tale signs, most of which would have been visible from the outset. Because, when I retraced my steps and stood once again at the bottom of the stairs, I was surprised to discover that I could see after all what I had previously overlooked – the blemishes and dust on the otherwise invisible surface of the glass, the unmistakable gleam of the bevelled edge, and the mirror image of the banister on the immediate foreground. Any one of these clues would have been enough to give the game away and yet, for some reason, I failed to notice them until the appearance of my own image convinced me that I was looking at a mirror. This doesn't mean that the appearance of our own mirror image is an unconditional requirement for making the distinction between a reflected view and a real one, and that the visibility of any other evidence to that effect is meanwhile in abeyance. Under normal circumstances, mirrors betray their identity without the assurance of a personal reflection, just as they do in paintings where, for obvious reasons, we are denied the opportunity of seeing ourselves reflected. Besides, when it comes to the crunch, the often invisible surface that separates the real world from its virtual counterpart makes itself mechanically apparent. But, in contrast to a sheet of plate glass with which we can painfully collide without any advance warning, it is impossible to get that close to a mirror without meeting yourself coming in the opposite direction.

It is this encounter that Lewis Carroll (1871) leaves so artfully undescribed when he smuggles his drowsy heroine from her own room into its reflected equivalent on the other side of the mirror. Alice, you will remember, amuses herself by entertaining the improbable but by no means impossible idea that the reflected room is an actual one and that, by pretending that the glass has softened enough to let her through, she can visit the looking-glass house. So far so good. What the author conveniently forgets to mention is the perplexing and indeed indescribable shemozzle that would have occurred when Alice met herself coming in the opposite direction. In fact, considering

Tenniel Through the Looking Glass and What Alice Found There 1871

2

how observant Lewis Carroll allows her to be about all the other contents of the looking-glass room, it is decidedly odd that she fails to notice the fact that it is occupied by someone who looks and acts just like her. Are we to assume that she thinks the reflected Alice is as actual as the reflected room? If the reflected room is sufficiently actual to allow the real Alice to visit it, she has no reason to believe that its reflected occupant is any less actual. But if both Alices are actual, how are we meant to visualise their collision? It is all very well to pretend that the glass which separates them can soften, but that won't do when it comes to getting through each other because, if one Alice politely softens in deference to her twin, the courtesy will be symmetrically reciprocated, leaving no Alices at all. End of story.

In order to be sure that his story continues, Lewis Carroll had to gloss over the difficulty of reconciling the apparent actuality of the reflected scene and the self-evident virtuality of Alice's appearance in it. Until she caught sight of herself, Alice could sustain the admittedly pretended belief that the room she could see on the far side of the chimney-piece was just as real as the one on the near side. But this illusion would have been shattered as soon as she saw herself because, in contrast to everything else shown in the mirror – which could after all have been a reverse duplicate of the real room – Alice had incontrovertible first-person knowledge of where she, the one and only Alice, was standing. And unless she made the deeply counter-intuitive assumption that the looking-glass world included a continuously updated replica of herself, she would be bound to recognise that the 'other Alice' was a virtual image of her own actual presence on the near side of the mirror. In conceding *that*, she would have had to concede that the looking-glass world was just as virtual and that the apparently distant wall beyond her own image was none other than the one behind her own back.

For someone of Alice's age, the idea that she could see what was behind her by looking at something straight in front of her would have been perfectly intelligible. What is more, the intelligibility of the idea would not have required the immediate guarantee of seeing herself in the reflected scene at the same time. What *was* required was the ability on her part to recognise her own reflection if and when she did happen to see it. And as a child of, let's say, ten years old, this ability would have been acquired about eight years earlier as

a result of playing games with her own reflection.

What I am suggesting is that, in acquiring her ability to recognise herself in a mirror, Alice had acquired the ability to recognise mirrors in general, and that in doing so she became intuitively aware of the fact that reflections afforded her a view of things behind her own back.

Now, as it happens, the date at which a child learns to recognise herself in a mirror coincides, though not exactly, with the moment when, for other reasons, she becomes aware of the fact that there is a potentially visible world behind her own back.

Understanding that there is an invisible world behind our own back is not something we are born with. Even for an adult who clearly understands that what they can see from a given viewpoint is less than there is to be seen in the immediate neighbourhood, it comes as a surprise to learn that the visual field has a sharply defined circumference. Because it does not *look* like that. When I fix my eyes on a distant point, although I know that there is a visible world just beyond and behind what I can see at the moment, I cannot see the boundary. What I see is an apparently *un*bounded visual world and it requires a special procedure called perimetry to demonstrate that there is, after all, a distinct margin to my visual field.

The diagram on this page (**2**) represents the overlapping visual fields of the right and left eye respectively. It is obtained by seating the subject in a darkened room opposite a black screen which is sown with a concentric pattern of tiny electric lights. With one eye closed at a time the subject is told to fix their gaze upon a red light in the centre of the screen. The lights distributed on the rest of the screen are switched on one at a time without verbal warning. The subject has to report when and if a light is seen. By plotting the distribution of these reports we can obtain an objective measure of the scope of each visual field.

Until it is about eighteen months old, the young infant does not even suspect the existence of an invisible world just beyond what it can see. As far as the young baby is concerned, what it can see is all there is. But it learns. And one of the most important factors in its learning is provided by the visual behaviour of its carers. This has recently become apparent as the result of imaginative research into what is now referred to as Joint Visual Attention, by which is meant a tendency to look where other people are looking. In addition to their unmistakable interest in the appearance of the human face, young infants display a particular concern for someone else's eyes and by the eighth week of life babies show an undeniable preference for looking at the eyes as opposed to any other part of the face. Not only that. The infant appears to be remarkably sensitive to the *direction* of the adult gaze so that he will fix his attention on eyes that are looking at him and rapidly lose interest if they happen to be looking elsewhere. There is as yet no recognition that a gaze directed elsewhere bears witness to something worth looking at elsewhere. But in a paper published in 1975 the American psychologists Scaife and Bruner showed that after eight or nine weeks the infant had learned to *follow* its mother's gaze. It is as if the child has understood that the act of *looking* bears witness to the experience of *seeing*, and that if the mother turns her gaze in a given direction it is reasonable to assume that she had seen something worth looking at.

These findings were developed by George Butterworth and his colleagues at the University of Sussex (1995). By videotaping the interactions between mothers and children he showed that babies could locate an object referred to by the mother's change of gaze, though not necessarily with great accuracy. However, until the second year of life the baby seemed incapable of following its mother's gaze beyond the margins of its own visual field. But by the middle of the second year a dramatic change had taken place. The infant had become much more accurate in locating objects referred to by its mother's change of gaze and, more significantly, was now capable of following her gaze beyond its own immediate field of vision. If the mother shifted her gaze to a place unoccupied by an object, the infant reacted by looking briefly in that direction. On finding there was nothing there to intercept his mother's gaze, he followed her eyeline into the invisible space behind him.

Some psychologists have interpreted this finding as evidence of 'mind-reading' on the part of the young infant. The implication is that the child follows the mother's gaze beyond the boundaries of its own visual field in the belief that the mother has seen something somewhere along the trajectory of that eyeline. Butterworth argues, however, that it is unnecessary to assume that the infant entertains any such theory: it is simpler to suppose that by the time

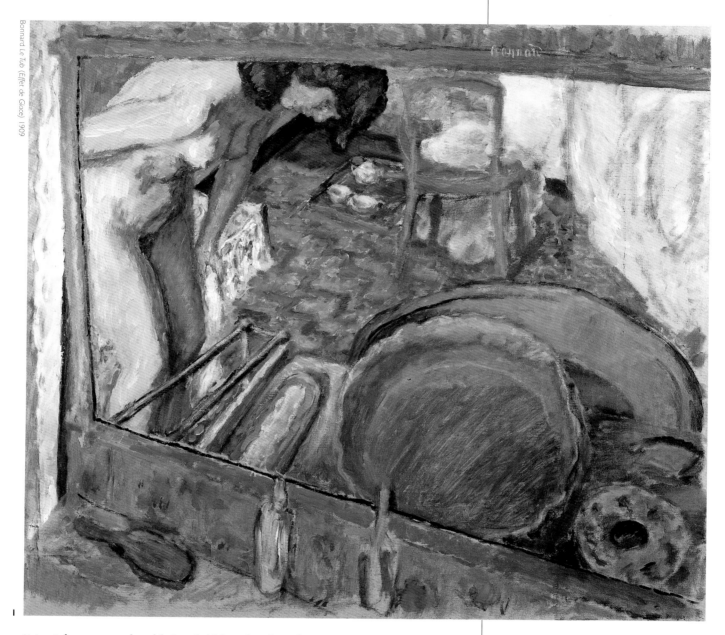

Bonnard *Le Tub (Effet de Glace)* 1909

it is eighteen months old the child has developed a mental model of the three-dimensional space which surrounds it, and that it can be triggered to turn and look at the invisible sector of this container by extrapolating the eyeline of someone seated opposite.

It seems, then, that some time between the end of the first year and the middle of the second year of postnatal life, the infant understands that the world it can see at any given moment is a relatively small proportion of the potentially visible environment and that the behaviour of someone seen *within* the visual field can indicate the presence of something *beyond* it. Most of the reports indicate that this ability is in working order shortly before the moment at which the infant recognises himself in the mirror. Although it is difficult to

Without any visible duplication of the objects which are to be seen in the obliquely angled frame in Bonnard's interior (**1**) it is difficult to be sure that we are looking at a mirror. But since it is unlikely that we are peering through a serving hatch at such a scene, it is reasonable to assume that what we *can* see is reflected, and that it therefore represents the invisible space behind us. But since it is only a painting there is no chance of confirming our hunch by seeing ourselves reflected.

harvest any reliable evidence to this effect, I suspect that in identifying the mirror image of himself the infant is already in a position to grasp the idea that the reflected space is just as virtual as the reflected *self* — and that by looking ahead he is seeing behind.

It is this that accounts for the mysterious appeal of reflective surfaces. Apart from the straightforward sensuous allure of things which shine, shimmer, glint, glimmer, gleam or flash, reflections appeal to us — rather as shadows do — by paradoxically representing states of affairs whose actual existence is somewhere other than where they seem to be.

In the history of Western art, painters have exploited such vicarious viewings with different intentions. In many cases the reflected view is incidental to the representation of surface shine. Even when the highlight is depicted with extraordinary detail, the imagery is subordinated to the identity of the object in whose surface it appears. As large sheets of reflective glass became more and more inexpensively available, artists were able to divert themselves with the paradoxes of contradictory viewings. There are intimations of such playfulness in Savoldo's *Portrait of a Man*, just as there are in the intriguing aquarium reflections in some of Ingres's great portraits. In these examples, the visibility of the mirror is almost negligible and we can only infer its presence from the mysterious duplication of the subject. In Holman Hunt's *The Awakening Conscience* the representational ambiguity is even more insistent. What exactly can we see at the far end of the room? Are we looking through a window into a garden beyond or is it the glittering reflection of something which only the guilty young woman can see directly? It is in fact a mirror but it requires the subtlety of a detective to identify the duplications which give the game away.

Since it is unlikely that there is a shadowy voyeur in Holman Hunt's intimate scene (**2**) we must assume that the indeterminate silhouette at the back of the room is the reflection of the conscience-stricken girl standing in the front, and that the garden, which *we* seem to see *beyond*, is the mirror image of the one which *she* can see *ahead* of her. Another clue is the barely perceivable fact that the rectangular format of the window is framed by the larger format of what must therefore be a mirror (**1**).

Overleaf
Velázquez *Kitchen Scene with Christ in the House of Martha and Mary* (detail) c.1618
In contrast to *Las Meninas*, there are no optical clues by which to tell that the rectangular scene in the top right-hand corner of Velázquez's painting is a mirror. It could be an eccentrically hung painting or, as some have claimed, an oddly placed opening into a room beyond. But the gaze of the young cook suggests that she is looking at the scene of which we can see only the reflection, and the old lady is nudging her to get on with her work and mind her own business. From the fact that Jesus appears to be making a blessing gesture with his left hand, it seems likely that we are looking at a reflection of the scene.

1

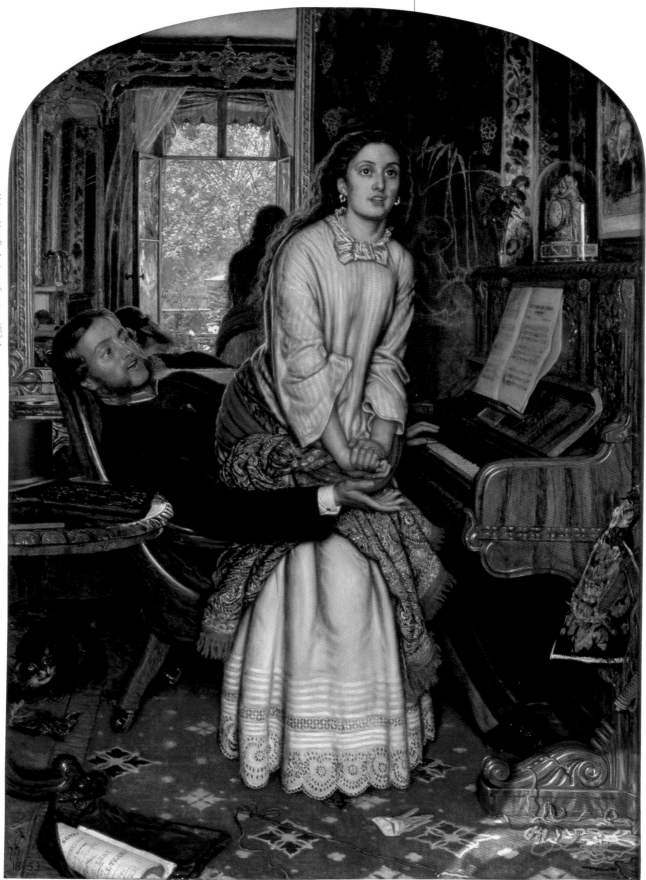

Holman Hunt *The Awakening Conscience* 1853–4

Caillebotte In a Café 1880

Manet's *Bar at the Folies-Bergère* is controversially celebrated as one of the most spectacular representations of reflected rear-viewing, but it is difficult to say why we should visualise it in such terms. The mirror's frame is barely visible and none of the supposed duplications adds up. Yet one of the reasons why the picture appeals as much as it does is that the spectator wobbles delightfully between looking forward and seeing backwards.

There is no such doubt about Caillebotte's café interior in which the room is miraculously enlarged by representing what we know for certain to be the brilliantly daylit window behind us.

Manet *Bar at the Folies-Bergère* 1881–2

2

In Caillebotte's painting (**1**) the duplicated silhouette of the young man's bowler indicates that he is standing in front of a mirror and that we are therefore looking at a reflection of the scene at which he is gazing.

The ornamental frame which confirms this suspicion is unhelpfully reticent in Manet's picture (**2**), and since the young lady seen from the rear is in the wrong position to be the reflection of the barmaid who is facing us, we cannot be sure that this is, as commonly supposed, a large mirror.

Matisse *The Painting Lesson* 1919

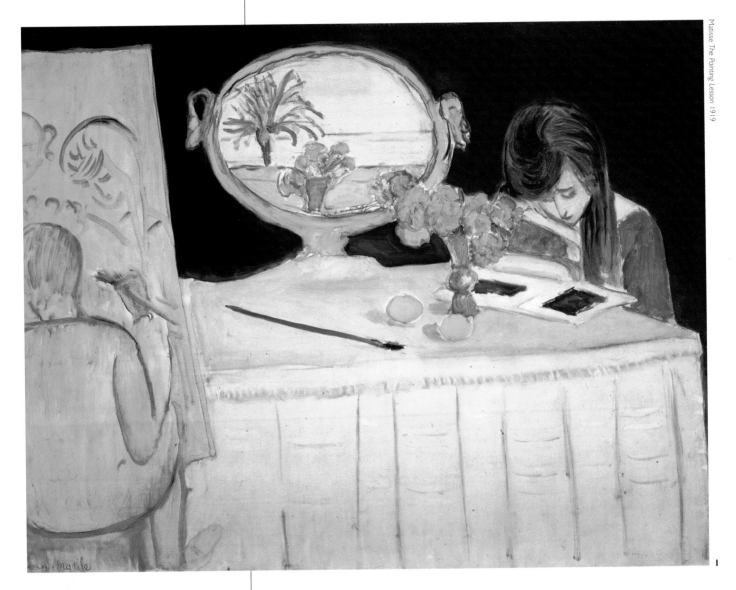

Although Matisse's decorative style does not lend itself to the illusionistic representation of reflective surfaces, there is plenty of circumstantial evidence to support the belief that the oval format in the centre of the painting (**1**) encloses a reflection of the sunlit view beyond the window in the unseen foreground; and that since it *is* a mirror, it gives us the opportunity of looking in two directions at once. The same mirror recurs in some of Matisse's other paintings, and in some of the examples its featureless blackness indicates that it is facing away from the window, towards the relatively unlit interior.

Unlike the young girl engrossed in her book who is free to look at the real view reflected in the mirror whenever she wishes, the Lady of Shalott (**2**) is forbidden, on pain of death, to look at the view itself, and must content herself with seeing it at one remove, reflected, albeit perfectly, in the great mirror. According to the philosophical tradition inaugurated by Plato, we are all, like the Lady of Shalott, condemned to see reality indirectly, 'in' the darkened glass of the human senses.

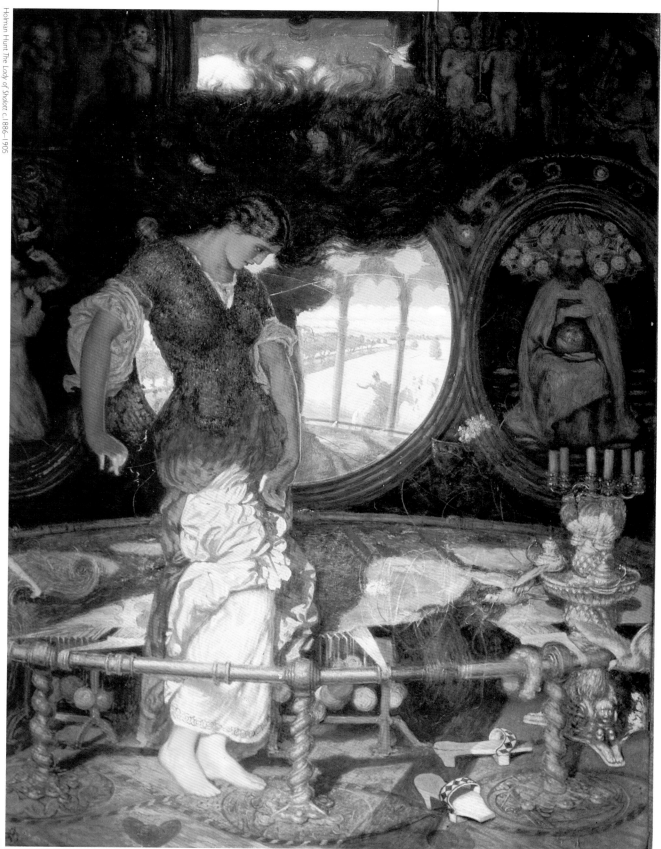

2

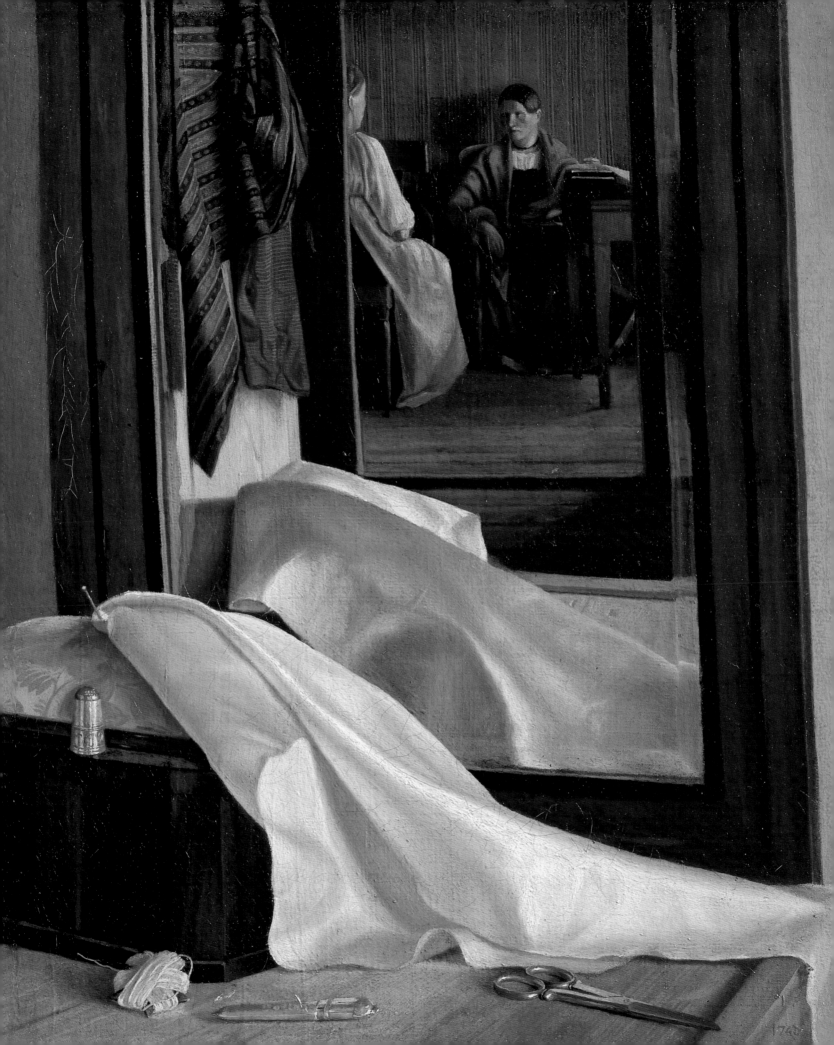

Unknown Artist *Reflections in a Mirror* mid-19th century

Reflections in a Mirror on the opposite page takes this ambiguity to its limit. At first sight it looks puzzlingly like a doorway through which we are looking through yet another one into a room beyond. Closer examination reveals the reflectively bevelled edge of what must be a full-length mirror in a wardrobe door. This suspicion is confirmed by the somewhat equivocal duplication of the folded linen in the foreground. Once these clues fall into place, our perception of the picture is dramatically changed. The objectively invisible surface of the glass now acquires a previously unnoticed lustre. We become disconcertingly aware of the fact that the murmured conversation which we are about to interrupt in the depths of the room beyond is actually going on behind our own back — and that we may have been the topic of the gossip.

I suspect that one of the reasons why mirrors played a relatively inconspicuous part in the composition of paintings until the middle of the nineteenth century is that such effort and ingenuity had gone into the elucidation of the geometrical principles whose use would guarantee a reliable representation of actual space that there was an understandable tendency to avoid pictorial enterprises which might confuse or confound the efficient exercise of perspective.

The largest object in the enigmatically original painting by an unknown artist (**1**) – it takes up three-quarters of its pictorial area – is paradoxically almost invisible. It betrays its presence indirectly, by the imagery which it reflects, and it is quite easy to miss the fact that the imagery *is* reflected. But as soon as we assimilate the relevant cues we are aware of seeing two things, though as with the duck/rabbit, not at the same time. At one moment we see or seem to see the mirror itself, as a distinct object standing in the foreground. And then we see what it reflects, which immediately makes us aware of the invisible scene just behind us.

O'Conor's painting (**2**) is less interestingly ambiguous and although the mirror is not readily distinguishable as a distinct entity we somehow know that the windows, seen in the background, represent the foreground source of illumination.

O'Conor *Reclining Nude before a Mirror* – sketch (detail) 1909

1 2

Self-recognition

In 1886 the Austrian physicist Ernst Mach sat down in a *chaise-longue* and drew a simplified sketch of everything he could see with one eye closed and the other fixed on a point at the far end of his room. In many respects the drawing is a misleading representation of what someone would see under such conditions. As we have already seen, the visual field does not have such sharply defined edges and since the retina does not record visual details uniformly, Mach's sketch shows more resolution than it should. Nevertheless it truthfully includes something which we normally overlook: the extent to which our own physique intrudes on the visual field. Under normal circumstances we are completely unaware of the edge of our own nose and unless we undertake a manual task which requires visual control, we pay little or no attention to the way in which our arms intrude upon the circumference of the visual field. So in this sense Mach's sketch draws attention to a neglected aspect of visual experience. Even so, his picture is somewhat misleading since it reveals both more and less of ourselves than we normally see. If we are standing upright

Mach's sketch (**1**) is the illustrated equivalent of one of the two overlapping visual fields shown in the perimetry chart on page 121. The amount by which our own physique 'gets into the scene' varies according to the attitude of our four limbs and of course according to the orientation of our gaze. However, a certain fixed proportion of our bodily self remains permanently invisible. We can *try*, without any success, to see our own hindquarters, but when it comes to seeing what we see *with*, the notion of trying makes no sense whatever. In fact our own head and neck are incorrigibly invisible.

Mach Monocular Visual Field 1886

1

looking straight ahead with our hands down at our sides it is almost impossible to catch sight of ourselves at all. But conversely, by turning our head this way and that – up, down, right and left – we can take in much more of our own physique than Mach did at his artificially single glance.

But if we make an allowance for the way in which the drawing forgivably misrepresents the visual appearance of our own body, it draws attention to the fact that no matter how much we can see of our own physique, try as we may, twist and turn, the part by which we would expect to be identified and recognisably portrayed is inescapably invisible and that without the help of a mirror we would never be acquainted with the appearance of our own face. If we lived in a world without reflections, self-portraits would be inconceivable or else they would have the strangely beheaded appearance represented by Mach.

How then do we succeed in recognising our own reflection when we *do* catch sight of it? If we don't know what we look like until we see ourselves in the mirror, how can we tell, when we do see it for the first time, that the reflected face is ours?

One answer might be that in recognising everything else that appears in the mirror as a duplicate of what we can see around us, we might deduce the identity of our own reflection by a process of elimination since it would be the one item appearing in the mirror for which there was no counterpart in the immediate environment.

A much more significant clue about the identity of our own mirror image is the fact that its behaviour is perfectly synchronised with our own. Remember the famous scene in *Duck Soup*. But wait ... if our facial behaviour

Universal Studios Still from *Duck Soup* 1933

2

Chico has noisily broken into Groucho's house by night (**2**). Groucho gets up to investigate the din, distinctively dressed in night gown, night cap and bed socks. Recognising that he runs the risk of meeting a member of the household, Chico gets himself up to look just like his brother, including the trademark moustache. Predictably, it is the two brothers who unexpectedly encounter one another on opposite sides of a wide double doorway. If he had met anyone *but* Groucho, Chico might have got away with merely resembling him. But under *these* circumstances, Chico's best bet is to try and convince Groucho that he, Chico, is Groucho's reflection, and not, as Groucho might suspect, a burglar unaccountably dressed and moustached to *look* like him. Given that this is Chico's strategy, the fact that he merely resembles Groucho is not sufficient. He must *do* exactly as Groucho does. In other words he is obliged to synchronise his own movements with those of his brother. Since Groucho, on the other hand, suspects that he is confronting an impudent lookalike, *his* best bet, as the author of his own actions, is to make such sudden and unpredictable movements that only a genuine reflection would have a hope in hell of matching them.

Pajou *La famille Pajou* (detail) 1802

It's hard enough to tell from an instant snapshot, and when it comes to a painting, in which the job of representation lasts much longer than the moment it represents, it's impossible to say for certain what Pajou's little boy makes of his own reflection. It would take a movie to know for sure. He is probably too young to be able to recognise that he is looking at himself. But even if he were, what do we mean exactly when we say that someone recognises their own image? How can I reconcile the fact that I know myself to be here and see what seems to be myself somewhere else?

is invisible, how can we tell that it *is* synchronised with the expressions we can see in the mirror? For the simple reason that we are directly acquainted with our own actions, facial or otherwise, without having to see them. I know that I am smiling, waving or frowning, not because I can see myself, but because I can feel it. Each of us has a so-called kinæsthetic sense of our own muscular activity. This sixth sense is based on two sources of information, only one of which is strictly sensory. When we move intentionally, the nerve impulses which are despatched to the appropriate muscles leave a copy of themselves in our central nervous system, so that we have a more or less conscious representation of the forthcoming movement. Since the ensuing action is then monitored by sense organs embedded in the muscles and joints which execute the gesture, we have detailed information about what we are going to do and about what we have just done. So, confronted by what happens to be our own reflection, we can recognise a correspondence between the actions of which we *know* or *feel* ourselves to be the author, and the visible movements in the mirror with which these muscular feelings are so accurately synchronised.

However, the fact that something changes its appearance in time with our own actions does not necessarily mean that we would recognise it as our own image. It is easy to imagine an experimental set-up in which an artificial configuration of squares, discs and rectangles was wired up to a television camera in such a way that it changed its appearance in step with changes in the facial expressions of the subject, who would inevitably recognise that there was a causal relationship between his own facial expressions and the mechanical movements of the Calder-like mobile in front of him. But that would not lead him to think that he was seeing his own reflection. In order to *identify* with an image, as opposed to recognising a causal relationship with it, the subject would have to recognise that there was a fundamental *resemblance* between him and it. In other words, he would have to see it as the same *type* of thing as himself and that there was an anatomical equivalence between some of its moving parts and some of his own. All this takes care of itself when and if the individual can see his own moving parts (in other words, the parts Mach could see when he looked at himself without the help of a mirror). For example, if I move my arm and can see myself doing so without the aid of a mirror, I have something visible with which to compare the visible movements of the reflected arm. If they look alike and move at the same time as one another, the chances are that they are one and the same thing, and that I am in fact looking at myself. But when it comes to parts of myself which I cannot see without the aid of reflection – my face – then there *is* a problem. Admittedly I can feel the difference between opening my mouth and poking out my tongue, but how can I tell that what I can *feel* but not *see* myself poking out, corresponds to what I

can *see* but not *feel* poking out in the mirror? The fact that I *can* tell, indicates that I have an anatomical representation of my face, albeit a non-visual one, and that I can accurately map its 'felt' parts on to the corresponding features of a visually represented face. It could be argued that this correspondence has to be learned, but there is experimental evidence to show that it is innate.

In at least one study it has been shown that in the first ten minutes of life (!) a newborn infant will follow or 'track' a face-like pattern in preference to a 'scrambled' one. Further research has shown that the infant reacts to such

2, 3

patterns as if it recognised the anatomical correspondence between the as yet invisible features of its own face and the visible features of someone else's. In 1977 Andrew Meltzoff and Keith Moore demonstrated that within the first few weeks of neonatal life, an infant will discriminatingly mimic the facial expressions of an adult. That is to say, in addition to following a face with her eyes, the newborn infant will respond to the sight of someone protruding his tongue by poking out her own. If the adult gapes, the infant will accurately copy the expression with her own mouth. In order to rule out the possibility that this might be a crude reflex response, Meltzoff momentarily frustrated the reaction by putting a dummy or pacifier in the infant's mouth immediately before it was shown the test expression. In spite of the fact that the adult carefully assumed a neutral expression just before removing the dummy, the

The visual system of newborn infants is so sensitively tuned to the appearance of the human face that even a schematic representation will evoke recognisable signs of interest (**2**). But the features have to be correctly arranged. If they are noticeably disordered (**3**) the infant will pay no attention.

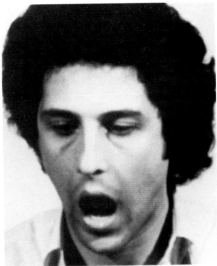
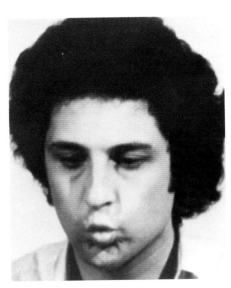

1, 2, 3

Since these experiments in facial imitation were published twenty years ago (**1**, **2**, **3**, **4**, **5**, **6**) psychologists have tried to imagine the mechanism by which the infant recognises the correspondence between the parts of his own face, which, as yet, he knows only by their 'feel', and the equivalent parts of someone else's face. With little success as yet.

Miller Rosie 1996

7

infant mimicked what she had just seen but had been prevented from responding to a moment earlier. It was as if she had retained a visual record of the mouth opening and then imitated it from memory.

All in all, then, the newborn infant (a) can distinguish a human face as something peculiarly interesting; (b) can tell that someone else's face is sufficiently like her own to merit playful interaction; (c) in spite of the fact that she is unacquainted with the appearance of her own face, she can recognise the correspondence between the parts of herself that she can *feel* and the equivalent parts of someone else that she can *see*. In reacting imitatively to something which she recognises as *similar* to herself, the infant is halfway towards recognising something which happens to be identical to herself: her own reflection. All the same, it takes at least sixteen months, and sometimes as many as twenty-four, before the infant *does* recognise her own reflection. The method by which she does so is largely experimental. She plays games with her own reflection, challenges it almost. On finding that its behaviour is accurately synchronised with her own, she comes to the inescapable conclusion that she is looking at herself.

But what exactly does that mean? The statement 'Rosie recognises that she is looking at herself' presupposes that Rosie is aware of something other than the reflection: namely, the self with which she identifies it. The difficulty is that in contrast to all the other entities about which it is possible to make intelligible statements as to what they do or do not resemble, it is devilishly difficult to say what a self is, let alone what awareness of it consists of. Suffice it to say that the ability to identify ourselves in a mirror presupposes a distinctive form of consciousness – namely self-consciousness – and that human beings display it or have it to a remarkable degree.

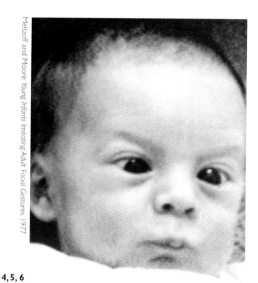
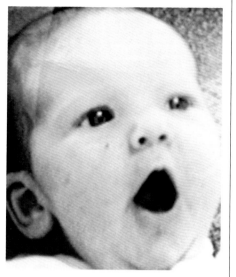

Meltzoff and Moore *Young Infants Imitating Adult Facial Gestures,* 1977

4, 5, 6

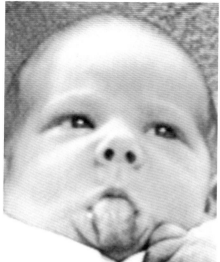

A moment after this picture of incipient self-recognition was taken (**7**) Rosie did a 'Groucho' and challenged her own reflection. She walked away, took off the striped scarf and came back to see whether the person in the mirror had done the same thing (**8**).

However, the fact that human beings are endowed with a high level of self-consciousness does not necessarily mean that the privilege is confined to *Homo sapiens*. If it *is* a privilege — that is to say if having it confers a selective advantage and, as I shall argue later, there are reasons for thinking that it *does* — then we would expect to find traces of it in some of our closer relatives, perhaps even developed to the point where they too could identify themselves in the mirror.

As it happens, there is only one other primate species in which self-recognition is unanimously agreed to exist. Although comparable claims have been made for orang-utans, for 'one' domesticated gorilla and even (predictably) for dolphins, the chimpanzee is the only other animal for which the evidence seems to be uncontroversial. The first experimental tests were carried out by Gordon Gallup in 1970. He took a group of young chimpanzees reared in captivity and placed them in cages equipped with a large mirror. To begin with they reacted to their own reflections as if they were other members of their own species, displaying social and sometimes aggressive behaviour. On other occasions they investigated the mirror itself, poking it and looking behind. After a few hours they began to behave as if they understood that their own actions were the cause of the reflected ones. Before long they began to use the mirror to inspect parts of their own body which would not otherwise have been visible — the inside of the mouth, the soles of the feet, etc. As Gallup goes on to say (1994):

In an attempt to validate my impressions of what had transpired, I devised a more vigorous, unobtrusive test of self-recognition. After the tenth day of mirror exposure the chimpanzees were placed under

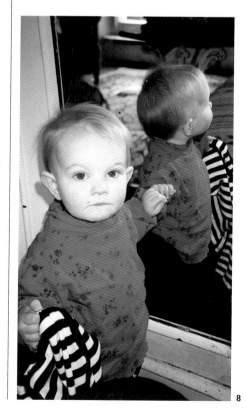

anæsthesia and removed from their cages. While the animals were unconscious I applied a bright red odourless alcohol-soluble dye to the uppermost portion of an eyebrow ridge and to the top half of the opposite ear. The subjects were then returned to their cages and allowed to recover. Upon seeing themselves in the mirror the chimpanzees all reached up and attempted to touch the marks directly while intently watching the reflection. In addition to these mark-directed responses there was also an abrupt threefold increase in the amount of time spent viewing their reflection in the mirror.

Gallup noted that when the same procedures were applied to various species of monkeys — macaques, etc. — none of them went beyond the first stage: they continued to react to their reflections as if they had seen another animal of the same species.

Unlike Groucho, whose previous experience with mirrors has led him to believe, wrongly as it happens, that he *might* be confronting his own reflection, the chimpanzee has no reason to even *suspect* such a thing. For the novice, the idea of seeing himself at some distance from where he *feels* himself to be, would be inconceivable. And even when the synchronised behaviour of this mysterious 'other' convinced him that he was, after all, looking at himself, it is difficult to imagine what such a perplexing conclusion would actually mean to him. 'How can I possibly be in two places at once?'

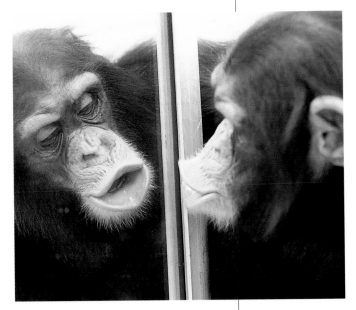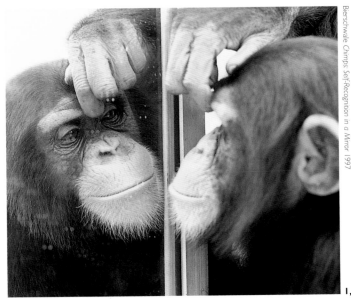

Bierschwale *Chimps: Self-Recognition in a Mirror* 1997

1, 2

When a chimp learns to identify his own reflection, the experience of seeing *himself* does not, as we might expect, draw his attention to the existence of the mirror as such, nor does he show any noticeable interest in anything else it reflects.

Apart from the fact that the natural opportunities for doing so are few and far between, it is difficult to imagine the biological advantage of a chimpanzee's being able to recognise its own reflection. This must mean that the skill which is so readily demonstrable in captive chimps can only be the unforeseen and functionless by-product of a capability which was selected for its usefulness. What could that have been? The most likely candidate is the one mentioned above: self-consciousness. In a sociable species whose individual members are bound to one another in a complex web of cooperation and competition, it might be a matter of some importance for the individual to recognise himself as the target for the same sort of Machiavellian designs that he entertains towards his fellows. In order to strike the most profitable balance

between trust and suspicion, probity and deceit, it seems reasonable to suppose that the chimpanzee might develop or inherit a wordless hypothesis whose unstated premise is that members of his own species are fundamentally intentional – scheming, believing, desiring and expecting, just as he is himself. Since Premack and Woodruff's classic paper of 1978, this notion has been generally referred to as the 'theory of mind' by which is meant a theory about the possession of mental states by individuals other than oneself. The selective advantage of entertaining such a theory is almost self-evident, since it puts the individual in a position to predict and make allowances for the self-promoting schemes of others. It presupposes, and to some extent is constituted by, an awareness of oneself as an agent and as a believer. One of the consequences of such profitable levels of self-consciousness seems to be the predictable though biologically functionless interest in one's own reflected image.

But it would be rash to assume that the degree of self-consciousness

Gordon Gallup's 'mark' test was conducted with animals who had already established a relationship with their own reflected appearance and who could therefore recognise the discrepancy between their previously *unmarked* features and their newly blemished ones. This implies that the animal had retained a mental image of its normal appearance and was therefore in a position to compare it with the subsequent reflection.

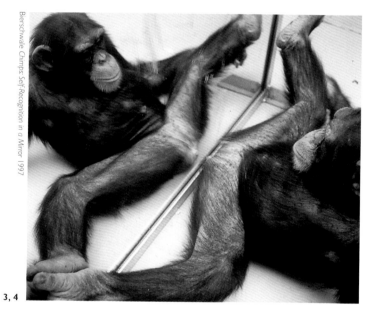
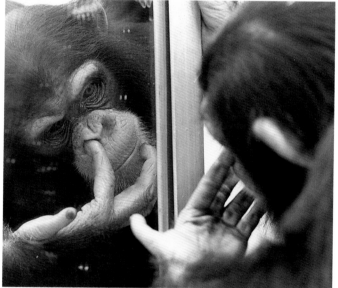

Bierschwale *Chimps: Self-Recognition in a Mirror 1997*

3, 4

sufficient to account for self-recognition necessarily implies the possession of a 'theory of mind'. The controversy still rages as to the extent or even existence of such a theory in the higher apes. But when it comes to two-year-old *human* infants, the evidence seems to support the belief that the moment of self-recognition coincides with the appearance of behaviour that can only be explained on the assumption that the child has a mental representation of the beliefs, wishes and interests of others. As far as some psychologists are concerned, failure to pass the mirror test by twenty-four months is taken to be a diagnostic sign of incipient autism, a condition which, as its name implies, is characterised by the inability to represent the mental life of others.

The animals show no signs of either approving or disapproving such changes in their appearance: 'God I look a mess!'. Human beings, on the other hand, have distinct preferences as to the face they present to the world and in that sense the mirror has become an essential accessory to vanity.

Bellini *Woman with a Mirror* (detail) 1515

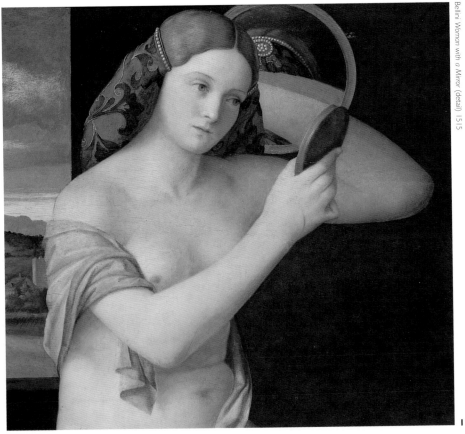

1

Whereas chimpanzees are 'ambushed' by their own reflections, and *accidentally* discover changes inflicted by someone else, human beings deliberately exploit mirrors with the express purpose of improving their own appearance. Each individual has an idealised version of the self which they would prefer to offer to the world at large, and with the aid of a mirror this publicly visible façade can be carefully constructed and rehearsed before curtain up. In contrast to the figure of Venus (**1**) who is frequently represented in conference with her own reflection, the Holy Virgin is never to be seen using the mirror which traditionally symbolises her purity. In what is said to be Konrad Witz's drawing (**2**) she is seated in a posture which epitomises her humility, chastely indifferent to her own appearance. Meanwhile, her divine offspring is innocently preoccupied with his own watery reflection.

Attributed to Witz *Madonna and Child with a Basin* (detail) c.1440

2

In contrast to chimpanzees who would not normally encounter their own reflections, whose self-recognition has to be experimentally induced, most human beings are born into a culture in which the mirror is already a significant artefact and where the act of self-inspection is so spontaneous and so recurrent that it figures as a prominent and varied motif both in literature and the visual arts.

With rare exceptions the inaugural encounter between a child and its own reflection is never represented and it is difficult to think of a painting in which mirror-gazing is represented as something prompted by objective curiosity, as if to say 'How odd, here I am and there I am again.' Broadly speaking, when human beings are represented in explicit relationship to their own mirror images the pictures fall into two recognisably distinct categories:

• Ethically neutral, non-judgemental representations in which the mirror figures as one of many household appliances with which the individual might be engaged in daily life.

• Moralising tableaux in which the subjects' preoccupation with their reflection is represented as the personification of either a vice or a virtue.

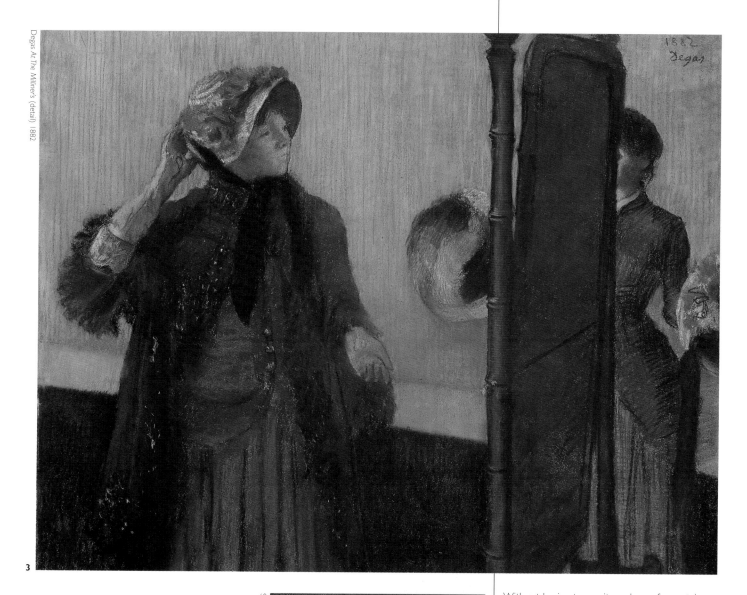

Degas *At The Milliner's* (detail) 1882

3

Studio of Ribera *A Man with a Mirror* 17th century

4

Without having to see it, we know for certain that the young woman in Degas' *At The Milliner's* (**3**) is looking at her own reflection. Her activity and her expression would be unintelligible unless we assume that the vertical structure just in front of her face is a mirror. People don't behave like that unless partnered by an image they recognise as their own. Conversely, although we *can* see the inexplicably enlarged reflection in the painting from Ribera's studio (**4**) it's difficult to tell what is going on in the head of the philosopher contemplating it. Technically speaking, this is not, as it might seem, a straightforward representation of someone looking at himself. In all probability, it represents a philosopher, exemplifying the virtue of Prudence by acquiring self-knowledge in the only way that an artist can represent it.

In genre paintings the figure, almost invariably a woman, is using a mirror to check or change her appearance. The tone of such paintings is relaxed and easy-going and in most examples the subject is quite literally at home with her own reflection. Without any implied moral comment the act of self-adornment is represented as one of many domestic tasks dedicated to the blameless upkeep of appearances.

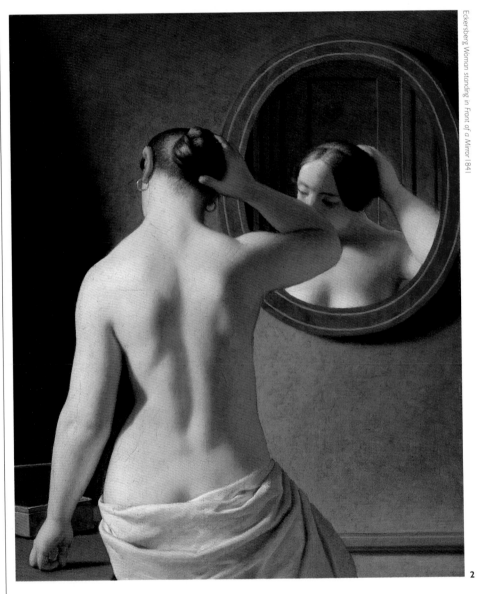

O'Conor *Girl arranging her Hair in Front of a Mirror c.1909–10*

Eckersberg *Woman standing in Front of a Mirror 1841*

The voluptuous young woman in Eckersberg's painting (**2**) enjoys the modest domestic companionship of her own mirror image, apparently unaware of the fact that the part of her body with which she is, at the moment, unconcerned, is the subject of our rapt invisible scrutiny.

In neither this, nor in O'Conor's painting (**1**), is there any suggestion of moral disapproval. We are overlooking a scene of blameless propriety in which the upkeep of personal appearance is one of many household duties.

As Ann Hollander (1993) points out, in sixteenth- and seventeenth-century paintings the mirror is characteristically small and reflects little more than the subject's face. To a large extent this must have been because of the unavailability of larger mirrors but by the nineteenth century paintings and photographs show women examining themselves at full length. Although the larger mirrors revealed parts of the body which would have been visible

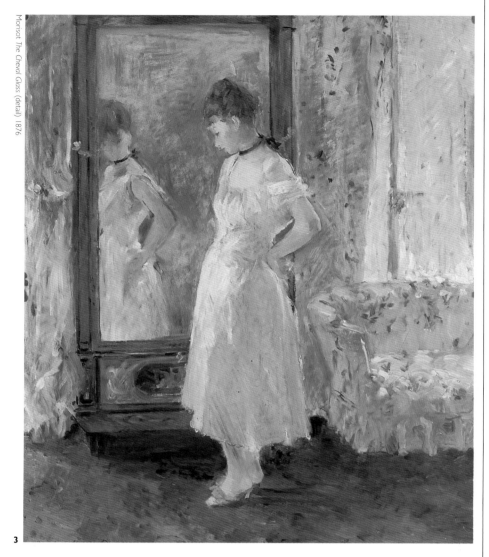

Morisot The Cheval Glass (detail) 1876

3

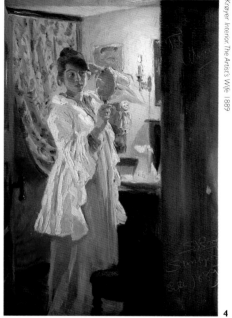

Krøyer Interior. The Artist's Wife 1889

4

Even in the eighteenth century, by which time it was technically possible to decorate an interior with large, framed panels of silvered glass, the mirrors in which women are to be seen at their toilet are not much bigger than they were in the previous century. And yet less than a hundred years later we see women viewing themselves at full length in free-standing mirrors, which in France are intriguingly referred to as Psyches (**3**, **4**).

without the aid of reflection, they did so from a viewpoint quite different from the one from which the subject would have seen herself without the aid of a mirror. As Mach's drawing shows only too well, the unaided view of our own extremities is steeply foreshortened, whereas the reflected view, being at a right angle to the long axis of the body, corresponds to the appearance we have for others. By posing in front of a full-length mirror the subject stages her social appearance and can rehearse the improvements as she would like them to be seen by her fellows. It is interesting to note that the sort of activities for which the mirror is necessary are characteristically the ones for which visual control is absolutely essential: that is to say, ones in which the effects of the actions cannot be judged without seeing them. Of course there are many interactions between the face and the hand for which the visibility of neither is required. We can effectively blow our nose in the dark and accurately cup our hands to our ears without having to watch ourselves doing so. Dining tables do

In eighteenth-century pictures the transition from nudity to full dress is supervised by a helpful assistant who is conspicuous by her absence in the later paintings to be seen on this and the previous page. Without the attentive eye of a Susanna, the Countess would require the services of her full-length reflection. Besides, as the nineteenth-century woman increasingly ventures into public places, the need to check her appearance from top to toe becomes more important.

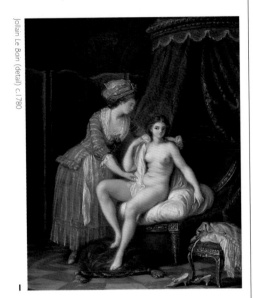

Jollain *Le Bain* (detail) c.1780

1

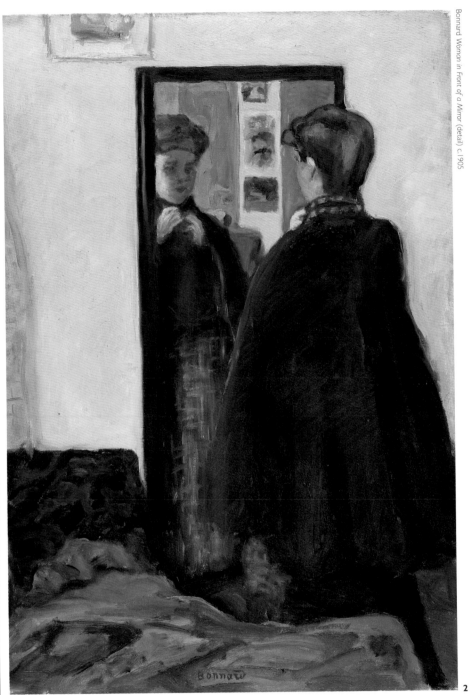

Bonnard *Woman in Front of a Mirror* (detail) c.1905

2

not have to be equipped with mirrors in order to guarantee the successful outcome of a meal. But when it comes to adjustments of personal appearance, reflection is the only way in which success can be judged. In tribal societies whose members employ elaborate forms of self-decoration, the absence of a mirror meant that each individual had to submit himself to the cosmetic skills of someone else. It was only with the arrival of European traders that self-adornment was increasingly performed with the aid of reflection.

Strathern c.1970

Faris Kadlindar Decorating c.1970

Even with practice it is difficult to execute a complex design on our own face in the dark. The problem is that the sensation of a moving point leaves no trace of its progress. It is, in effect, like writing in water, so that without a *visual* record of the marks made by the cosmetic crayon, the make-up runs the risk of looking a mess.

Tweedie 1997

Overleaf

In spite of the fact that the act of self-adornment is always under moral suspicion, there are many paintings in which it is difficult to detect the expression of an ethical attitude. Scenes such as the ones represented on pages 148 and 149 are part of the daily round of a woman's work that is never done. There is a sense in which the only way toiletry differs from cuisine is that the job requires a mirror in one but not in the other.

McEvoy *The Ear-Ring* c.1911

Ter Borch *Woman at a Mirror* c.1650

Although many of the paintings that include mirrors are ethically neutral, they grade imperceptibly into representations in which there is an unmistakably moral attitude to the act of self-regard. Without any explicit statement to that effect the disapproval is conveyed by the expression of self-satisfaction on the subject's face, or, as in many of Balthus' paintings, by a look of rapt entrancement. And in some cases the self-indulgence is collusively encouraged by smiling attendants. In such pictures the reflective surface is implicitly represented as a seductive trap in which self-regard can lead to culpable self-satisfaction.

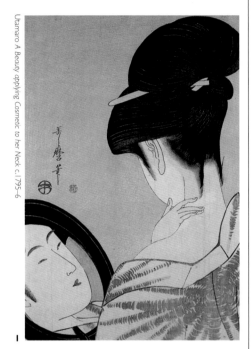

Utamaro *A Beauty applying Cosmetic to her Neck* c.1795–6

1

In the surprisingly large number of pictures which represent someone in the act of considering their own reflection (**1**, **2**), the figure portrayed is almost invariably that of a woman, and yet with rare exceptions the artist is a member of the opposite sex.

It's not as if men are unacquainted with their own reflections, or that in contrast to women they chastely deny themselves the services of a mirror but, more significantly, that they refrain from portraying members of their own sex in an activity which might, as they see it, compromise the sturdy virtues of masculinity. But women thus engaged are regarded as fair game, partly because as women, they are seen by men to be peculiarly susceptible to their own reflected appearance. Their desirability is teasingly enhanced by the spectacle of their secretly luxuriating in their own man-trapping charms.

White *The Mirror* (detail) 1912

2

Balthus *Les Beaux Jours* (detail) 1945–6

Although children can confidently recognise themselves by the time they are two years old, and from then on use mirrors to see how they look when they clown around or dress up, it is not until puberty that we can tell from their expression that they are beginning to view their appearance with a sexually appreciative eye.

The adolescent girl in Balthus' painting (**3**) seems to be in an erotic trance of self-regard, whereas in Norman Rockwell's vignette (**4**) the child is doubtfully assessing the prospects of the young woman she is just about to become.
In Brockhurst's etching (**5**) the transformation is shown as a painful crisis of personal identity.

Rockwell *Girl at the Mirror* (detail) 1954

4

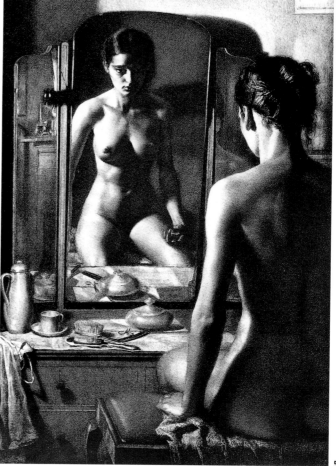

Brockhurst *Adolescence* (detail) 1932

5

Schall Evening Toilet c.1785–90

1

Bellocq Untitled (Storyville Portrait) (detail) c.1912

2

20th Century Fox Snow White and the Three Clowns 1961

4

Rembrandt A Woman bathing in a Stream (Hendrickje Stoffels?) 1654

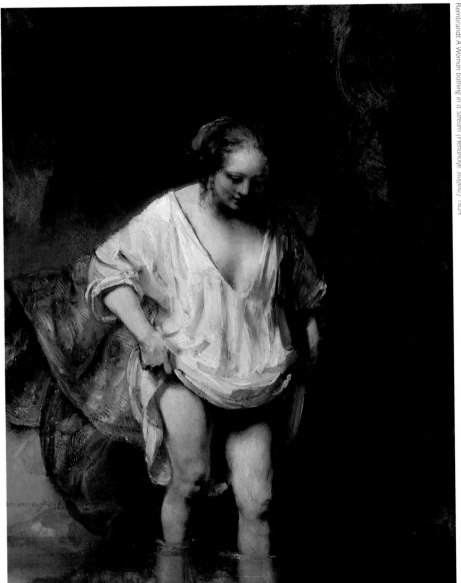

3

With the exception of the still from *Snow White*
(**4**) none of the pictures on this page is an
explicit representation of vanity.
Instead of being personifications of a vice they
are representations of individual women,
privately and pleasurably absorbed in their own
appearance. And although the onlooker might
view them with some disapproval we cannot be
sure that this was the artist's purpose.
Nevertheless it's difficult to avoid the impression
that each of these three women is appreciating
her appearance in terms of the standards
by which a man would approve of their
naked charms.

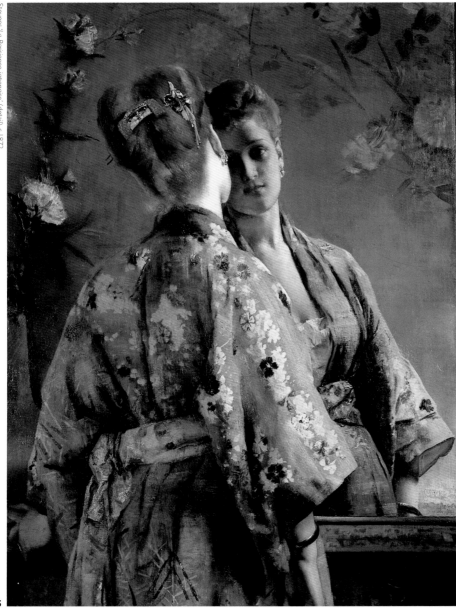

Stevens 'La Parisienne japonaise' (detail) c.1872

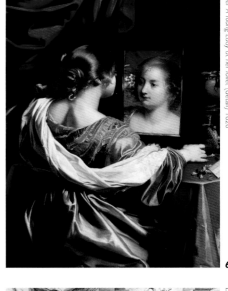

Régnier A Young Lady at her Toilet (detail) 1626

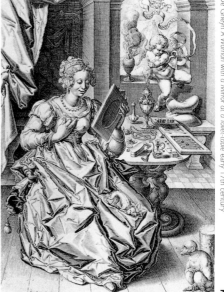

De Gheyn A Woman with a Mirror at a Toilet-table early 17th century

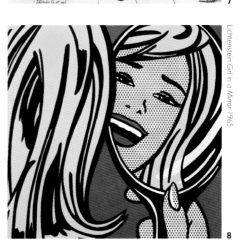

Lichtenstein Girl in a Mirror 1965

In Alfred Stevens' 'La Parisienne japonaise' (**5**) the gentle inclination of the young woman's head seems to express an appreciation of her own reflection which possibly anticipates the adoration of an undisclosed male admirer. Régnier's picture (**6**), like the engraving immediately below (**7**), are unequivocally representations of Vanity itself. And although twentieth-century artists such as Roy Lichtenstein (**8**) no longer work in such an emblematic tradition, the rapturous expression on the reflected face of the bimbo seems to imply an ironically moral attitude to the act of self-regard.

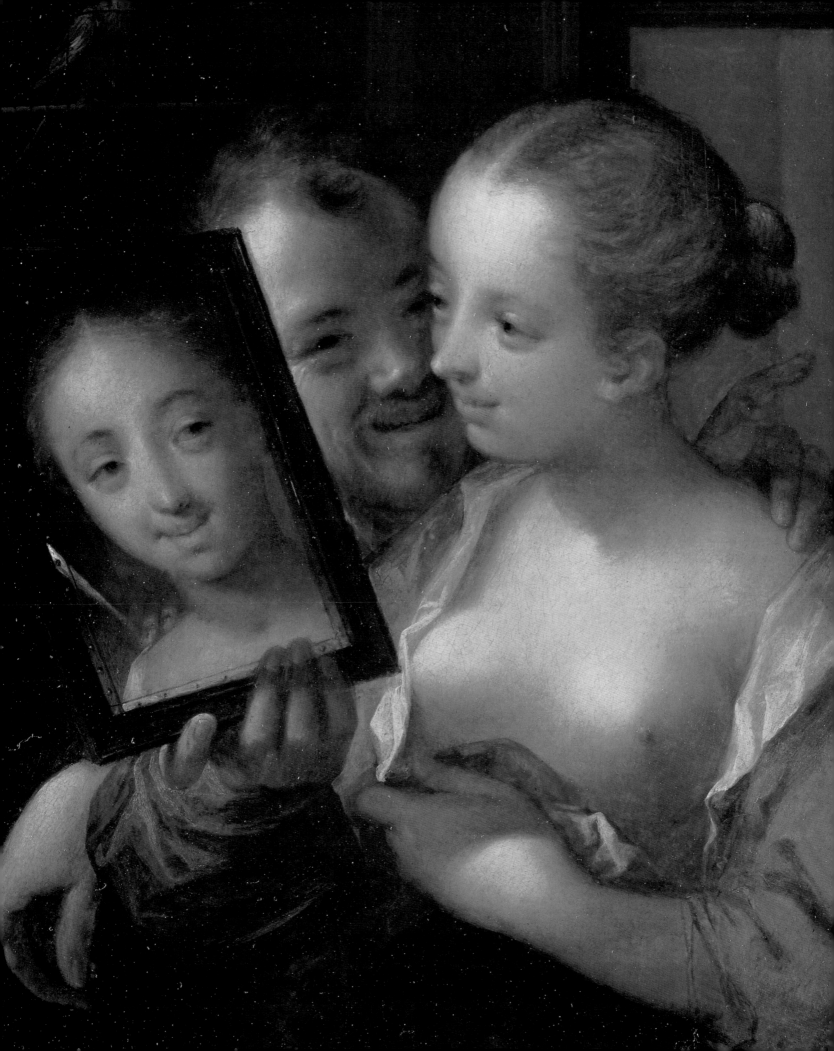

Von Aachen *Couple with Mirror* c.1596

Rowlandson *The Curious Wanton* c.1810–20

2

In many works of art in which women are portrayed in conference with their own reflection they are accompanied by attendants who seem to be egging them on to take an illicit pleasure in their own appearance.

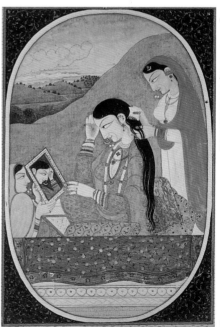

Utamaro *Hanamurasaki of the Tamaya* 1793

3

Titian *Lady at her Toilet* (detail) c.1515

1 **4**

Kangra School *The Lady and the Mirror* c.1820

5

Self-regard

The most notorious example of an individual annihilated by reflective self-absorption is the figure of Narcissus. The irony is that the fatal outcome was not, as often supposed, the result of Narcissus falling in love with himself. On the contrary, as Ovid insists in his *Metamorphoses*, Narcissus fell for and indeed into his own reflection without recognising that he was looking at himself. 'Unwittingly,' says Ovid, 'he desired himself without knowing what he was looking at.' No narcissist he. Pretty as a picture maybe, but not half as smart as a chimpanzee.

The myth of Narcissus portrayed here by a follower of Leonardo (**1**) is one of the rare examples in which a man is shown contemplating his own reflection.

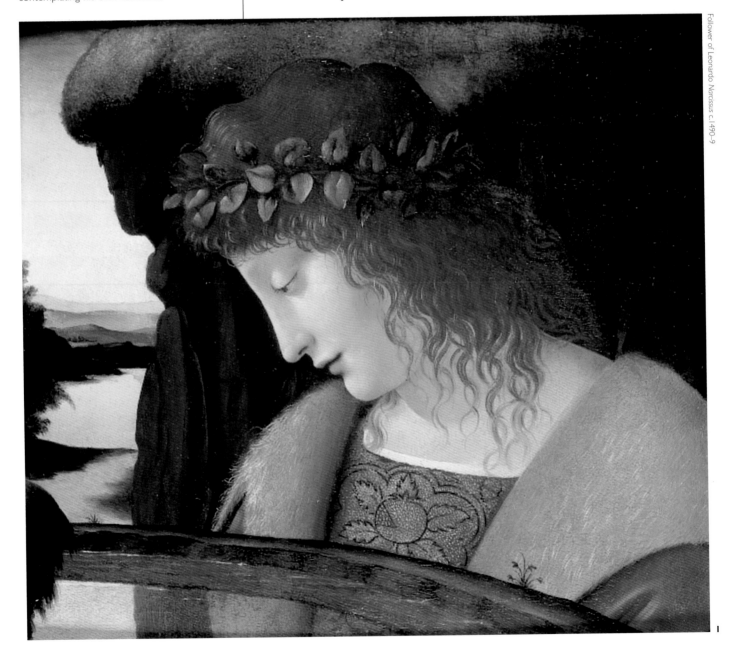

Follower of Leonardo *Narcissus c.1490–9*

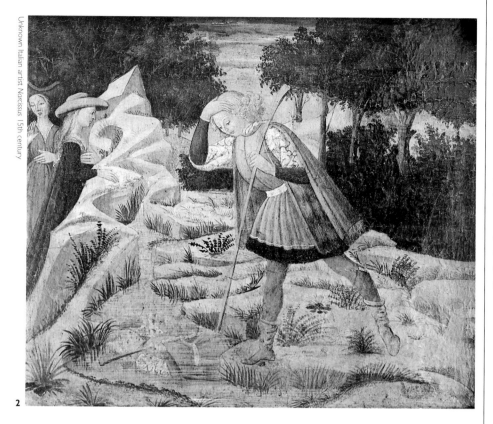

Unknown Italian artist *Narcissus* 15th century

Although the fatal outcome was not the result of his falling in love with himself, since he naïvely mistook his reflection for someone else, the popular misinterpretation of the story of Narcissus gradually superseded the account given by Ovid, so that the concept of Narcissism became synonymous with that of self-love, a weakness from which men seem peculiarly anxious to exonerate themselves.

By representing Narcissus as an effeminate exception who thoroughly deserved his sticky end, artists could construct, by default as it were, an ideal of manly virtue characterised by a robust indifference to personal appearance.

2

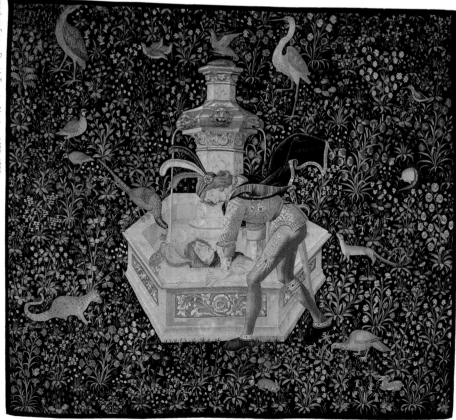

French or Franco-Flemish Tapestry *Narcissus* 1480–1520

3

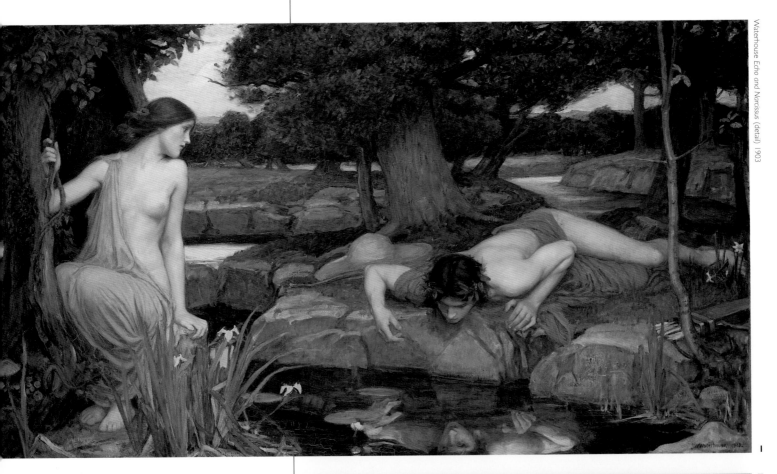

Waterhouse *Echo and Narcissus* (detail) 1903

1

In *The Taming of the Shrew*, Shakespeare summarises the ideal of manhood in terms of productive energy. One who 'commits his body to painful labour both by sea and land' is contrasted with women who are represented offering as tribute ('too little payment for so great a debt') 'love, *fair looks* and true obedience'.

The figure of Narcissus blurs and confuses this distinction. With a womanly interest in his *own* 'fair looks' he betrays no signs of familiarity with 'painful labour' either by sea or land.

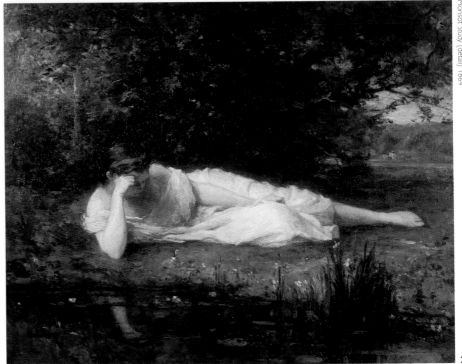

Morisot *Study* (detail) 1864

2

Caravaggio Narcissus c.1599–1600

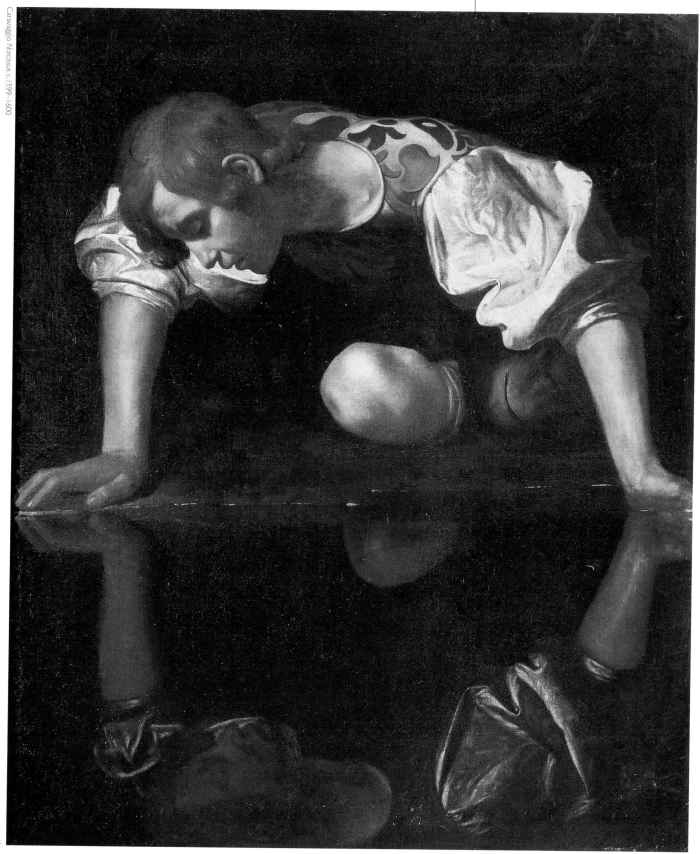

3

But when it comes to the explicit representation of the cognate vices of Vanity, Pride, Self-Love and Luxury, the observer is left in no doubt that the personification of the vice in question identifies the reflection as the flattering image of herself and that the undue preoccupation with reflected appearances grows by what it feeds on. It was this morbid condition that Freud identified as Narcissism, apparently unaware of the fact that Narcissus fell in love with what he believed to be someone else and that he did not therefore exemplify the condition that now bears his name. As far as Freud was concerned, the comprehensive egotism of the infant was a natural stage in human development in which the newborn infant was unable to differentiate between himself and the external world. Successful maturation requires the establishment of a boundary between the self and everything else, and if this development is arrested or delayed so that the individual fails to come to terms with what Freud describes as the 'reality principle' it is impossible for the afflicted individual to play a significant part in social life.

In the absence of an extenuatingly domestic setting, the single figure of a woman preoccupied by her own reflection has an unmistakably allegorical significance, although it is sometimes difficult to tell which of the self-regarding vices is represented. It may be Pride (**1**), Vanity (**2**, **3**), Luxury (**4**), or Venus who may, in certain cases, represent all three.

Matham *Pride* (detail) 17th century

Studio of Memling *Vanity* (detail) c.1500

1

2

The painters of the Middle Ages and the Renaissance did not identify vanity or pride in such clinical terms. As far as they were concerned the overvaluing of the self was a spiritual defect inherited from Man's disobedient first ancestor. It was a sinful proclivity to which mortal flesh was heir and unless it could be suppressed or disciplined salvation would be denied. Because they were unable to represent it in any other way, artists were forced to exploit a repertoire of visual imagery in which pride and vanity were identified with a preoccupation with physical appearances. But from the philosophical literature which inspired such representations it is perfectly clear that the implication is moral as well as physical. The suggestion seems to be that the individual who is entranced by her own appearance could be just as dangerously in love with the secret configurations of her inner self. For that reason perhaps the figure of Venus has a somewhat equivocal significance, and it is often difficult to know whether she is represented as the personification of admirable Beauty or as the incarnation of Pride, Vanity and Self-Love.

Attributed to Cousin *Woman with Mirror* (detail) 16th century

3

Sassetta *Luxury* (detail from *Saint Francis in Glory*) 1437–44

4

Without the peeping voyeurs drooling in the background of Tintoretto's painting (1), the chaste figure of Susanna might be confused with that of Venus, or Vanity, or of a Venetian courtesan – or perhaps all three rolled into one. Whoever she is, the satisfaction she takes in her own reflection presupposes the excitement which her appearance might arouse in the male onlooker.

Perhaps it is unrealistic to make such a distinction. In any case the implication seems to be that treacherous beauty is the fatal lure by which men are drawn to eternal damnation. We can see intimations of this idea in some of the Vanity pictures in which the self-intoxicated woman spares us a reflected glance as if to see the effect of her own attractions. Velázquez's Venus (2), who is often described as looking at herself, is more disconcertingly looking at us, enigmatically contemplating the reflected spectacle of someone revelling in a beauty such as hers.

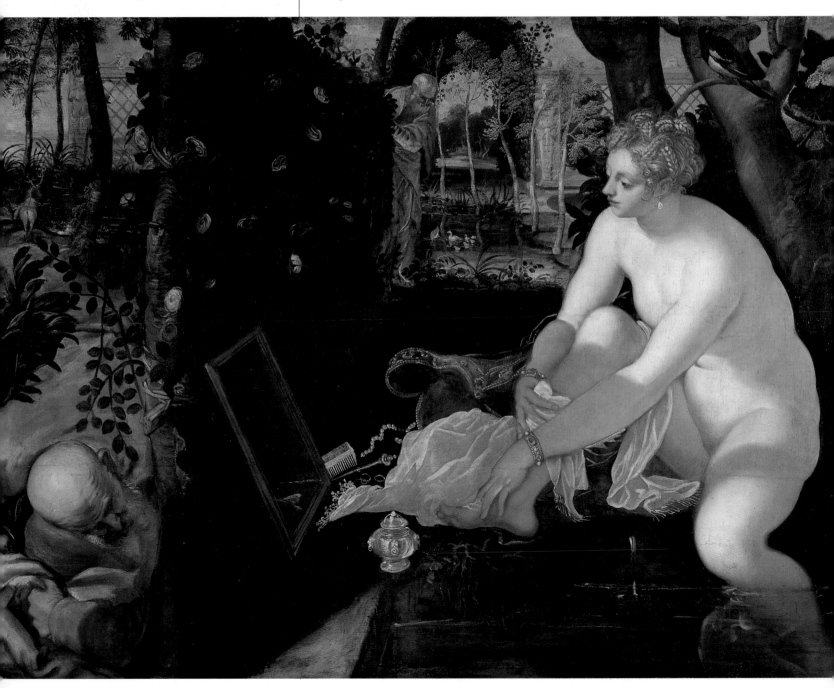

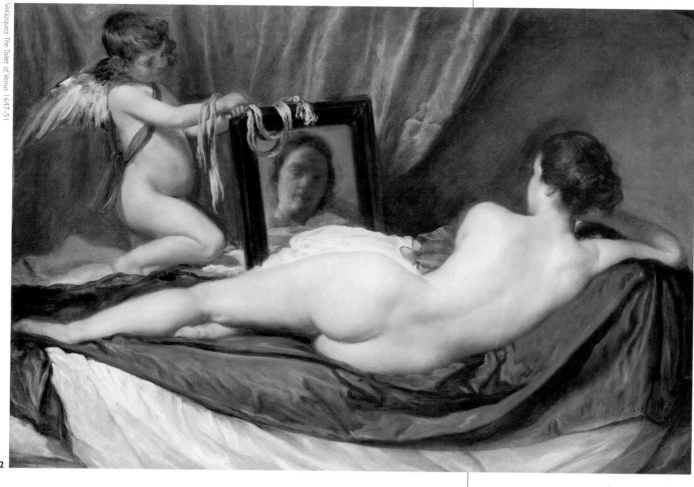

Velázquez *The Toilet of Venus* 1647–51

Tintoretto *Susanna and the Elders* (detail) c.1555

2

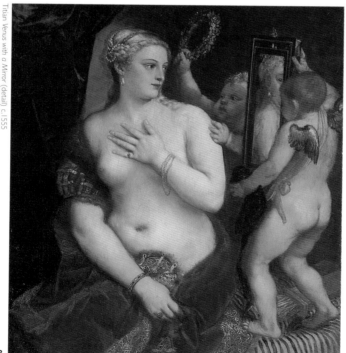

Titian *Venus with a Mirror* (detail) c.1555

3

1

In sixteenth-century Venetian painting there are many representations of a voluptuously dishevelled woman at her toilet. When she is attended by a winged Cupid who encourages her to revel in her own beauty (**3**) the figure is usually identifiable as that of Venus. In other examples it is a courtesan who is portrayed. But perhaps the distinction is trivial. Although Velázquez's famous painting (**2**) is understandably identified as that of Venus there is something about her posture and her glance which points forward to Manet's *Olympia*.

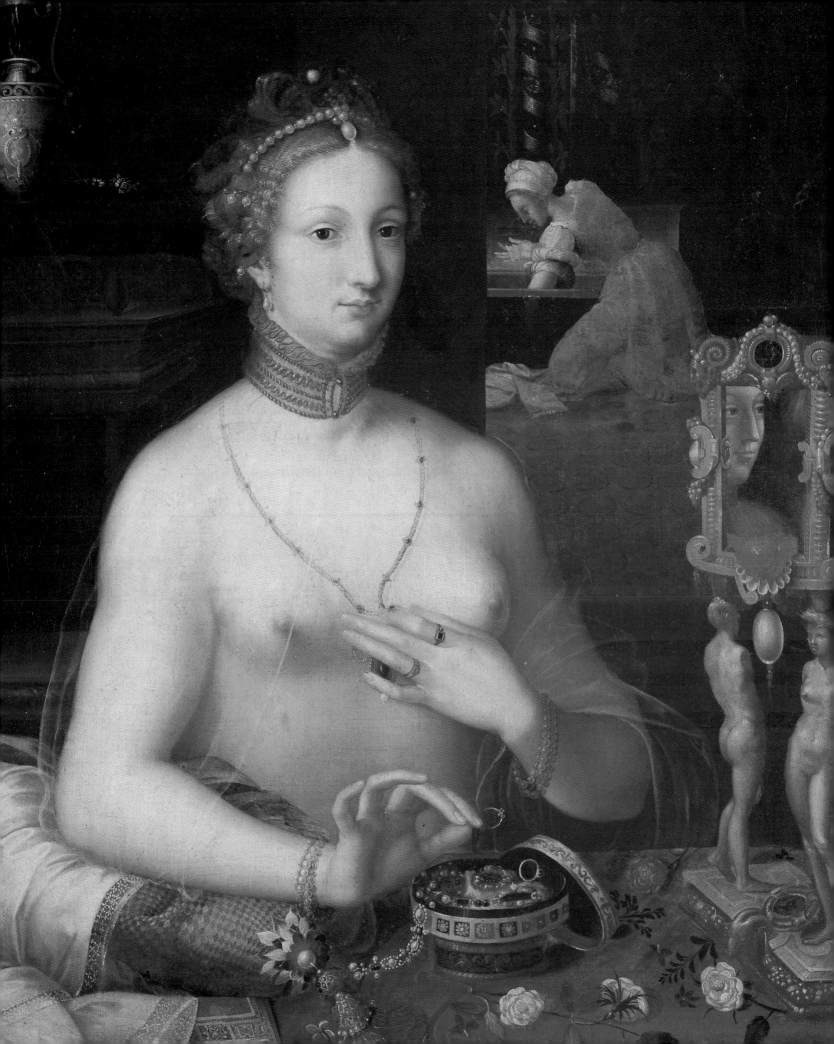

When a provocatively undressed lady is conspicuously equipped with the 'tools of Venus', the implication is that she is neither Venus nor a lady but a courtesan culpably adept at the arts of love.

In an article by Cathy Santore (1997) it is pointed out that the association of mirrors with both courtesans and with Venus has antique roots. 'A courtesan who plied her trade for some years in Venice, associates herself with Venus and alludes to the ancient practice of prostitutes dedicating offerings in the Temple of Venus.'

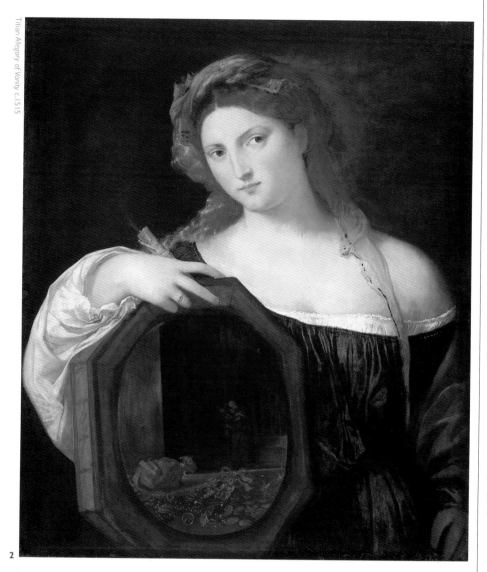

Tableaux in which the desirable figure of a woman is threatened (**1**) and sometimes devoured (**2**) by a famished corpse allude to the literal meaning of the word sarcophagus – the flesh-eating tomb which impatiently awaits its heedless occupant and makes a mockery of her short-lived mortal pleasures.

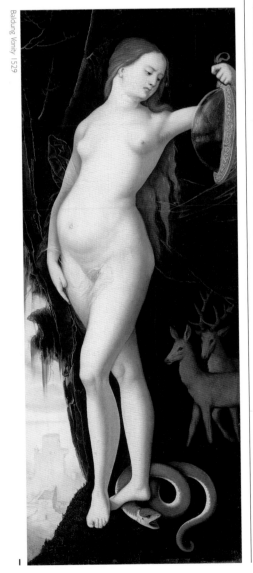

Baldung *Vanity* 1529

1

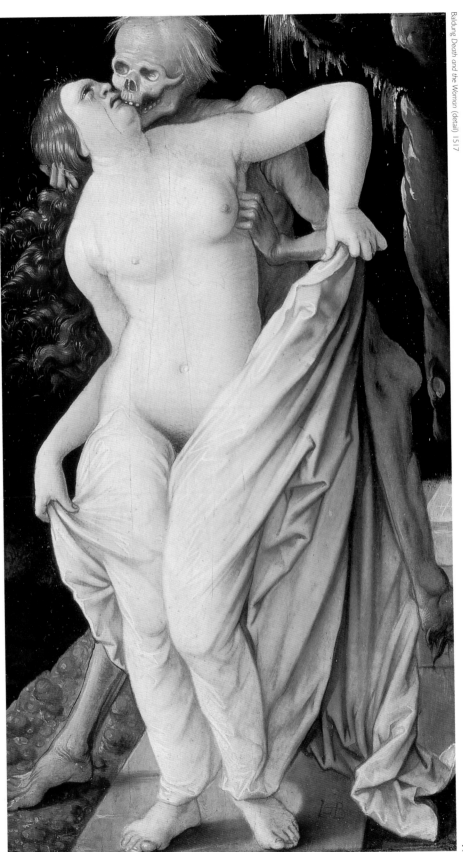

Baldung *Death and the Woman* (detail) 1517

2

In a set of variations which are closely related to the analogous theme of Death and the Maiden, the personification of Vanity is accompanied by an apparently unheeded figure, whose sinister presence makes a mockery of whatever satisfaction is to be had from gratifying such a vice. In innumerable pictures the grimacing figure of Death and/or the Devil is trying to remind the entranced maiden that in a life which is hastening towards senility and decay it is a folly and not just a vice to set store by the meretricious loveliness that appears in the mirror. The implication of these tableaux is the deceitfulness of

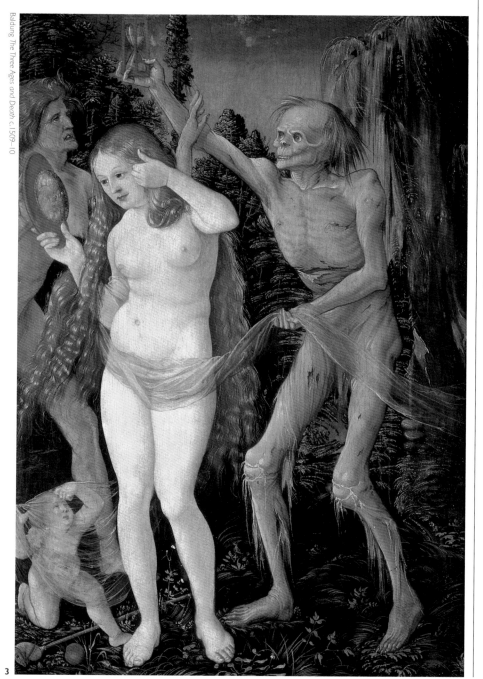

Baldung *The Three Ages and Death* c.1509–10

3

What are we to make of the fact that the victim of mortality is so often female, and that the carnivorous figure of her forthcoming death is that of a man? In Baldung's and Dürer's pictures (**3**, **4**) she preens herself in front of a mirror as if preparing for a nuptial deathbed.

Dürer *Allegory of Youth, Age and Death* c.1520–1

4

reflection. The brittleness of the glass in which the image appears bears witness to the transience of beauty itself, and the fact that the mirror can only disclose what it momentarily reflects exemplifies the briefness of human existence. In most of these pictures the gorgeously apparelled figure of Vanity is so wrapped up in her own reflection that she is apparently indifferent to the reminders of her forthcoming decay, even when they appear in the mirror itself. In a subtler version of the same theme, Vanity is absorbed into the figure of the penitent Magdalen who ignores the flattering mirror and meditates instead upon the skull and the brief candle.

In what looks like a rhapsody of auto-erotic excitement, the voluptuous beauty (**1**) revels in the reflection of her own hindquarters, apparently deaf to the summons of her cadaverous bridegroom.

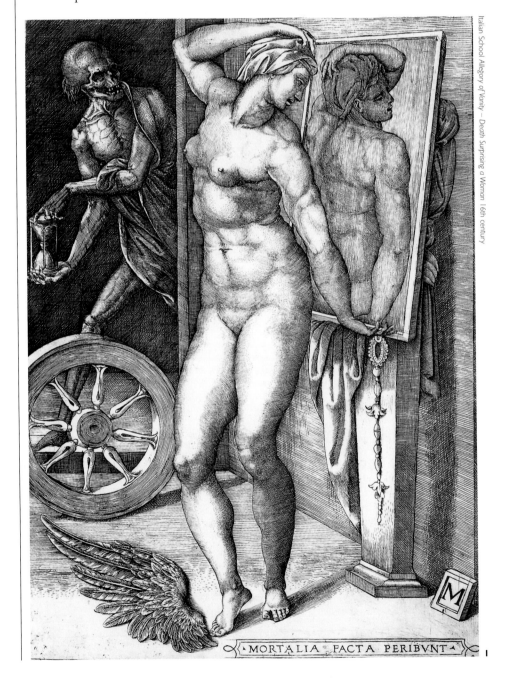

Italian School *Allegory of Vanity – Death Surprising a Woman* 16th century

· MORTALIA · FACTA · PERIBVNT ·

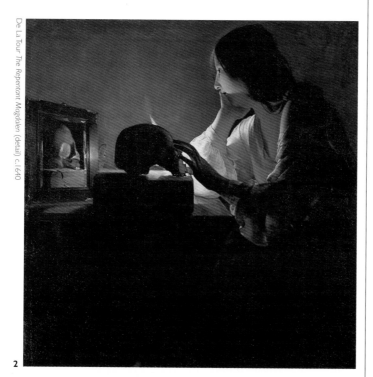

De La Tour *The Repentant Magdalen* (detail) c.1640

2

In contrast to the Venetian courtesans who tinker with their pearls and perfumes in front of a flattering mirror, De La Tour's *The Repentant Magdalen with the Mirror* (**2**) penitently contemplates the reflected beauty by which she once earned her shameful living.

In the painting below (**3**) it is the prudent Martha who draws Mary Magdalen's attention to the corrupting dangers of the mirror.

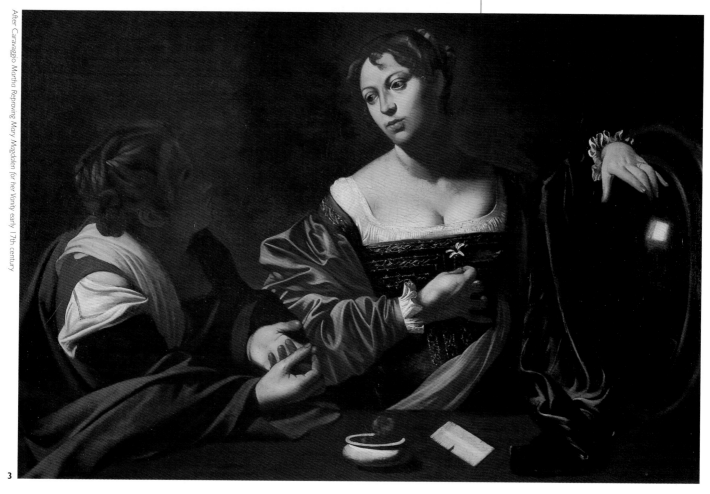

After Caravaggio *Martha Reproving Mary Magdalen for her Vanity* early 17th century

3

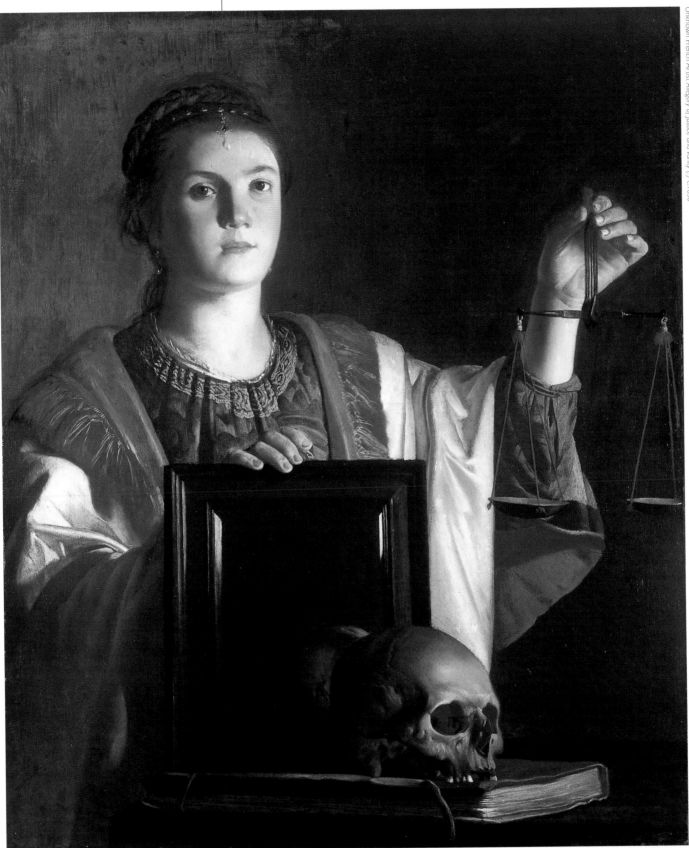

Unknown French Artist Allegory of Justice and Vanity (?) c.1630

Falck *Old Woman at her Toilet* (detail) 17th century

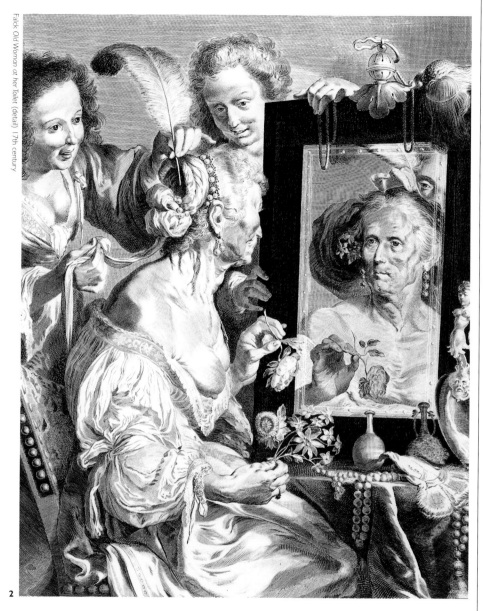

2

Dix *Woman before a Mirror* (detail) 1921

3

The representation of Vanity is given a much more naturalistic twist in Falck's engraving (**2**). Are we to assume that the withered crone fails to see what time has done to her, and she is persuaded by the mocking flattery of her attendants, or that the poor old thing is all too aware of the wreckage? Dix's old tart (**3**) is blind to the insults of her own mirror.

Furtnagel's picture (**4**) conveys a much more generalised message about the vanity of human life itself – that even such a blameless and grimly worthy couple as this will come to nothing. From their expression and her gesture we get the impression that they are inviting us to do as the motto on the mirror suggests: to know ourselves before death catches up.

With its props and its lighting the painting on the opposite page (**1**) bears an unmistakable resemblance to De La Tour's *The Repentant Magdalen with the Mirror* on page 169. But because of its composition, it projects an altogether different type of moral. The skull and mirror are turned to face us, and it is *our* vanity that is impugned by the unquestionably virtuous gaze of the allegorical figure of Justice.

Furtnagel *Portrait of the Artist Hans Burgkmair and his Wife Anna* (detail) 1529

4

Van Leyden *Prudence* 1530

PRVDENCIA

The allegorical significance of an emblem presupposes a text which explains how and why it signifies what it does. Thus, the figure of Prudence is all too easily confused with that of Vanity, and even when she occurs in a pictorial sequence which includes all the other Virtues, if the uninformed observer does not recognise what the sequence as a whole signifies, he will misunderstand the meaning of the one in question.

In Lucas van Leyden's engraving (**1**) the inscription identifies the figure as Prudence, but in the absence of such a title the presence of Cupid would make us think of Venus. In della Robbia's ceramic (**2**) the Serpent of Wisdom indicates that the mirror is at the service of self-knowledge.

In Vouet's painting (**3**) the serpent has the same iconographic significance. But the heroic tone of the picture as a whole makes it unlikely that the young woman represents anything other than Prudence. The figure of Time who reveals Truth confirms this.

As with so many physical objects which acquire emblematic significance, the metaphorical implications of the mirror are not necessarily negative or censorious. The configuration in which the mirror epitomises the vice of Vanity is almost indistinguishable from the one in which it represents the virtue of Prudence and without a subtitle or a legend it is sometimes difficult to tell which is which. But the context is often helpful. The traditional figure of Prudence, who is consistently shown studying her own reflection, generally appears in a pictorial setting which unambiguously identifies her as one of the Seven Virtues (Temperance continently emptying her flagon of wine, Fortitude with her cudgel, Faith with the Crucifix and chalice). And from the company which she keeps we can tell the virtuous use to which she is putting an otherwise treacherous mirror.

The fact that the same configuration can be used to represent both a vice and a virtue indicates that the mirror itself has an equivocal reputation. The use to which Prudence puts it presupposes the reliability of reflection and the practical usefulness of the mirror has always been recognised as an argument in favour of its truthfulness. In spite of the fact that the defects of a mirror can compromise its fidelity, the assumption is that in the limiting case of optical perfection the reflected image is the epitome of representational accuracy.

Vouet *Allegory of Prudence* (detail) c.1645

Della Robbia *Prudence* c.1475

Kerver, *The Virgin with Emblems*, 1505

Since the beginning of Wisdom is said to be self-knowledge it is not altogether surprising that Prudence should be shown in conference with her own reflection. In the long tradition which medieval authors traced back to Socrates, the mirror is repeatedly recommended as a tutorial device whose reliable imagery was to be exploited in the pursuit of self-knowledge. In text after text, young men are encouraged to examine themselves in a mirror. They are told that if they were pleased by what they saw they should try to behave with comparable grace, and that if the reflected image was ugly or deformed it would encourage them to 'hide the defects of the body by undertaking improvements of the mind'. There is a philosophical problem associated with the claim that self-knowledge can be acquired by examining our own appearance. What we *look* like is not necessarily a reliable indication of what we actually *are*, and although there is an intelligible sense in which the expressions of our face register the movements of our mind, it is also understood that our face can conceal just as much as it shows. But since there are no pictorial resources for representing the more appropriate act of *introspection*, the study of our own reflection has become the conventional way of representing the examination of our own soul.

In its role as an emblematic accessory to the virtue of Prudence the mirror is exercising one of several affirmative functions, each of which presupposes a truthful correspondence between reality and its reflection. Thus there are mirrors for magistrates and kings. Hamlet recommends drama as a mirror held up to Nature, and the mind itself is frequently referred to as a mirror in which the image of Nature is reliably reflected. It is in this affirmative context that the mirror plays a significant role as one of several emblems signifying the immaculate perfection of the Holy Virgin — *Speculum Sine Macula*.

Colombe Prudence and a Mirror 1502–7

2

The mirror is one of seven attributes by which the virginity of the Mother of God is symbolised. The flawlessness of its surface represents Her purity. The fact that the light passes through glass without altering its composition signifies that the Holy Spirit penetrated the virgin body without compromising its chastity. The lead in the glass stands for Her Divine Humility.

3

Self-representation

In the history of human knowledge certain instruments are understandably credited with the discovery of previously unknown aspects of the natural world. The telescope revealed the existence of undetected moons orbiting the planet Jupiter. With the aid of a simple arrangement of lenses the Dutch naturalist Anthony van Leeuenhoek discovered the unsuspected existence of living organisms swarming in his own saliva. There is nothing which appears in a mirror, however, with which we can even begin to compare these discoveries. With one exception the mirror shows what we could just as easily see by looking around us. Without the aid of a mirror, however, we would be completely ignorant about the appearance of our own face. But in contrast to the microscope and the telescope which introduced human beings to a previously unknown *class* of objects, it did not require the invention of the mirror to familiarise us with the existence of the human face. We can see that everyone else has one and by analogy at least it would seem reasonable to assume that we have one too. But it is not only by *analogy* that we know about the existence of our own face. We can feel that it is there, and we can effectively and discriminatingly find our way around it with our eyes closed. What is more, we can recognise an unmistakable correspondence between the unseen parts of our own face and the visible parts of everyone else's. If someone points at their own mouth and asks me to do the same, I can do so without hesitation. In other words, there appears to be an inborn sense of equivalence between the *feel* of our own face and the *look* of everyone else's.

The fact remains that the knowledge we have of our own face by virtue of *inhabiting* it is altogether different from the knowledge that we gain by looking at it in the mirror. The discrepancy is such that we are often startled to find that although there is a general correspondence between what we feel and what we see, we are unacquainted with the subtle details by which other people identify us. It is interesting to imagine what a self-portrait would look like if it had to be executed on the basis of its *non*-visual representation: if it had to be drawn or painted from the way it felt as opposed to the way it looked. Earlier I suggested that it would have the grotesquely beheaded look of Mach's drawing. But of course Mach deliberately took no account of the fact that he was furnished with a non-visual representation of his own face, so it is unlikely that he would have depicted himself as altogether faceless. Nevertheless it seems reasonable to assume that the self-portrait he would have improvised under these circumstances – that is to say, without the aid of a mirror – would have been extremely generalised and that it certainly would not have been one by which he would expect to be individually identified.

In fact without a mirror there would be no reason to believe that our appearance was such that we could be identified simply by looking at it.

In 1484, encouraged, it is said, by the example of his father, the thirteen-year-old Albrecht Dürer completed what is sometimes claimed to be the first explicit example of self-portraiture. Forty years later, when he was putting his papers in order, he added the following inscription across the top of the drawing: 'I fashioned this of myself out of the mirror when I was still a boy.'

The portrait is so startlingly accomplished for a boy of thirteen that it is

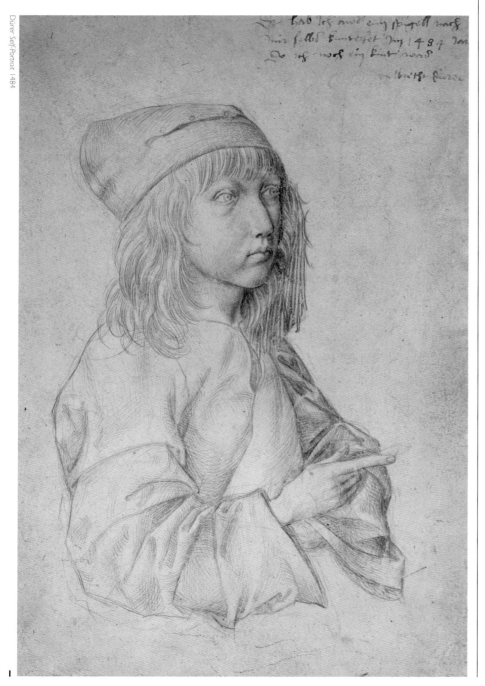

Dürer *Self-Portrait* 1484

In his earliest attempt to represent his own appearance in a mirror the youthful Dürer chose a viewpoint which might have been that of someone else. By eliminating any signs of a drawing instrument he gave no indication that he was responsible for the portrait (**1**).

easy to overlook the features which appear to contradict the claim that it was done with the help of the mirror. The reflection in which he would have seen himself as represented, in three-quarter profile, must have been somewhere off to his left side, and yet he has shown himself staring straight ahead at an angle which would have denied him the necessary view of his own reflection. This can only mean that having studied himself askance, he 'corrected' the sidelong gaze, thereby giving the paradoxical impression that he reproduced his own likeness without actually seeing it. Similarly, the hands are represented as if they played no part in the drawing. The right hand, which would have been executing the drawing, is disconcertingly idle, hidden, as if paralysed, behind the sleeve of his left arm. It is as if the young artist has deliberately effaced any evidence of his being the maker of his own image. It looks like a portrait drawn by someone else.

Seven years later in the so-called Erlangen drawing, no inscription is required to support the belief that it was done 'out of a mirror'. With his head propped thoughtfully against his left hand, the twenty-year-old artist visibly confronts what must have been his own reflected appearance. But it would be rash to assume that the picture was intended to represent the artist in the act

In the Erlangen drawing (**1**) Dürer visibly confronts his own reflection. But since the right hand with which he presumably executed the drawing is supporting his face it would be wrong to assume that we were looking at a picture of Dürer in the act of representing his own likeness.

Dürer Self-Portrait c.1491

of rendering his own likeness. The posture, which some historians have described as that of an artist steadying his own gaze, has also been identified as the traditional attitude of melancholy, and judging by the number of his own works in which that very posture recurs it could be argued that Dürer was studying the expressive relationship between hand and cheek and that the self-portrait was the incidental by-product. One way or the other, the demeanour of the portrait depends on which of these two descriptions we accept. If it is taken to exemplify Dürer in the act of representing himself, the gaze unarguably expresses the look of someone objectively examining his own appearance, and the right hand which was presumably executing the drawing that we can see is therefore conspicuous by its absence. But if we visualise the same drawing as a working study of someone in a state of melancholy, the position of the hand assumes a correspondingly expressive appearance and the gaze now looks as unfocused and as abstracted as it does in Dürer's later picture of *Christ as Man of Sorrows*.

The posture in which Dürer represents himself in the Erlangen drawing (**1**) recurs in some of his later work (**2**, **3**, **4**). The image of someone supporting his head on his hand was by that time well-established as a traditional pictorial motif. It could represent the psychological temperament of Melancholy and also the sin of Sloth or Accidia.

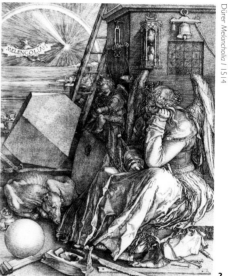

Dürer Melancholia I 1514

3

Dürer Holy Family (detail) c.1492–3

2

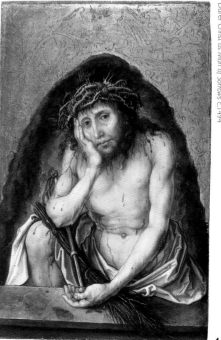

Dürer Christ as Man of Sorrows c.1494

4

The only drawing in which Dürer indisputably represents himself in the act of fashioning a likeness of his own mirror image is the one which is now to be seen in the Lehman Collection in New York. Here, for the first time, the right hand is introduced as the active accomplice of its owner's eye, and although the pen is teasingly excluded from its grip, the delicately prehensile gesture resembles that of an artist measuring the proportions of what he is about to depict.

When it came to portraying himself in a finished work of art, Dürer systematically eliminated any evidence of his being the maker of his own

In contrast to the Erlangen drawing in which there is no visible sign of manual activity, Dürer's Lehman picture (1) brings the artist's hand so far into the foreground that it looms as large as his face. But in spite of its prehensile gesture it is not the hand with which he would have executed the drawing. So presumably he is measuring the proportions of his reflection with his left hand and executing the drawing with his invisible right hand. When an artist wishes to portray himself in the act of doing so, he is caught up in a perceptual double bind. As long as his gaze is fixed upon his own reflection he cannot attend to the movements of his own hand. And conversely, when he drops his eyes in order to control the drawing, he immediately loses sight of what he is trying to depict.

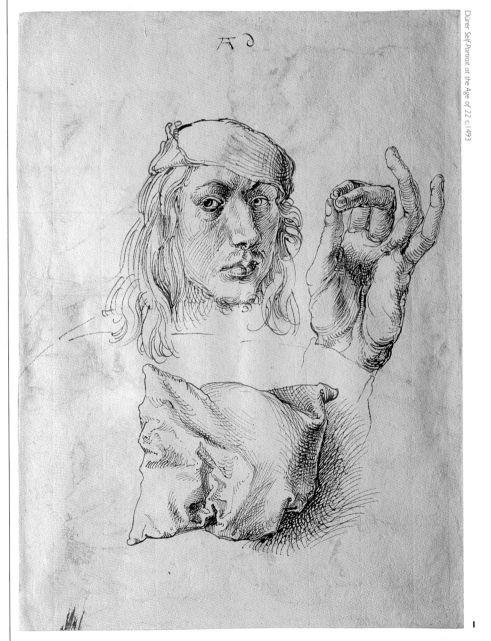

Dürer Self-Portrait at the Age of 22 c.1493

likeness. In the 1500 Munich self-portrait, with its hieratically frontal composition, the hands are so conspicuously *inactive*, and the brushwork so imperceptible, that the image gives the impression of having printed itself directly on to the photo-sensitive surface of the panel. This seems to have been the intended effect and it has been suggested that Dürer visualised the act of portraying himself as analogous to the process by which the face of Christ had miraculously appeared on the surface of certain holy relics. The devotional awe surrounding these images was based on the belief that they were brought into existence by direct contact with the sacred features of the Son of God.

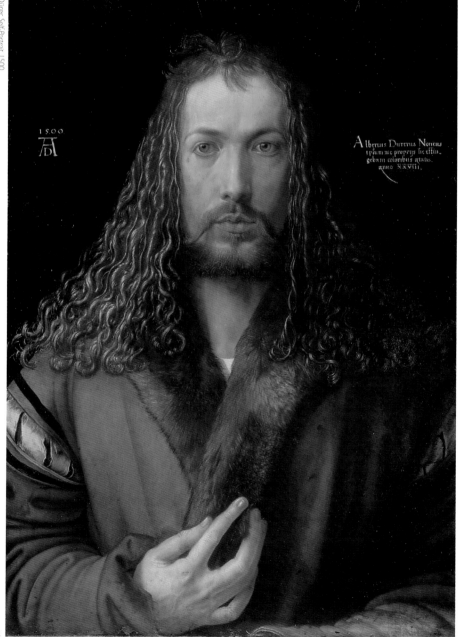

Dürer Self-Portrait 1500

1500

Albertus Durerus Noricus
ipsum me proprijs sic effin
gebam coloribus ætatis.
anno XXVIII.

2

In the Munich self-portrait (**2**) Dürer's attention is monopolised by the reflection which he confronts head-on. But his posture betrays no sign of the activity which resulted in the portrait we now see. In some altogether mysterious way it is the portrait of someone who happens to be the artist responsible for it.

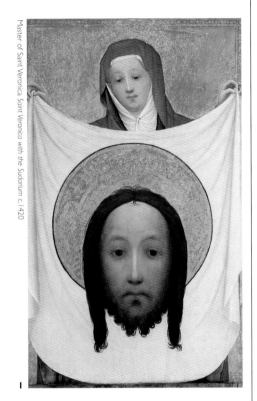

The mystical image of the Holy Face was a recurrent theme in late fifteenth- and early sixteenth-century Northern art. It is by definition an image brought about without the intervention of the skilful hand (**1**).

As the illumination of Marcia shows (**2**), capturing one's own likeness requires skill rather than magic.

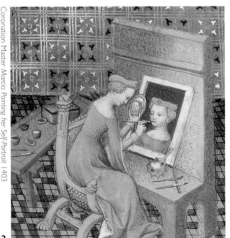

The most famous of these miraculous 'self-portraits' was the Sudarium or Vernicle. According to an early fourteenth-century narrative, a pagan woman named Veronica had pityingly wiped the Saviour's face on his way to Calvary. As a reward for her tenderness he 'autographed' the cloth with an authentically detailed imprint of his suffering features. By the end of the fifteenth century, the devotional cult of the Sudarium had spread throughout Northern Europe. And because of the disconcerting resemblance between Dürer's features and the traditional representations of the Holy Face, it seems reasonable to believe that in designing what is often said to be the first significant self-portrait in Western European art, Dürer was influenced by the traditional notion of the acheiropoietic image: a physical likeness brought into existence without the intervention of manual skill (a = without, cheir = the hand, poiesis = making).

For understandable reasons the Munich self-portrait has been reproached for its blasphemous Narcissism, but as Erwin Panofsky points out (1945) the picture does not necessarily exemplify self-glorification on the part of the artist.

> To understand his intentions we must remember two things. First, that at Dürer's time the doctrine of the 'Imitatio Christi' … was interpreted more literally than nowadays and could be illustrated accordingly … Second, that for Dürer the modern conception of art as a matter of genius had assumed a deeply religious significance which implied a mystical identification of the artist with God. To his way of thinking the creative power of a good painter derives from, and to some measure is part of, the creative power of God.

But even without such doctrinal considerations, it is easy to understand the seductive allure of a magical process which might relieve the artist of the necessity of exercising a manual skill. How convenient it would be if a physical surface were so sensitive that it would automatically record the appearance of anything to which it was exposed! The mirror can do so, and yet the accuracy with which it reflects reality is not matched by a capacity to retain the image. So that as the illustration of *Marcia Painting her Self-Portrait* shows only too well, the skill of the artist is required to mediate between the fleeting perfection of the mirror image and the permanent portrait.

The camera as mirror

The irony is that the very surface in which sixteenth-century artists had *studied* their own features was the first one which, when chemically treated, would accurately retain the reflected image. With Niepce and Daguerre's discovery of chemically sensitised silver, the Vernicle was effectively secularised, and in the act of portraying himself in a photograph the artist could virtually eliminate any evidence of his own participation. Nevertheless, in spite of the fact that the earliest photosensitive surfaces were made of silver, it would be misleading to think of a photograph as a chemically fixed reflection. A physical surface, reflective or otherwise, is not capable of forming 'what we humans, with our excellent eyes would recognise as a proper image' (Richard Dawkins 1995). The formation of an image necessitates the projection of light through a small aperture on to the back wall of a darkened chamber and this may also require a system of lenses to give accurate focus.

How convenient it would be if mirrors could retain the image of what they reflect. Portraits could be done just by sitting in front of a looking-glass. But this is an absurd fantasy. Reflections leave no trace of themselves and even if the surface could be coated with photosensitive chemicals, each image would be obliterated and confused by its successor – that's why we have to wind on the film between each exposure. There is a more significant objection. If light rays behaved as they do in (**4**) the sensitised mirror would reproduce the appearance of whatever it reflected. In reality each part of the object sends a ray to every point on the mirror surface so that the image becomes hopelessly swamped (**5**). The surface has to be enclosed in a darkened chamber pierced at the front by a pinhole (**6**).

Clementina Lady Hawarden *Seated in Reflection* 19th century

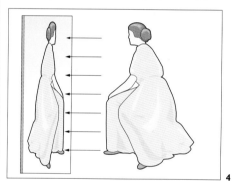

4

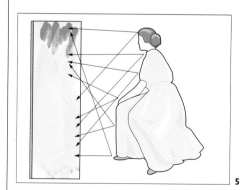

5

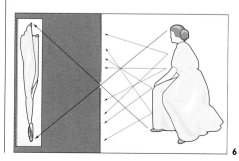

6

In order to retain a permanent record of this projected image, the back wall of the chamber must be fitted with a surface whose chemical composition will visibly change when light falls upon it. If the exposure of the aperture is too brief there will be insufficient chemical change to record the image. If the aperture is kept open for too long, the image will be overexposed and indistinct. This means that the operator must fiddle with the apparatus in order to control the exposure, thereby exempting himself from the role of model.

There are two ways round this problem. By photographing himself in a mirror, the photographer can simultaneously operate the camera and act as his own model, but the resulting image will inevitably include a representation of the camera. By exploiting a more cunning technique the photographer can represent himself without betraying any visible sign of the apparatus which secured the image. He can as it were dissociate the roles of operator and model by putting the apparatus on a timer. He can pre-set the camera so that it 'goes off' five seconds later, thus giving him just enough time to dodge round the front and act as the unconcerned model. Alternatively he can operate the shutter by remote control, surreptitiously concealing the button which releases the shutter. Either of these techniques would have produced an image comparable to the one which appears in Dürer's Munich *Self-Portrait* (**2**). We could easily imagine that in the apparent gesture of benediction Dürer was actually pressing the remote-control button concealed in his fur collar.

Although Diane Arbus (**1**) could have portrayed herself by standing in front of a camera which was timed to 'go off' when she was ready to pose, she deliberately photographed her own reflection so that what we see is the picture of her in a mirror.

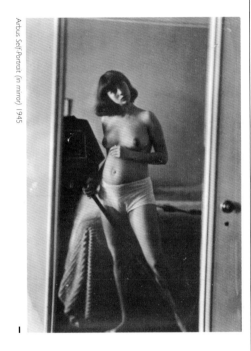

Arbus *Self-Portrait (in mirror)* 1945

1

Dürer's self-portrait (**2**) is the record of someone consciously looking at his own reflection, whereas Mapplethorpe, working with a camera, had no need to see himself in order to leave a record of his appearance. Mapplethorpe (**3**) could use a camera to portray himself in the same way that Dürer did in 1500.

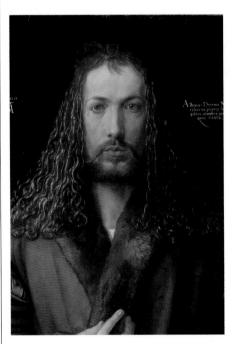

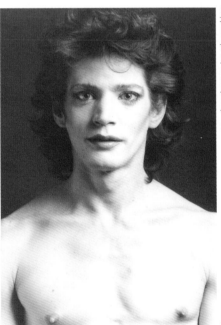

Mapplethorpe *Self-Portrait (detail)* 1980

2, 3

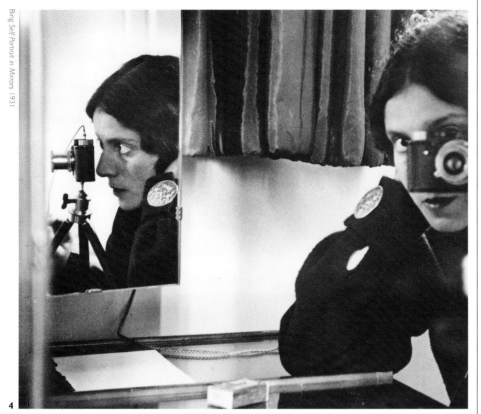

Bing Self-Portrait in Mirrors 1931

In each of these four examples the mirror, though not necessarily required for photographic self-portraiture, is playfully included, and as a result (**4**, **6**, **7**), the camera, too, is caught red-handed.

Man Ray Self-Portrait (detail) c.1944

5

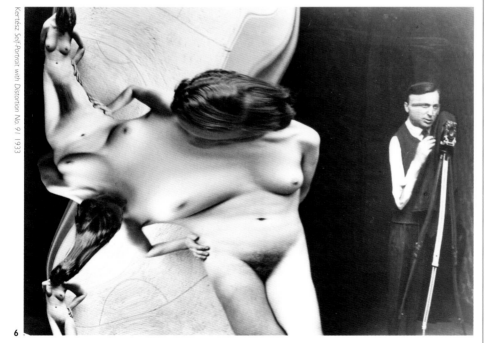

Kertész Self-Portrait with Distortion No. 91 1933

6

Boubat Self-Portrait (detail) 1958

7

Self-assertion

Regardless of the method by which the artist records his own appearance – camera or paintbrush – it requires a complicated act of dissimulation to give the impression that the image was brought into existence by anyone other than himself and the extent to which any given self-portrait acknowledges the method by which it was produced varies enormously. As the inaugural example of the genre, Dürer's Munich *Self-Portrait* panel epitomises the most reticent representation of all. The mirror, without which the picture could not have been painted, is neither represented nor implied. The frontal gaze betrays no sign of its being employed in self-examination and, as we have already seen, the painter's hands are conspicuously inactive. How can we reconcile the appearance of the picture with the certain knowledge that it was produced by

In order to represent himself as he appears in his own *Self-Portrait* Stanley Spencer, like Dürer and Mapplethorpe, must have gazed at himself just as he appears in the picture (**1**). But in thus gazing at himself he would have been unable to look at or control his own handiwork. The work therefore had to proceed in alternating instalments of gazing and painting. Whereas if this had been a photograph, the camera would have captured the single moment of Spencer gazing into it.

Spencer *Self-Portrait* 1913

1

the very person it represents? We can only assume that in constructing his own image Dürer retreated from the building site, successively removing incriminating signs of his own artistic presence and that he concluded the clean-up by correcting what would otherwise have been the tell-tale look in his own eyes.

Dürer's determination to exonerate himself from any visible responsibility for his own self-portrait seems to have been the expression of a mystical attitude to the act of creation. But the same configuration recurs throughout the succeeding centuries. In the two thousand self-portraits which line the walls of Vasari's corridor in the Uffizi in Florence the same sort of figure can be seen again and again: one in which the necessary mirror is neither represented nor implied, and in which the hands of the artist are paradoxically inactive. But in the very same corridor the almost unknown

Gumpp Self-Portrait (detail) 1646

2

Johannes Gumpp's *Self-Portrait* (**2**) is one of the rare examples in which the painter reveals the set-up which is required to represent his own likeness. There are however puzzling suggestions of an infinite regress, since by including his own rear view Gumpp raises the intriguing question of how he could have seen himself from behind while painting himself by reflection from the front.

artist Johannes Gumpp goes to the opposite extreme and reveals all the trade secrets of self-representation. In this mysterious picture Gumpp shows the mirror, the portrait and himself in the act of painting. But where was he standing to see himself doing so?

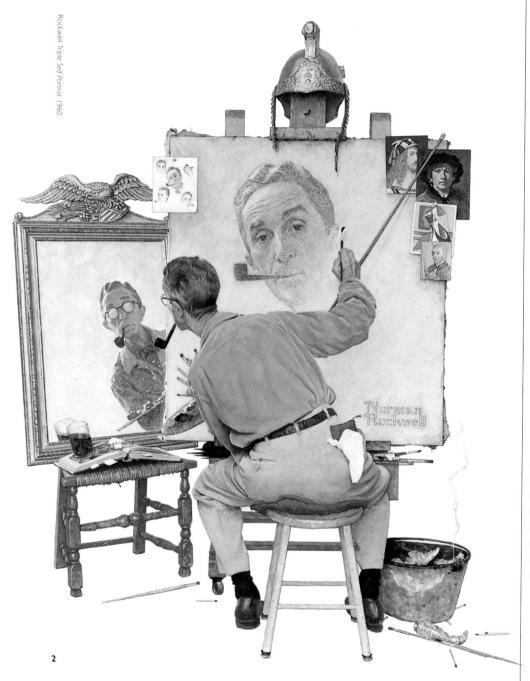

Rockwell *Triple Self-Portrait* 1960

2

In the Kenwood *Self-Portrait* (**1**) Rembrandt made an interesting mistake which he later corrected. An X-ray of the portrait reveals the artist holding his brush and palette in the wrong hand – in other words as they would have appeared in the reflection that he would have consulted in order to paint the picture.

It is unlikely that Rockwell (**2**) was acquainted with Gumpp's little-known picture in Florence, but the pictorial set-up is more or less the same, and from the reproductions pinned to the top right-hand corner of the canvas we can see that the artist was playfully intrigued by the problems of portraying himself in a mirror.

There are some interesting discrepancies between the reflection and the portrait. In order to look at himself Rockwell apparently had to use his spectacles which are conspicuously absent from the painting and the angle at which he holds his pipe in his mouth is unmistakably different. In any case, the as yet unfinished portrait is flatteringly younger than the gig-lamped old boy looking back from the mirror.

Are we to assume that there was an even larger mirror just out of sight in the immediate foreground in which Rockwell could see everything which is represented in the picture? Even if not, the fact that Rockwell was responsible for portraying both his older self and his younger portrait indicates that the Rockwell we cannot see was in on the joke.

Between these two extremes the variations are almost unlimited. They can be broadly classified as follows:

• fully frontal compositions in which neither the mirror nor the canvas is represented, but in which the model nevertheless declares himself to be the artist by holding the tools of his trade. For obvious reasons, however, the act of painting itself is not represented, and in many cases it is difficult to tell whether the gaze is directed at the mirror or at the as yet unfinished canvas

In contrast to the self-portraits by Gumpp and Rockwell the artists on this page have rotated the pictorial set-up through 180 degrees so that the mirror which would have been required is implied without being represented. Each of these paintings capture the moment at which the artist inspects his own reflection. But in order to paint what he sees he must now switch his gaze to the working surface of the canvas, so that he must hold the reflected image in his mind's eye. This means that he is painting the mental image of something seen a moment earlier.

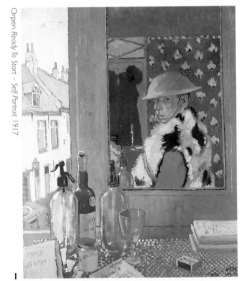

Orpen *Ready To Start — Self-Portrait* 1917

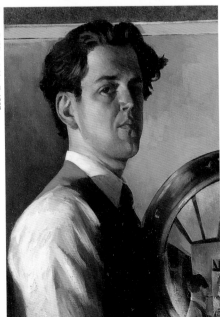

Conroy *Self-Portrait* (detail) 1987

• oblique self-portraits in which neither the mirror nor the canvas is represented, although the sidelong gaze now seems to imply that the artist is dividing his attention between the mirror out front and the invisible canvas somewhere off to the side. Within this group the canvas can sometimes be seen edging into the picture but in most of these examples the artist's gaze is ambiguously directed towards what must be his own reflection

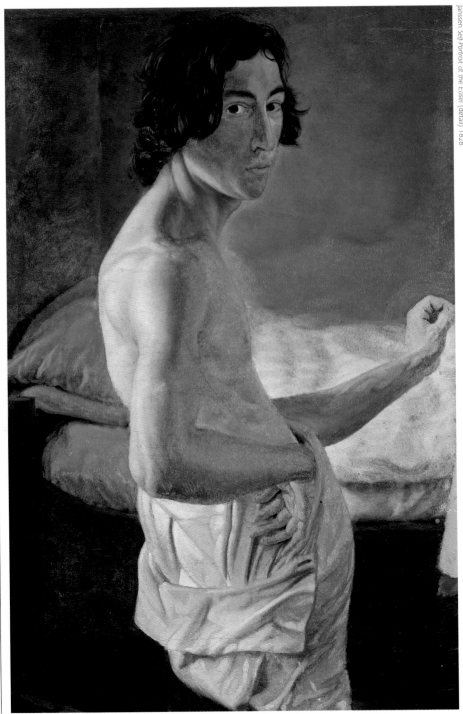

Janssen *Self-Portrait at the Easel* (detail) 1828

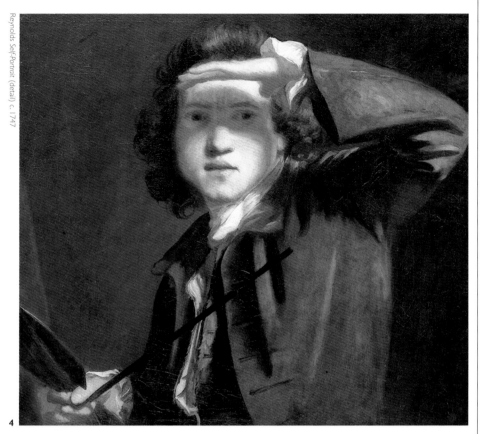

The youthful Reynolds (**4**) momentarily shades his eyes against the incident light. But what exactly is he trying to look *at*? Is he looking at the canvas which now bears the picture that we can see? Or is he looking straight ahead at his own reflection from which he will turn a moment later to work on the canvas which is just out of sight to our left and his right?

The same problems of alternating gaze are to be seen in the other two self-portraits (**5**, **6**).

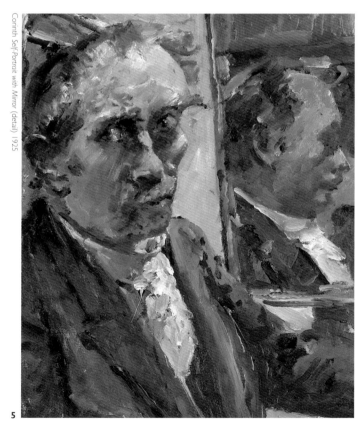

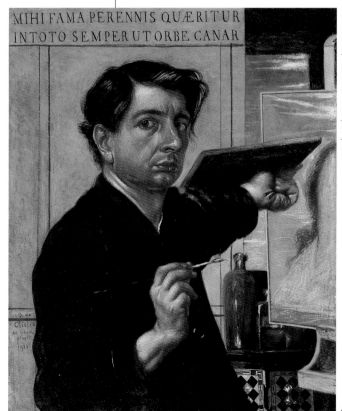

MIHI FAMA PERENNIS QUÆRITUR
INTOTO SEMPER UT ORBE CANAR

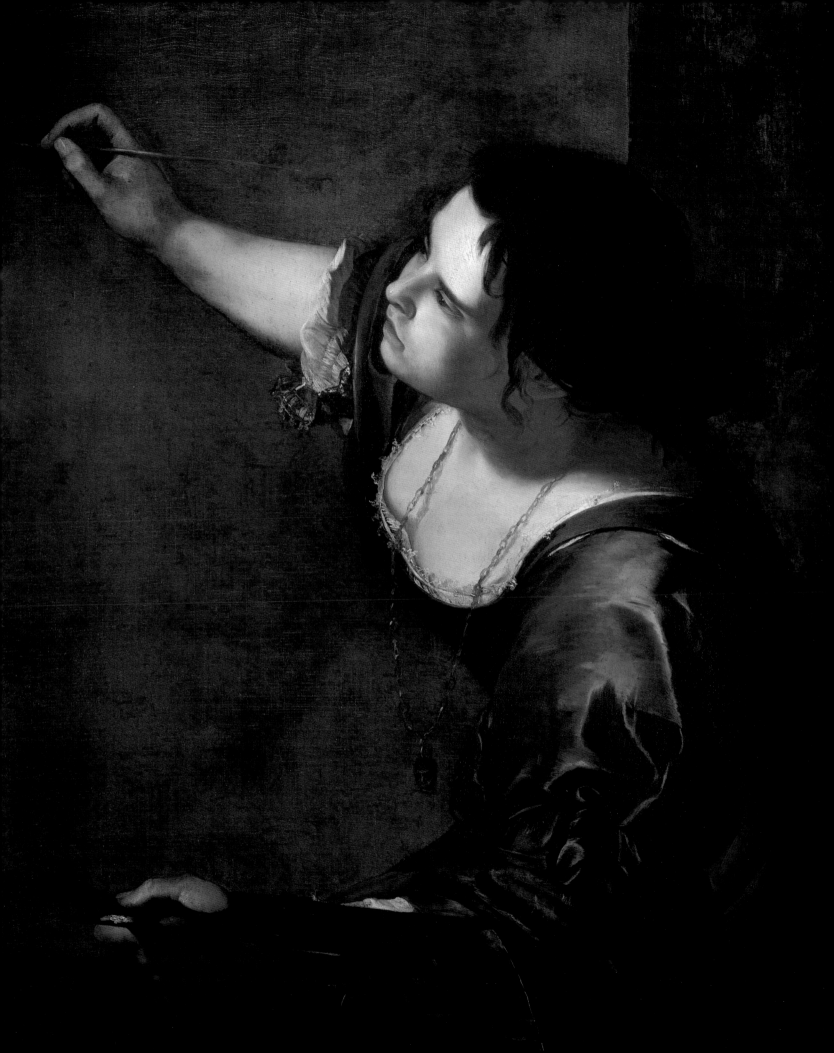

Gentileschi Self-Portrait as La Pittura c.1630

• theoretically impossible self-portraits in which the artist, by representing herself in the act of guiding her own brushstrokes, denies herself the reflected view of this activity. In Artemisia Gentileschi's *Self-Portrait* it is difficult to work out where, if anywhere, the mirror would have been in which she could have seen herself thus engaged, since the viewpoint from which she represents herself is enigmatically contradicted by the direction in which she seems to be looking

• self-portraits in which the reflection is explicitly represented. In Parmigianino's *Self-Portrait* in the Kunsthistorisches Museum, Vienna, the frame of the picture coincides with that of the mirror and were it not for the anamorphic distortion of the foreground hand, the presence of the mirror would be undetectable. In any case there is no other indication that the artist was his own model

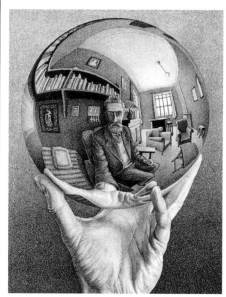

Escher Hand with Reflecting Sphere 1935

3

Artemisia Gentileschi (**1**) has represented herself in a position from which she would have been denied the view of her own reflection. How could she have seen herself while thus engaged? The mirror in which Parmigianino is looking at himself is not merely *included* in the painting (**2**), it is coextensive with it. The reason we know that the mirror is actually represented in or at least by the painting is that there is no other way of explaining the deformed flipper that appears in the foreground. Escher (**3**), who was presumably well aware of his youthful predecessor, introduces a second order of pictorial paradox by representing his undistorted hand holding up the disfiguring globe. But the hand with which he holds the globe is the opposite to the one which is reflected in the globe. So whose hand is it?

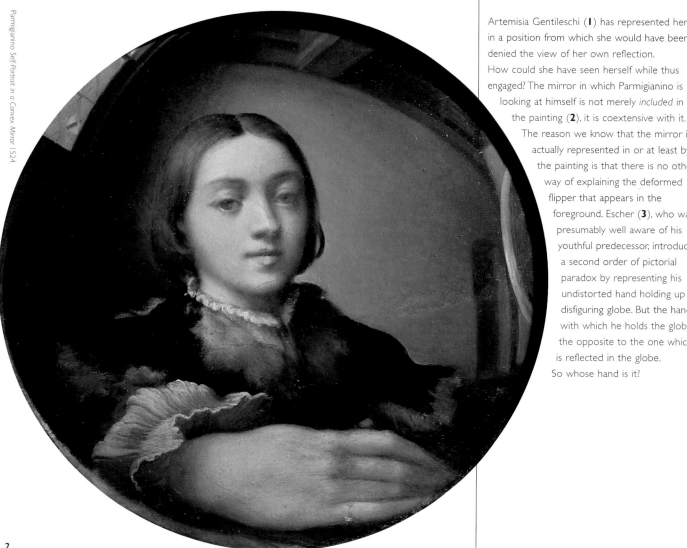

Parmigianino Self-Portrait in a Convex Mirror 1524

In other examples the mirror is unambiguously represented within the pictorial space, with or without evidence of manual activity. In each of these groups there is an unavoidable element of fiction because in contrast to paintings in which the artist is representing something other than himself, self-portraiture, as with any painting from the life, involves two activities, each of which precludes or at least compromises the representation of the other. At the moment when he is putting the paint on to the canvas, the artist is unable to study the reflection of his doing so. Conversely, in order to study his own appearance the artist must suspend the act of painting.

Although both of Lucian Freud's paintings (**1**, **2**) are literally speaking self-portraits, in that the artist is recognisably present in each of them, there is a sense in which they are paintings of mirrors which happen to include the artist.

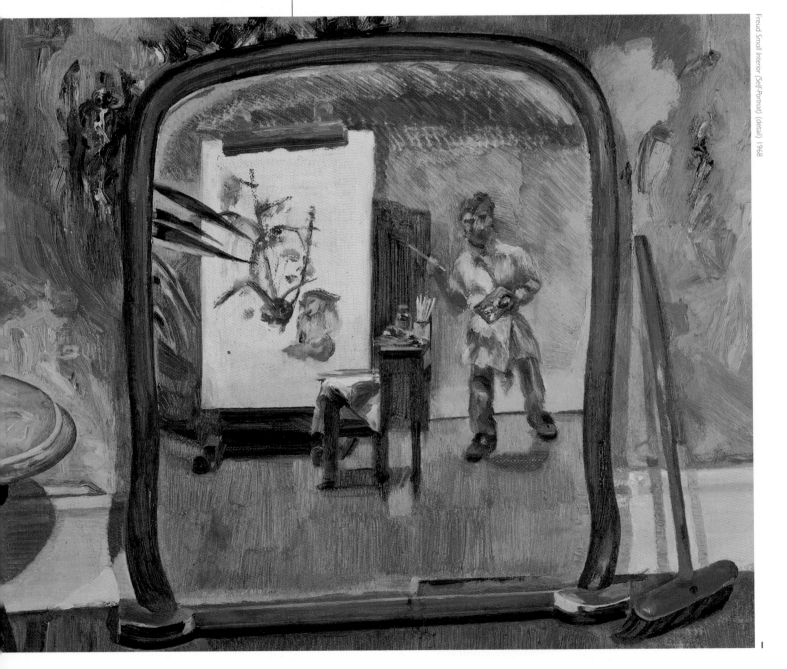

Freud Small Interior (Self-Portrait) (detail) 1968

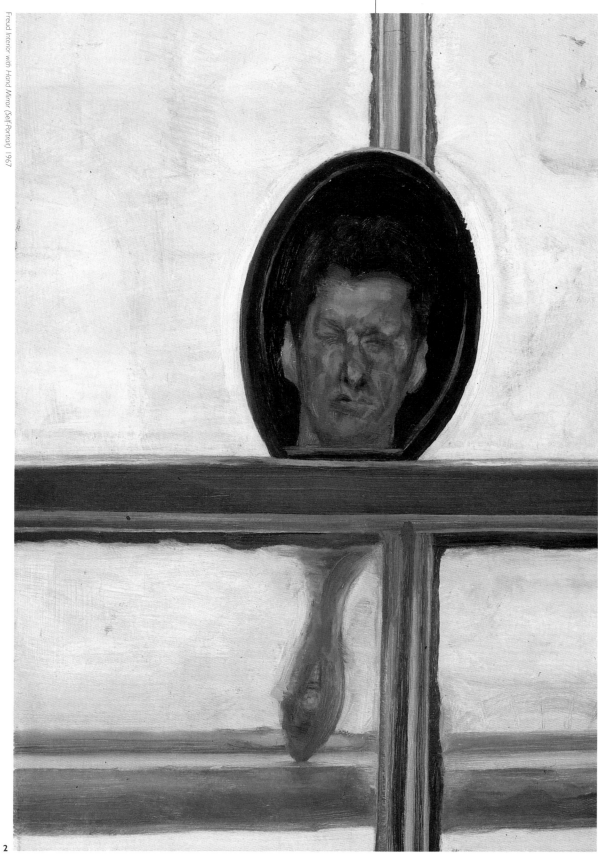

• self-portraits occasionally appear as incidental features of a painting devoted to another subject altogether. It's almost as if the artist allows himself a guest appearance in one of his own creations.

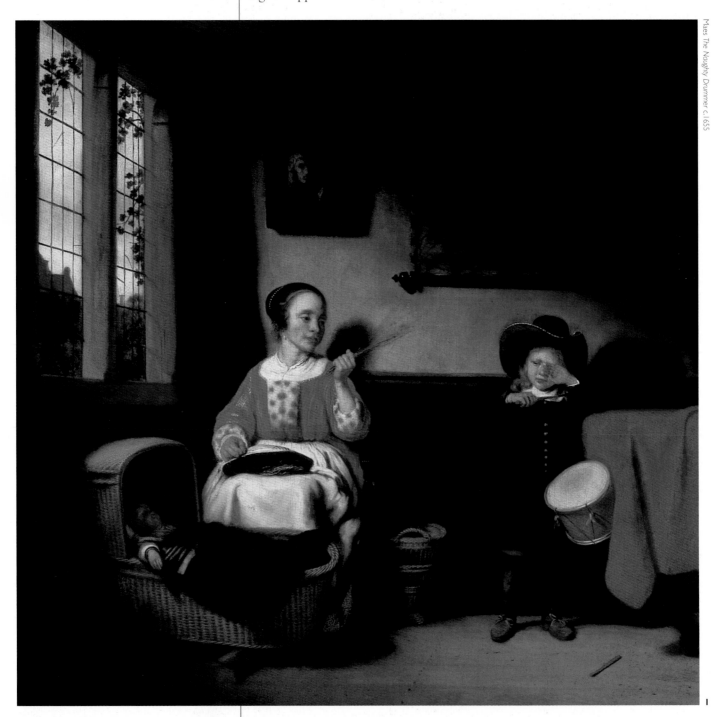

Maes *The Naughty Drummer* c.1655

1

Friedrich *View of the Artist's Studio, Right Window* (detail) 1805–6

In each of these examples (**1**, **2**, **3**, **4**) the artist portrays himself as a barely perceptible Alfred Hitchcock.

Maes *The Naughty Drummer* (detail) c.1655

3

Van Beyeren *Banquet Piece* (details) c.1675

2

4

Someone else

From the examples I have just cited an interesting fact begins to emerge: that although the meaning or *sense* of the term 'self-portrait' is easy enough to grasp, its range of *reference* cannot be established on the basis of particular appearances. In other words, a portrait which happens to be one in which the artist and the subject are the same person cannot be identified as such just from the way it looks. It requires *non*-pictorial evidence to distinguish it from a portrait done by someone else.

Without the inscription with which Dürer subsequently identified his 1484 drawing as 'his own likeness fashioned by himself', we might, from its appearance, confuse it with a portrait done by someone other than the boy seated in the picture. In fact, judging by the viewpoint from which he is represented, not to mention the direction of his gaze, it is difficult to

The viewpoint from which the youthful Dürer represents himself in this portrait (**1**) appears inconsistent with the claim that it was done 'out of a mirror', since his gaze is directed away from the one which would have reflected this profile. There are two possible solutions to this puzzle. If the portrait was drawn with the aid of *one* mirror, which he could have seen only by looking sideways, he must have corrected his eyeline once the drawing was completed. Alternatively, he could have used *two* mirrors. If there was one mirror somewhere ahead of him, as his pointing finger seems to indicate, it would have reflected the image to be seen in another mirror which would have reflected the profile as represented in the portrait. Even so, the way in which Dürer represents his own hands appears to belie the claim that the artist was his own model.

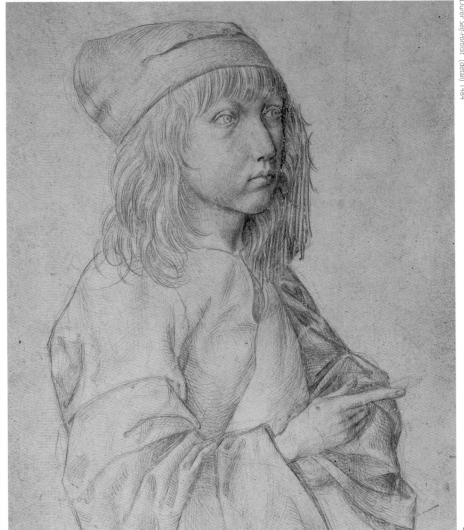

Dürer *Self-Portrait* (detail) 1484

1

understand how it *could* have been done by the boy in the picture. The same applies to the 1500 Munich *Self-Portrait*, although in contrast to the earlier drawing, the direction of the subject's gaze is at least *consistent* with the position of a mirror in which he might have seen himself represented. But the *pictorial* evidence in favour of its being a self-portrait is equivocal – and as with the equally frontal portrait of and by Stanley Spencer, there is nothing in the picture itself from which we could tell that the artist was his own model.

Even in those examples where the subject is portrayed with brush and palette in hand, sparing a sidelong glance from what seems to be a canvas edging into the frame, the fact that it looks like, and presumably is, the portrait of a painter, does not mean that it was done by the painter who is portrayed. It would look just the same if whoever it was a portrait *of* had posed like that for *another* painter. But that, in a sense, is exactly what a

Price (The New Yorker) *Mirror* 1953

3

When an artist portrays himself by consulting his own reflection (**2**), he does so on the understanding that he is confronting himself and no one else. And yet as the cartoon (**3**) suggests, it is difficult to avoid the suspicion that this reflected partner might be a subversive competitor.

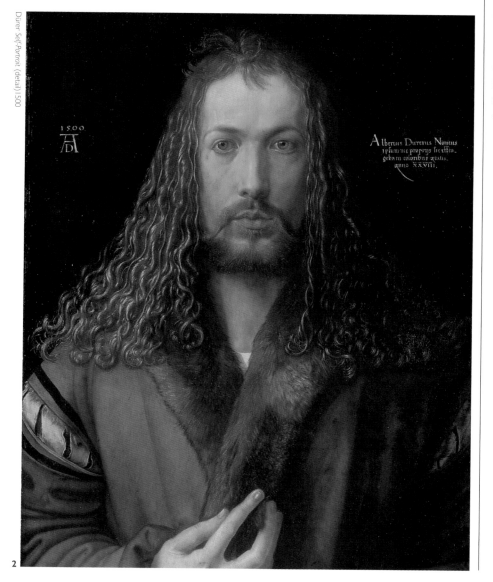

Dürer *Self-Portrait* (detail) 1500

2

When we see ourselves in more than one mirror at the same time we take it for granted that each one will reflect us from a slightly different *angle*. What we don't expect is that each mirror will disclose a different *moment* of our existence.

Bratby *Three Self-Portraits with a White Wall* 1957

1

self-portrait is. With the aid of a mirror, the artist has taken the opportunity of seeing and representing himself as if he *were* someone else, so it is hardly surprising that the resulting portrait is visually indistinguishable from one *actually* done by someone else.

As far as the artist is concerned, the experience of studying his own appearance *as if* it were that of someone else is somewhat different from studying the appearance of someone who really *is* someone else. Apart from the practical awkwardness of alternating between passive model and active painter, there is the sheer oddness of seeing himself from another person's viewpoint. The chances are that he is too preoccupied with the technical problems of rendering a likeness of what he sees in the mirror to be distracted by existential doubts as to its identity. Still, unless he was stupified by narcissism, or, like Narcissus, stupid enough to believe that he was looking at someone else, no one could spend that much time in front of a mirror without occasionally asking himself who was looking at who.

The obvious answer – that he is looking at himself – is not altogether satisfactory, because although the identity of our own mirror image is irreversibly established in early infancy, and in subsequent encounters we recognise it as our own with the same unquestioning ease with which we reindentify anyone else, the knowledge that it *isn't* just anyone else leads to the occasionally disconcerting conclusion that we are paired for life with an intermittently visible counterpart of the person or individual we know or feel ourselves to be. What makes this so disquieting is the admittedly improbable idea that this identical twin might have an autonomous existence, and that although its behaviour is obediently synchronised with our own as long as it is under direct supervision, there is the lurking suspicion that it might have an undisclosed agenda to be energetically and perhaps nefariously pursued as soon as its proprietor's back is turned.

There are unintended intimations of this to be seen in almost any painting or photograph in which the person portrayed is near to but facing away from the mirror that reflects them. Although there is a perfectly natural explanation for the averted posture of such a disregarded mirror image – it is bound for *optical* reasons to turn in the opposite direction to the person it reflects – the observer of the scene sometimes gets the impression of witnessing a moment of alienation, in which the reflected double uncannily assumes interests of its own off-stage.

One of the earliest examples of what I am describing is to be seen in Savoldo's *Portrait of a Man*, mentioned earlier. While the young warrior gazes out front, his shadowy reflection turns towards the back of the room, apparently preoccupied with something we cannot see or know. This cannot be

2

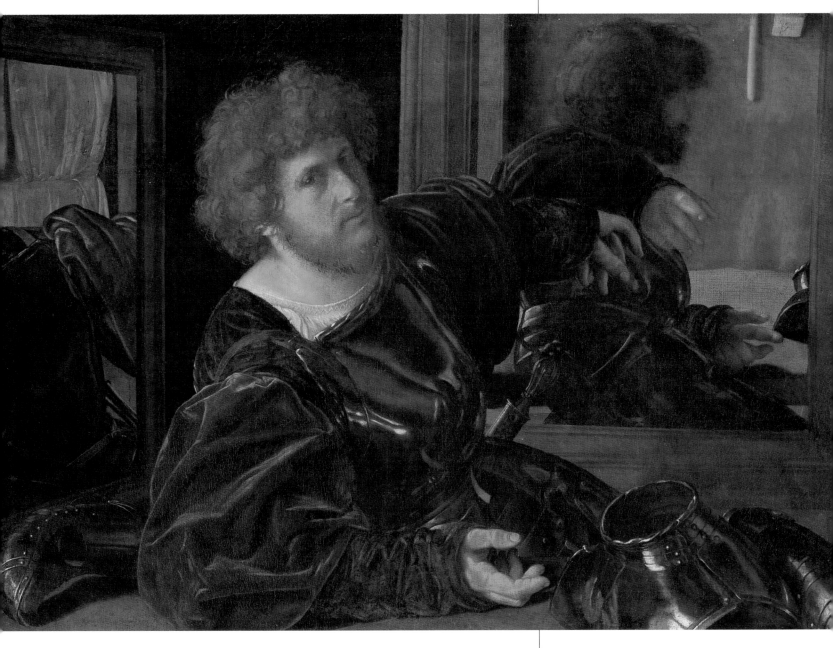

what Savoldo intended, but to the modern observer, conditioned by some of the supernatural themes in Romantic literature, not to mention more recent interest in multiple personalities, it is difficult to escape the feelings I have described, just as it is in Ingres's portrait of *Madame Moitessier* in the National Gallery, London. For Ingres, the large mirror was a scenic device which alluringly deepened the pictorial space – and the reflected profile is incidental to that effect. But the presence of this ghostly bust, so conspicuously gazing elsewhere, suggests the existence of an alternative personality whose interests are at an angle to those of the woman who confronts us. The frequency with which the Victorian photographer Clementina Hawarden reiterates and varies

The composition of Savoldo's picture suggests that the young courtier is trying to detach himself from his reflected twin.

Ingres *Madame Moitessier* 1856

the motif of young women duplicated by their disregarded reflections suggests that the notion of a second self might have been lurking somewhere in her imagination – though not, it would seem, with any sinister connotations. As with the Whistler portrait of *The Little White Girl*, the duplication could have been a purely decorative device, comparable to the use of *geometrical* reflection in ornamental art.

For obvious reasons it is in literature rather than in visual art that the theme of the subversive 'double' or doppelgänger is explicitly developed, although it is not necessarily expressed there in terms of reflection.

In contrast to Lewis Carroll who artfully ignores the alternative person that Alice would have encountered at the interface between her room and the one on the other side of the mirror, Whistler (**1**) is preoccupied by this melancholy prisoner of the looking-glass world. Like the heroine of a ghost story by Henry James, the young woman in white is haunted by the phantom of her second self.

Whistler *The Little White Girl: Symphony in White No 2* (detail) 1864

For example, in Oscar Wilde's *The Picture of Dorian Gray* (1891), it is a hidden *portrait* which secretly unfolds the corrupt character of the apparently blameless man; and in Robert Louis Stevenson's novel (1886), the vicious Mr Hyde is just as real as the virtuous Dr Jekyll with whom he alternates.

One of the most vivid examples of a mirror image which takes on a life of its own occurs in the story of 'The Student of Prague', unforgettably realised in Conrad Veidt's 1929 film version. Baldwin, an impoverished student, falls in love with an unattainably rich countess and enters into a pact with the devil who promises to furnish him with limitless funds in exchange for whatever he, the devil, might care to take from the student's lodgings. Baldwin agrees to the deal – at which point the disguised mischief-maker leads him to a full-length mirror and summons his reflection to step through the glass. The duplicate, now liberated from the synchrony by which Baldwin as a child would have identified it as his own image, departs and begins to enjoy an independent existence perpetrating misdeeds for which the real Baldwin is understandably blamed. In a frenzy of guilty despair, Baldwin returns to his apartment, fires a pistol at the vacant mirror and is briefly relieved to discover that his absconded reflection has magically reappeared in the shattered glass. But in doing away with his delinquent double, Baldwin turns out to have fatally injured himself and he perishes among the broken shards of his dying mirror image.

The idea of committing suicide by destroying one's own reflection is a supernatural fiction, but recent research has shown that it has a natural counterpart in clinical reality, and that under certain circumstances the experience of seeing the reflection of one's own body can exert a dramatic and irresistible influence on its feelings.

Taylor (The New Yorker) Alone 1955

"Tremaine, could I see you for a moment—alone?"

For more than one hundred years, neurologists have reported and discussed the so-called 'phantom' limb – the paradoxical and often painful sensation which follows the loss of an arm or a leg. Patients who have suffered such mutilations as the result of either trauma or surgery usually complain that they can still feel the missing limb, sometimes so vividly that they may try to use it 'to fend off a blow, wave goodbye, break a fall or even to shake hands'. In other cases the missing part is felt to be painfully frozen in one position and no amount of voluntary effort – whatever *that* means – can relieve the muscular 'spasm'. Following the amputation of an arm, some patients complain that they feel the missing hand tightly clenched with the nails digging into the flesh of a non-existent palm.

The neuro-psychologist V.S.Ramachandran recently conducted a series of experiments designed to show the influence of *vision* on these peculiar bodily sensations. He constructed what he calls a 'virtual reality box', symmetrically divided into right and left corridors by a vertical partition, one side of which was mirrored. The patient placed the intact arm along the corridor on to which the mirror faced. Meanwhile he brought the amputated stump as near as he could to the entrance of the adjacent corridor. In a preliminary experiment the patient had to close his eyes and was then asked to make symmetrical movements with both hands – that is, with the good hand *and* with its phantom partner. Under these conditions, the patient predictably reported that while he could feel the movements of his intact hand, the phantom remained motionless, 'frozen as if in a cement block'. But as soon as he was allowed to look at the reflected movements of his intact hand, the experience gave rise to corresponding feelings of movement in the phantom.

In some cases, a phantom which had remained painfully motionless for years suddenly mobilised itself. As one patient exclaimed: 'All these years I have often tried to move my phantom several times a day without success, but now I feel I am moving my arm.'

Under normal circumstances we do not require *visual* evidence to convince ourselves that we have moved one of our own limbs. I can tell that I am raising my arm, not because I see it going up but because it's an *action* of mine. It's not something that *happens* to my arm, it's something I *do* with it, and I can do it with my eyes closed. In Ramachandran's experiment, the patient, having lost the arm, can't even *try* to move it, at least not in the ordinary sense of the word. And yet, on seeing the movement of what *looks* like the missing arm, he feels himself to be the author of its non-existent movements.

Apart from the vexed problem of how this anomalous reaction might be implemented, it raises perplexing questions about the logic of representation.

Even to an external observer the reflection of the patient's intact hand gives the uncanny impression that the missing limb has been resurrected, notwithstanding the enigmatic gap that separates it from the amputated stump. But for the patient, who can feel the missing limb in addition to seeing its reflected counterpart, the experience of seeming to see it move gives the irresistible sense of it doing so.

Ramachandran *Mirror synaesthesia* 1995

2

Because the sense in which the reflection could be said to represent a limb which *isn't* there is unarguably different from the more typical sense in which it represents one which *is*. In the latter case the representation is, as we say, *veridical*: its appearance is systematically determined by the presence of the real limb lying just in front of the mirror.

The question then is this: How can a reflection, which the patient recognises to be that of his *intact* limb, represent the missing one sufficiently to excite sensations of movement in its 'phantom'?

One answer might be that the *reflection* as such is irrelevant, and that it's the sight of the intact limb itself on the move that excites sympathetic sensations in its phantom partner. But no. The experiment shows that it's only by looking at the *reflected* movement that the patient can succeed in 'mobilising' his non-existent arm — in which case there must be something distinctive about the mirror image of one arm which lends it the capacity to represent the arm of which it is *not* in fact the reflection.

The solution to this paradox turns out to be quite simple. Since the human body is bilaterally symmetrical — which is another way of saying that the left half is the mirror image of the right — the *optical* reflection of one limb is geometrically identical to its opposite partner. So that in looking at the reflection of his intact arm — at what we have agreed to call its veridical representation — the patient inevitably gets the impression of looking at what, if he still had it, would be the other one.

The fact that the patient could be provoked into feeling the movements of a non-existent arm by seeing the reflected actions of a real one suggests that at some level at least he was fooled into thinking that his missing arm had been resurrected. And yet unlike the bewildered cat with which I introduced this essay, Ramachandran's patient was fully conscious of the fact that he was looking at a reflection. In other words, although he *reacted* to the duplicate as if it were something actual, he consciously recognised it as a mere representation. Not only that, he recognised it as a representation of the intact limb.

It's significant that it was a mirror that brought about this conflict between the virtual and the actual. In contrast to the conventional systems of representation — pictures, diagrams, maps and models — the fidelity with which reflections reproduce the appearance of what we take them to be representations of, is so great that the mirror is almost universally regarded as the epitome of representation. This is why the mirror has been so frequently invoked in describing the perceptual relationship between the mind and nature. Thus the English philosopher John Locke, who established the stereotype for the popular view of the mind in the eighteenth century,

insisted that the human understanding was the passive recipient of physical sensations which it can 'no more refuse to have, nor alter when they are imprinted, nor block them out and make new ones itself, than a mirror can refuse, alter, or obliterate the images or ideas which the objects set before it do therein produce'.

The persuasiveness of this metaphor is related to another, somewhat subtler, property of mirrors which I have already discussed. It is this. In addition to the fact that it so faithfully reproduces the appearance of whatever it reflects, there is nothing to be seen in a mirror *apart* from what it reflects. Unlike a painting, which requires the observer to take note of the marked surface in which the representation is realised, the surface of an ideal mirror is completely invisible so that it is impossible to detect the medium which supports its imagery. And in that negative respect, the mind could be said to represent the world just as the mirror does. The Scottish philosopher David Hume, for example, insisted that 'nothing appears requisite to support the existence of a perception'. Now although Hume does not, like Locke, explicitly invoke the mirror, the way in which he describes the contents of his own mind is remarkably similar to the way in which I have described the experience of reflection: 'for my part, when I enter most intimately into what I call *myself*, I always stumble upon some particular perception or other … I can never catch *myself* at any time without a perception and can never observe anything but the perception'.

In contrast to perceptions, which don't visibly occur in anything, reflections appear in, and are visibly supported by, a surface to which they lend a recognisable lustre. But when we crop the picture progressively so that we lose the evidence in favour of it being a reflection, the imagery is recognisably supported by a visible medium.

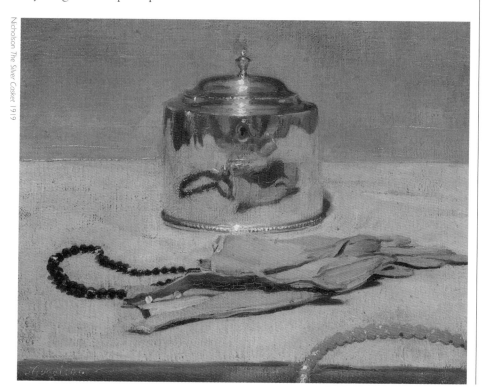

Nicholson *The Silver Casket* 1919

Although there are undeniable parallels to be drawn between perceptions and reflections – both of them bear a veridical relationship to what they represent or stand for – it would be dangerous to overlook their fundamental differences. One difference is that whereas reflections are something *at* which we can look, distinguishable from something *other* than a reflection *at* which we can also look, perceptions are not something we look *at*. We simply *have* them. And when we have them, we do not, as we do with mirrors, look *at* something in which they occur. When I look at the houses on the opposite side of the road I am not aware of seeing them *in* anything, as I

Miller *Untitled* 1998

am when I see their reflections in a mirror. I just see them. In contrast to a mirror whose imagery I can readily compare with whatever it happens to be the imagery *of*, there is no way in which I can compare my perception of the houses opposite with their *un*perceived appearance. Which means that I have to take their representational character on trust. Why should I do so? One reason is that although I cannot directly compare my perceptions with whatever I take them to be perceptions *of*, I can navigate by them so successfully that they must be causally related to the structure of the external world. In other words they are, like reflections, veridical representations.

But this does not mean that the way in which perceptions represent the world is identical to or even comparable with the way in which optical reflections do. Admittedly the image which is *projected* on to the retina resembles the world in much the same way as the image reflected in a mirror. But we don't perceive the world by looking at the retinal image of it. In fact, in contrast to a mirror, the visibility of whose imagery presupposes the existence of a spectator, there is no such thing as the visibility of a perception, let alone a spectator to whom it is visible. What we see is what perceptions represent, mirrors and their reflections included.

Works in the Exhibition

ROOM ONE
In, at, through

GAERTNER, Eduard (1801–1877)
The Friedrichsgracht, Berlin, probably 1830s
Oil on paper laid down on millboard,
25.5 × 44.6 cm
London, National Gallery

STEVENS, Alfred (1823–1906)
'La Parisienne japonaise', c.1872
Oil on canvas, 150 × 105 cm
Liège, Musée d'Art moderne et d'Art
contemporain

BEDOLI, Gerolamo (c.1505–c.1569/70)
Portrait of Anna Eleonora Sanvitale, 1562
Oil on canvas, 121.5 × 92.2 cm
Parma, Galleria Nazionale

VELAZQUEZ, Diego (1599–1660)
*Kitchen Scene with Christ in the House of Martha
and Mary*, probably 1618
Oil on canvas, 60 × 103.5 cm
London, National Gallery

PARMIGIANINO (1503–1540)
The Mystic Marriage of Saint Catherine, c.1527–31
Oil on wood, 74.2 × 57.2 cm
London, National Gallery

HOOGSTRATEN, Samuel van (1627–1678)
*A Peepshow with Views of the Interior of a Dutch
House*, c.1655–60
Oil and egg on wood, 58 × 88 × 60.5 cm
London, National Gallery

METSU, Gabriel (1629–1667)
Woman reading a Letter, c.1663
Oil on wood, 52.5 × 40.2 cm
Dublin, National Gallery of Ireland

DAHL, Johan-Christian (1788–1857)
View of Pillnitz through a Window, 1823
Oil on canvas, 70 × 45.5 cm
Essen, Museum Folkwang

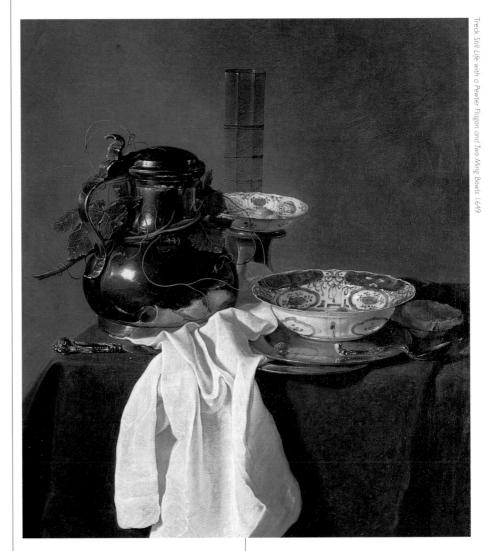

Treck Still Life with a Pewter Flagon and Two Ming Bowls 1649

ROOM TWO
The gleam in the eye

DELFT SCHOOL
An Interior, with a Woman refusing a Glass of Wine,
probably 1660–5
Oil on canvas, 117 × 92 cm
London, National Gallery

KALF, Willem (1619–1693)
*Still Life with the Drinking-Horn of the Saint
Sebastian Archers' Guild, Lobster and Glasses*,
c.1653
Oil on canvas, 86.4 × 102.2 cm
London, National Gallery

WALSCAPPELLE, Jacob van (1644–1727)
Flowers in a Glass Vase, c.1670
Oil on canvas, stuck on oak, 59.8 × 47.5 cm
London, National Gallery

TURNER, Joseph Mallord William (1775–1851)
*Reflections and Refractions in Two Transparent
Globes, One Half-filled with Water*, lecture diagram,
c.1810
Watercolour on paper, 22.4 × 40 cm
London, Tate Gallery (bequeathed by the
artist, 1856)

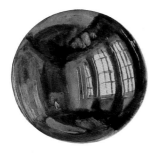

TURNER, Joseph Mallord William (1775–1851)
Reflections in a Single Polished Metal Globe and in a Pair of Polished Metal Globes, lecture diagram, c.1810. Oil and pencil on paper, 64 × 96.8 cm
London, Tate Gallery (bequeathed by the artist,1856)

TRECK, Jan Jansz. (1605/6–1652)
Still Life with a Pewter Flagon and Two Ming Bowls, 1649
Oil on canvas, 76.5 × 63.8 cm
London, National Gallery

UNKNOWN ARTIST
Anamorphosis of a Ship Model with Cone Mirror, c.1770
Oil on wood, 62 × 53 cm
London, Science Museum (by courtesy of the Board of Trustees)

NICHOLSON, Sir William (1872–1949)
The Silver Casket, 1919
Oil on canvas, 32.5 × 41 cm
Private Collection

MELENDEZ, Luis (1716–1780)
Still Life with Oranges and Walnuts, 1772
Oil on canvas, 61 × 81.3 cm
London, National Gallery

ROOM THREE
Virtual surfaces

EYCK, Jan van (active 1422; died 1441)
The Arnolfini Portrait, 1434
Oil on oak, 81.8 × 59.7 cm
London, National Gallery

HEYDEN, Jan van der (1637–1712)
View of the Westerkerk, Amsterdam, probably 1660
Oil on oak, 90.7 × 114.5 cm
London, National Gallery

HUMMEL, Johann Erdmann (1769–1852)
The Granite Bowl in the Lustgarten, Berlin, 1831
Oil on canvas, 66 × 89 cm
Berlin, Neue Nationalgalerie

HUMMEL, Johann Erdmann (1769–1852)
The Polishing of the Granite Bowl, 1831
Oil on paper, 46 × 75 cm
Berlin, Neue Nationalgalerie

BURNE-JONES, Sir Edward (1833–1898)
*Study for 'The Mirror of Venus',*1867–77
Oil on canvas, 76.2 × 119.4 cm
Collection of Lord Lloyd-Webber

VALLOTTON, Félix (1865–1925)
Landscape in Provence – The Window, 1920
Oil on canvas, 81 × 60 cm
Switzerland, Private Collection

ROOM FOUR
Self-recognition

REYNOLDS, Sir Joshua (1723–1792)
Self-Portrait, c.1747
Oil on canvas, 63.5 × 74.3 cm
London, National Portrait Gallery

ORPEN, Sir William (1878–1931)
Ready to Start – Self-Portrait, 1917
Oil on panel, 60.9 × 50.8 cm
London, Imperial War Museum

FREUD, Lucian (born 1922)
Small Interior (Self-Portrait), 1968
Oil on canvas, 22.2 × 26.7 cm
Private Collection

FREUD, Lucian (born 1922)
Interior with Hand Mirror (Self-Portrait), 1967
Oil on canvas, 25.5 × 17.8 cm
Private Collection

BRATBY, John (1928–1992)
Three Self-Portraits with a White Wall, 1957
Oil on hardboard, 241.9 × 169.9 cm
Board of Trustees of the National Museums and Galleries on Merseyside (Walker Art Gallery)

CONROY, Stephen (born 1964)
Self-Portrait, 1987
Oil on canvas, 102 × 46 cm
Private Collection

Follower of LEONARDO da Vinci
Narcissus, c.1490–9
Oil on wood, painted surface 23.2 × 26.4 cm
London, National Gallery

ROMNEY, George (1734–1802)
Mrs Russell and Child, 1786–7
Oil on canvas, 146 × 113 cm
Private Collection

UTAMARO, Kitagawa (1753–1806)
The Priest Huiyuan from 'Three Laughters at Children's Playful Spirits', c.1802
Colour woodblock, 37.9 × 25.2 cm
London, Trustees of the British Museum

MASTER OF SAINT VERONICA
Saint Veronica with the Sudarium, c.1420
Oil on walnut, 44.2 × 33.7 cm
London, National Gallery

Utamaro The Priest Huiyuan c.1802

ROOM FIVE
Self-regard

KRØYER, Peder Severin (1851–1909)
Interior. The Artist's Wife, 1889
Oil on wood, 35.2 × 24.8 cm
Copenhagen, The Hirschsprung Collection

ECKERSBERG, Christoffer Wilhelm (1783–1853)
Woman standing in front of a Mirror, 1841
Oil on canvas, 33.5 × 26 cm
Copenhagen, The Hirschsprung Collection

BROCKHURST, Gerald (1890–1978)
Adolescence, 1932
Etching on paper, 36.5 × 26.5 cm
London, Trustees of the British Museum

REMBRANDT (1606–1669)
A Woman bathing in a Stream (Hendrickje Stoffels?), 1654
Oil on oak, 61.8 × 47 cm
London, National Gallery

VELAZQUEZ, Diego (1599–1660)
The Toilet of Venus ('The Rokeby Venus'), 1647–51
Oil on canvas, 122.5 × 177 cm
London, National Gallery

FONTAINEBLEAU SCHOOL
Woman at her Toilet, c.1560
Oil on canvas, 105 × 76 cm
Dijon, Musée des Beaux-Arts

MATHAM, Jacob (1571–1631)
Pride from 'The Vices' (after Goltzius), 17th century. Engraving, 22 × 14.1 cm
London, Trustees of the British Museum

BORDONE, Paris (1500–1571)
Venetian Women at their Toilet, mid-1540s
Oil on canvas, 97 × 141 cm
Edinburgh, National Galleries of Scotland

ROWLANDSON, Thomas (1756/7–1827)
The Curious Wanton, c.1810–20
Etching on paper, 17 × 11 cm
London, Trustees of the British Museum

GHEYN III, Jacob de (c.1596–1641)
A Woman with a Mirror at a Toilet-Table (Vanity), early 17th century
Engraving on paper, 27.6 × 18.5 cm
London, Trustees of the British Museum

FALCK, Jeremias (c.1610–1677)
Old Woman at her Toilet (after Johan Liss), 17th century
Engraving on paper, 37.5 × 30.4 cm
London, Trustees of the British Museum

ITALIAN SCHOOL
Allegory of Vanity – Death surprising a Woman, 16th century
Engraving on paper, 35.5 × 26.3 cm
London, Trustees of the British Museum

DÜRER, Albrecht (1471–1528)
Allegory of Youth, Age and Death (mounted with *Two Women and a Man making Music*), c.1520–1
Pen and brown ink on paper, 18.7 × 9.9 cm (18.6 × 9.8 cm)
London, Trustees of the British Museum

CHADWICK, Helen (1953–1996)
Vanity, 1986
Cibachrome photograph on paper, 59.7 × 59.7 cm
Birmingham Museums and Art Gallery

After CARAVAGGIO
Martha reproving Mary Magdalen for her Vanity, early 17th century
Oil on canvas, 97.7 × 135.8 cm
Oxford, Christ Church (by permission of the Governing Body)

UNKNOWN FRENCH ARTIST
Allegory of Justice and Vanity (?), c.1630
Oil on canvas, 101 × 82 cm
Oxford, The Visitors of the Ashmolean Museum

Studio of José de RIBERA
A Man with a Mirror, 17th century
Oil on canvas, 113 × 87.5 cm
London, Derek Johns Ltd

VOUET, Simon (1590–1649)
Allegory of Prudence, c.1645
Oil on canvas, 116 × 90 cm
Montpellier, Musée Fabre

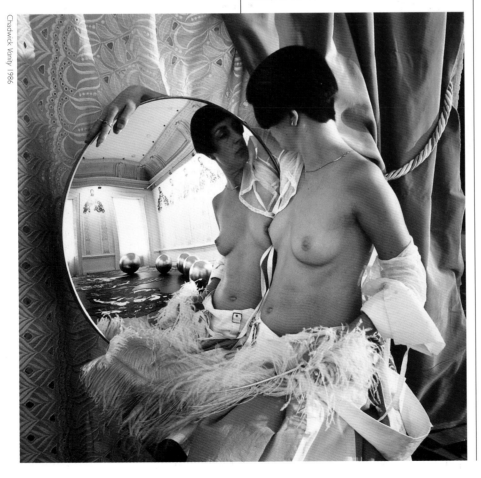

Chadwick Vanity 1986

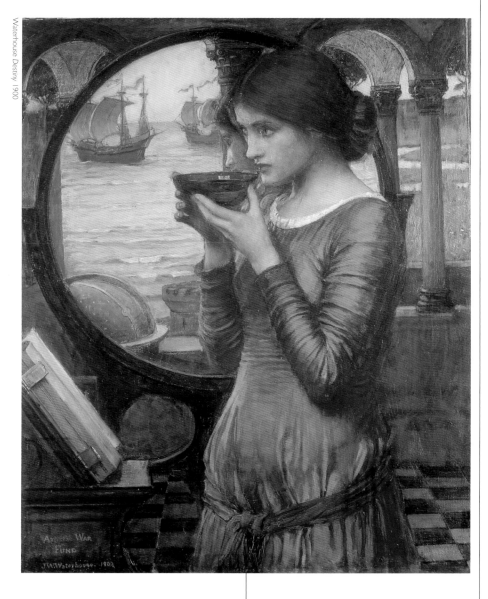

Waterhouse *Destiny* 1900

ROOM SIX
Another point of view

Attributed to MAN, Cornelis de (1621–1706)
The Card Players, 17th century
Oil on canvas, stuck on panel, 43.2 × 33 cm
Polesden Lacey, The McEwan Collection (The
National Trust)

INGRES, Jean-Auguste-Dominique (1780–1867)
Madame Moitessier, 1856
Oil on canvas, 120 × 92.1 cm
London, National Gallery

UNKNOWN ARTIST
Reflections in a Mirror, mid-19th century
Oil on canvas, 41.5 × 38.5 cm
St Petersburg, The State Russian Museum

CAILLEBOTTE, Gustave (1848–1894)
In a Café, 1880
Oil on canvas, 155 × 115 cm
Rouen, Musée des Beaux-Arts

MATISSE, Henri (1869–1954)
The Painting Lesson, 1919
Oil on canvas, 73.4 × 92.2 cm
Edinburgh, Scottish National Gallery of
Modern Art

BERMEJO, Bartolomé (documented 1468–1495)
*Saint Michael triumphant over the Devil with the
Donor Antonio Juan*, c.1468
Oil and gold on wood, 179.7 × 81.9 cm
London, National Gallery

WATERHOUSE, John William (1849–1917)
Destiny, 1900
Oil on canvas, 68.5 × 55 cm
Burnley, Towneley Hall Art Gallery and Museums,
Burnley Borough Council

HUNT, William Holman (1827–1910)
The Lady of Shalott, c.1886–1905
Oil on wood, 44.4 × 34.1 cm
Manchester City Art Galleries

WHISTLER, James Abbott McNeill (1834–1903)
The Little White Girl; Symphony in White, No. 2,
1864
Oil on canvas, 76.5 × 51.1 cm
London, Tate Gallery (bequeathed by Arthur
Studd, 1919)

Select bibliography

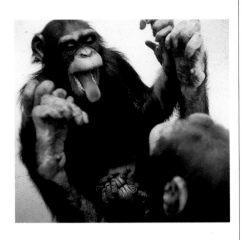

BALTHRUSAITIS, J., Anamorphic Art, Cambridge
1976.

BARON-COHEN, S., TAGER-FLUSBERG, H. and
COHEN, D.J. (eds) Understanding Other Minds:
Perspectives from Autism, Oxford 1993.

BENNETT, J., 'The Difference between Right and
Left', American Philosophical Quarterly, VII (3)
1970, pp. 175–91.

BERMUDEZ, J.L., MARCEL, A. and EILAN, N.,
The Body and the Self, Massachusetts 1995.

BIALOSTOSKI, J., 'The Eye and the Window.
Realism and Symbolism of Reflections in the Art
of Albrecht Dürer and his Predecessors', in
J. Bialostoski, The Message of Images, Vienna 1988.

BIALOSTOSKI, J., 'Man and Mirror in Painting:
Reality and Transience', in J. Bialostoski,
The Message of Images, Vienna 1988.

BLOCK, N.J., 'Why do Mirrors Reverse Right/Left
but not Up/Down?', Journal of Philosophy, LXXI,
1974.

BODEN, M. Artificial Intelligence and Natural Man,
London 1987.

BUTTERWORTH, G.E., 'The Ontogeny and
Philogeny of Joint Visual Attention', in A. Whiten
(ed.) Natural Theories of Mind, Oxford 1991.

BUTTERWORTH, G.E., 'Self-Perception as a
Foundation for Self-Knowledge',
Psychological Inquiry, 3(2), 1992, pp. 134–6.

BUTTERWORTH, G.E., 'Origins of Mind in
Perception and Action', in C. Moore and P. J.
Dunham (eds) Joint Attention, its Origins and Role
in Development, Hillsdale, N.J. 1995.

CARROLL, L., Alice's Adventures in Wonderland,
London 1865.

CARROLL, L., Through the Looking Glass and
What Alice Found There, London 1871.

CHENEY, D. and SEYFARTH, R., How Monkeys
See the World, Chicago 1990.

DAWKINS, R., Climbing Mount Improbable,
London 1996.

GALLUP, G.G. Jnr, 'Self-Recognition: Research
Strategies and Experimental Design', in S.T.
Parker, R.W. Mitchell and M.L. Boccha (eds),
Self-Awareness in Animals and Humans:
Developmental Perspectives, Cambridge 1994.

GIBSON, J.J., The Senses Considered as Perceptual
Systems, Boston 1966.

GIBSON, J.J., 'A Note on What Exists at the
Ecological Level of Reality', in E. Reed and R.
Jones (eds) Reasons for Realism: Selected Essays
of J. J. Gibson, Hillsdale, N.J. 1987.

GOMBRICH, E. H., 'Light, Form and Texture in
XVth Century Painting', Journal of the Royal
Society of Arts, 1964, pp. 826–49.

GOTTLIEB, C., 'The Mystical Window in Paintings
of the Salvator Mundi', Gazette des Beaux-Arts,
VI / LVI, 1960.

GRABES, H., The Mutable Glass. Mirror Imagery in
Titles and Texts of the Middle Ages and English
Renaissance, Cambridge 1982.

GREGORY, R. L., The Intelligent Eye, London
1970.

GREGORY, R. L., 'Perceptions as Hypothesis',
Philosophical Transactions of the Royal Society of
London B, 290, 1980, pp. 181–97.

GREGORY, R. L., Mirrors in Mind, Basingstoke
1997.

HARTLAUB, G., Die Zauber des Spiegels, Munich
1951.

HOLLANDER, A., Seeing Through Clothes,
California 1993.

JOHNSON, M.H., Developmental Cognitive
Neuroscience, Oxford 1997.

JOHNSON, M.H. and MORTON, J., *Biology and Cognitive Development: The Case of Face Recognition*, Oxford 1991.

KANISZA, G., *Organisation in Vision. Essays on Gestalt Perception*, New York 1979.

KEMP, M., *The Science of Art: Optical Themes in Western Art from Brunelleschi to Seurat*, Newhaven, Connecticut 1990.

KOERNER, J.L., *The Moment of Self-Portraiture in German Renaissance Art*, Yale 1993.

MACH, E., *The Analysis of Sensations and the Relation of the Physical to the Psychical*, revised edition, New York 1959.

MELTZOFF, A.N. and MOORE, M.K., 'Imitation of Facial and Manual Gestures by Human Neonates', *Science*, 198, 1977, pp. 75–8.

METELLI, F., 'The Perception of Transparency', *Scientific American*, 230, 1974, pp. 90–8.

MITCHELL, W.J., *The Reconfigured Eye*, Cambridge, Massachusetts 1992.

MOORE, C. and DUNHAM, P. J. (eds), *Joint Attention: its Origins and Role in Development*, Hillsdale, N.J. 1995.

OVID, *Metamorphoses*, translated by A.D. Melvill, Oxford 1986.

PANOFSKY, E., *Albrecht Dürer*, Princeton, N.J. 1945.

PEARS, D., 'Incongruity of Counterparts', *Mind*, 61, 1952, pp.78–81.

PREMACK, D. and WOODRUFF, G., 'Does the Chimpanzee have a "Theory of Mind"?', *Behaviour and Brain Sciences*, 4, 1978, pp. 515–26.

RAMACHANDRAN, V.S. and RAMACHANDRAN, D.R., 'Synaesthesia in Phantom Limbs Induced with Mirrors', *Proceedings of the Royal Society of London B*, 263, 1996, pp. 377–86.

ROCK, I., *The Logic of Perception*, Cambridge, Massachusetts 1983.

ROCK, I., *Perception*, Basingstoke 1984.

RUSKIN, J., *Elements of Drawing*, New York 1886.

SANTORE, C., 'The Tools of Venus', *Renaissance Studies*, 11(3), 1997.

SCAIFE, M. and BRUNER, J., 'The Capacity for Joint Visual Attention in the Infant', *Nature*, 253, 1975, pp. 265–6.

SCHWARZ, H., 'The Mirror in Art', *Art Quarterly* XV, 1952, pp. 97–118.

SMITH, P. K. and CARRUTHERS, P., (eds), *Theories of Theories of Mind*, Cambridge 1996.

STERN, D. N., *The Interpersonal World of the Infant*, New York 1985.

STEVENSON R. L., *The Strange Case of Dr Jekyll and Mr Hyde*, London 1886.

TYMMS, R., *Doubles in Literary Psychology*, Cambridge 1949.

VASARI, G., *Lives of the Most Eminent Painters, Sculptors and Architects*, translated by G. Bull, London 1965.

WILDE, O., *The Picture of Dorian Gray*, London 1891.

WITTGENSTEIN, L., *Philosophical Investigations*, Oxford 1953.

WOLLHEIM, R., *Art and its Objects: an Introduction to Aesthetics*, New York 1968.

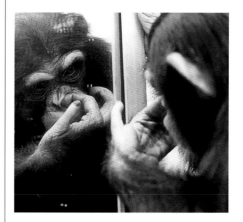

Picture list

page 59

3 Sir Edward Burne-Jones *Study for the Mirror of Venus* (detail) 1867–77, oil on canvas, 76.2 × 119.4 cm, Collection of Lord Lloyd-Webber

page 60

1 Félix Vallotton *Landscape in Provence – The Window* (details) 1920, oil on canvas, 81 × 60 cm, Switzerland, Private Collection

pages 61, 62, 63 and 64

Alexandre-François Desportes *Silver Tureen with Peaches* (details) c.1733–4 – p.54

page 65

2, 3 Henri Cartier-Bresson *Place de l'Europe in the Rain* 1932 (Photo: Cartier-Bresson/Magnum Photos)

page 67

6 French School *A Mon Seul Desir* (detail) from the series *La Dame à la Licorne* c.1490–1500, wool and silk tapestry, 376 × 473 cm, Paris, Musée du Moyen-Age, Cluny (© Photo RMN – Gérard Blot)

pages 68 and 69

1, 2, 3, 4, 5 Johann Erdmann Hummel *The Polishing of the Granite Bowl* (details) 1831 – p.22

pages 70 and 71

1, 2, 3, 4 Sandro Botticelli *Portrait of a Young Man* c.1480–5, tempera and oil on wood, painted surface 37.5 × 28.3 cm, London, National Gallery

pages 74 and 75

1 Robert Campin *Saint John the Baptist and the Franciscan Master of Arts, Heinrich von Werl* (detail) c.1438 – p.33

page 76

1, 2 Robert Campin *Saint John the Baptist and the Franciscan Master of Arts, Heinrich von Werl* (details) c.1438 – p.33

page 77

3 Diego Velázquez *Las Meninas* 1656 – p.12

pages 78 and 79

1, 2, 3, 4 Diego Velázquez *Las Meninas* (details) 1656 – p.12

page 80

1 Paul Cézanne *Still Life with Apples* (detail) c.1877–8, oil on canvas, 19 × 26 cm, Cambridge, Fitzwilliam Museum, By kind permission of the Provost and Fellows of King's College, Cambridge

page 81

2, 3 Samuel van Hoogstraten *A View down a Corridor* (details) 1662, oil on canvas, 264 × 136.5 cm, Dyrham Park, The National Trust (Photo: National Trust Picture Library)

page 82

1 Sébastien Stoskopff *Still Life with a Calf's Head* (detail) 1640 – p.19

page 83

2 Bill Brandt *Self-Portrait with a Mirror, East Sussex Coast* 1965, gelatin-silver print, 34.2 × 29.2 cm, Los Angeles County Museum of Art, The Audrey and Sydney Irmas Collection © Brandt Estate

page 84

1 Delft School *An Interior, with a Woman refusing a Glass of Wine* (detail) 1660–5 – p.18

page 85

2 Maurits Cornelis Escher *Rippled Surface* 1950, linoleum cut in black and grey-brown, printed from two blocks, 26 × 32 cm, The Hague, Gemeentemuseum, © 1998 Cordon Art – Baarn – Holland (All Rights Reserved)

3 Gustave Caillebotte *L'Yerres in the Rain* 1875, oil on canvas, 81 × 59 cm, Indiana University Art Museum, Gift of Mrs Nicholas H. Noyes (Photograph: Michael Cavanagh, Kevin Montague. Copyright 1998 Indiana University Art Museum)

page 86

1 Alexandre-François Desportes *Silver Tureen with Peaches* (detail) c.1733–4 – p.54

page 87

2 George Romney *Mrs Russell and Child* 1786–7, oil on canvas, 146 × 113 cm, Private Collection

page 88

1 René Magritte *La Reproduction Interdite* 1937, oil on canvas, 81 × 65 cm, Rotterdam, Museum Boijmans Van Beuningen (©1998 ADAGP, Paris and DACS, London)

page 89

2 Gerolamo Bedoli *Portrait of Anna Eleonora Sanvitale* (detail) 1562, oil on canvas, 121.5 × 92.2 cm, Parma, Galleria Nazionale

page 90

1 Norman Blamey *Conversation on the Landing* 1977, oil on board, 145 × 89 cm (Photo CCA Stationery)

page 92

1 Clementina Lady Hawarden *Clementina and Isabella Facing One Another* 19th century, London, Victoria & Albert Museum (V&A Picture Library)

page 93

2 Picasso *Girl Before a Mirror* 1932, oil on canvas, 162.3 × 130.2 cm, New York, The Museum of Modern Art, Gift of Mrs Simon Guggenheim (© 1998 Succession Picasso/DACS; Photograph © 1998 The Museum of Modern Art, New York)

page 94

1 Clementina Lady Hawarden *Clementina by a Mirror* 19th century, London, Victoria & Albert Museum (V&A Picture Library)

pages 96 and 97

1 Owen Jones *Greek No. 6* (detail) from *The Grammar of Ornament*, London 1856

2 Owen Jones *Renaissance No. 1* (detail) from *The Grammar of Ornament*, London 1856

3 William Morris *Honeysuckle* 1876, printed cotton, London, Victoria & Albert Museum (V&A Picture Library)

4 C.B. Griesbach *Gothic crockets and finials* from *Historic Ornament: A Pictorial Archive*, Dover Publications, New York 1975

5 Alois Riegl *Corinthian Capital* from *Stilfragen*, Vienna 1893

page 98

1 Caspar David Friedrich *View of the Artist's Studio, Right Window* (detail) 1805–6, sepia on paper, 31 × 24 cm, Vienna, Österreichische Galerie Belvedere

page 99

2 Jonathan Miller *Window in Bologna* 1995

page 100

1 Gabriel Metsu *Woman reading a Letter* c.1663, oil on wood, 52.5 × 40.2 cm, Dublin, National Gallery of Ireland (Reproduction courtesy of the National Gallery of Ireland)

page 101

2 Konstantin Somov *Matin d'Eté* 1932, watercolour heightened with white over pencil, 17.5 × 22.5 cm (Sotheby's Picture Library)

3 Christen Købke *Portrait of the painter Frederik Sødring* 1832, oil on canvas, 42.2 × 37.9 cm, Copenhagen, The Hirschsprung Collection (Photo: Hans Petersen)

4 Pierre Bonnard *Le Tub (Effet de Glace)* 1909, oil on canvas, 73 × 84.5 cm, Winterthur, Villa Flora (©1998 ADAGP, Paris and DACS, London)

page 102

1 Félix Vallotton *Landscape in Provence – The Window* (detail) 1920 – p.60

2 Johan-Christian Dahl *View of Pillnitz through a Window* (detail) 1823, oil on canvas, 70 × 45.5 cm, Essen, Museum Folkwang

page 103

3 Georg Friedrich Kersting *Before the Mirror* 1827, oil on wood, 46 × 35 cm, Kiel, Kunsthalle

page 104

1 Parmigianino *The Mystic Marriage of Saint Catherine* c.1527–31, oil on wood, 74.2 × 57.2 cm, London, National Gallery

page 105

2 Samuel van Hoogstraten *A Peepshow with Views of the Interior of a Dutch House* c.1655–60, oil and egg on wood, 58 × 88 × 60.5 cm, London, National Gallery

page 106

1, 2, 3, 4 Samuel van Hoogstraten *A Peepshow with Views of the Interior of a Dutch House* (details) c.1655–60 – p.105

page 107

5 Jan van Eyck *The Arnolfini Portrait* (detail) 1434 – p.10

pages 108 and 109

1, 2 Bartolomé Bermejo *Saint Michael triumphant over the Devil with the Donor Antonio Juan* c.1468 – p.13

pages 110 and 111

Pieter Claesz. *Still Life with a Turkey Pie* (detail) 1627, oil on panel, 75 × 132 cm, Amsterdam, Rijksmuseum

page 112

1 Pieter Claesz. *Still Life with a Turkey Pie* (detail) 1627 – p.110

page 113

2 Marian Wenzel *Rabbit or Duck?* (detail) from E. H. Gombrich *A Sense of Order*, Phaidon Press Limited, Oxford 1979

page 114

1 Giovanni Girolamo Savoldo *Portrait of a Man* (detail) c.1521, oil on canvas, 91 × 123 cm, Paris, Musée du Louvre (© Photo RMN – Jean Schormans)

page 115

2 Peter Paul Rubens *The Judgement of Paris* (detail) probably 1632–5, oil on oak, 144.8 × 193.7 cm, London, National Gallery

page 116

1 Antonio Pollaiuolo *The Martyrdom of Saint Sebastian* 1475, oil on poplar, 291.5 × 202.6 cm, London, National Gallery

page 117

2 Domenico Gargiulo *Six Studies from different Viewpoints of an armless female Statue* 17th century, pen and ink, 17.4 × 26.4 cm, London, Victoria & Albert Museum (V&A Picture Library)

page 118

1 Jonathan Miller *Staircase in Ferrara* 1995

page 119

2 Sir John Tenniel *Alice disappearing though the Mirror* from Lewis Carroll *Through the Looking Glass and What Alice Found There* 1871 (source: e.t. archive)

page 120

1 Sir John Tenniel *Alice emerging through the Mirror* from Lewis Carroll *Through the Looking Glass and What Alice Found There* 1871 (source: e.t. archive)

page 123

1 Pierre Bonnard *Le Tub (Effet de Glace)* 1909 – p.101

page 124 and 125

1, 2 William Holman Hunt *The Awakening Conscience* 1853–4, retouched 1856, 1857, 1864, 1879–80, 1886, oil on canvas, 76.2 × 55.9 cm, London Tate Gallery (Photo © Tate Gallery, London)

pages 126 and 127

Diego Velázquez *Kitchen Scene with Christ in the House of Martha and Mary* (detail) probably 1618, oil on canvas, 60 × 103.5 cm, London, National Gallery

page 128

1 Gustave Caillebotte *In a Café* (detail) 1880, oil on canvas, 155 × 114 cm, Rouen, Musée des Beaux-Arts (Photo: Didier Tragin/Catherine Lancien)

page 129

2 Edouard Manet *Bar at the Folies-Bergère* 1881–2, oil on canvas, 96 × 130 cm, London, Courtauld Gallery (Courtauld Gift 1934)

page 130

1 Henri Matisse *The Painting Lesson* 1919, oil on canvas, 73.4 × 92.2 cm, Edinburgh, Scottish National Gallery of Modern Art (© Succession H. Matisse/DACS, 1998)

page 131

2 William Holman Hunt *The Lady of Shalott* c.1886–1905, oil on wood, 44.4 × 34.1 cm, Manchester City Art Gallery (© Manchester City Art Galleries)

page 132 (and cover)

1 Unknown Artist *Reflections in a Mirror* (detail) mid-19th century, oil on canvas, 41.5 × 38.5 cm, St Petersburg, The State Russian Museum

page 133

2 Roderic O'Conor *Reclining Nude Before a Mirror – sketch* (detail) 1909, oil on canvas, 54 × 74 cm, Dublin, National Gallery of Ireland (Reproduction courtesy of the National Gallery of Ireland)

page 134

1 Ernst Mach *Monocular Visual Field* from *Contributions to the Analysis of Sensations* 1886

page 135

2 Universal Studios Still from *Duck Soup* 1933 Copyright © 1998 by Universal City Studios, Inc. Courtesy of Universal Studios Publishing Rights, All Rights Reserved (Photo: BFI Films: Stills, Posters and Designs)

page 136

1 Jacques-Augustin-Catherine Pajou *La Famille Pajou* (detail) 1802, oil on wood, 63 × 52.5 cm, Private Collection (© Photo RMN – Berizzi/Ojeda)

page 137

1, 2 Jonathan Miller *Scrambled Faces* 1997

pages 138 and 139

1, 2, 3, 4, 5, 6 A.N. Meltzoff and M.K. Moore *Young Infants Imitating Adult Facial Gestures* from 'Imitation of facial and manual gestures by human neonates', *Science 198*, 1977

7, 8 Jonathan Miller *Rosie* 1996

pages 140 and 141

1, 2, 3, 4 Donna T. Bierschwale *Chimps: Self-Recognition in a Mirror* 1997 (Photo: Donna T. Bierschwale, courtesy of the University of Southwestern Louisiana)

page 142

1 Giovanni Bellini *Woman with a Mirror* (detail) 1515, oil on wood, 62 × 79 cm, Vienna, Kunsthistorisches Museum

2 Attributed to Konrad Witz *Madonna and Child with a Basin* (detail) c.1440, pen and ink, 29.1 × 20 cm, Berlin, Kupferstichkabinett, Staatliche Museen Preussischer Kulturbesitz (Photo: Jörg P. Anders)

page 143

3 Edgar Degas *At the Milliner's* (detail) 1882, pastel on paper, 76.2 × 86.4 cm, New York, Metropolitan Museum of Art, Bequest of Mrs H.O. Havemeyer, 1929. The H.O. Havemeyer Collection (29.100.38). (Photograph © 1998 The Metropolitan Museum of Art)

4 Studio of José de Ribera *A Man with a Mirror* (detail) 17th century, oil on canvas, 113 × 87.5 cm, London, Derek Johns Ltd

page 144

1 Roderic O'Conor *Girl Arranging her Hair in Front of a Mirror* c.1909–10, oil on panel, 45.7 × 37.5 cm, Private Collection

2 Christoffer Wilhelm Eckersberg *Woman standing in front of a Mirror* (detail) 1841, oil on canvas, 33.5 × 26 cm, Copenhagen, The Hirschsprung Collection (Photo: Hans Petersen)

page 145

3 Berthe Morisot *The Cheval Glass* (detail) 1876, oil on canvas, 65 × 54 cm, Madrid, Museo Thyssen-Bornemisza (All rights reserved © Museo Thyssen-Bornemisza, Madrid)

4 Peder Severin Krøyer *Interior. The Artist's Wife* 1889, oil on wood, 35.2 × 24.8 cm, Copenhagen, The Hirschsprung Collection (Photo: Hans Petersen)

page 146

1 Nicolas-René Jollain *Le Bain* (detail) c.1780, oil on canvas, 22.5 × 20.5 cm, Paris, Musée Cognacq-Jay (© Photothèque des musées de la Ville de Paris, cliché Habouzit)

2 Pierre Bonnard *Woman in Front of a Mirror* (detail)

c.1905, oil on canvas, 52 × 37.5 cm, Munich, Neue Pinakothek, Bayerische Staatsgemäldesammlungen (©1998 ADAGP, Paris and DACS, London; Photo: ARTOTHEK)

page 147

3 Andrew and Marilyn Strathern *A Dancer scrutinises himself in a Mirror* c.1970 from Andrew and Marilyn Strathern *Self-Decoration in Mount Hagen*, Duckworth 1971 (© Andrew and Marilyn Strathern 1971)

4 James C. Faris *Kadūndōr decorating – slapping yellow ochre on right side of body, and decorating face with hand mirror* c.1970 from James C. Faris *Nuba Personal Art*, Duckworth 1972 (© James C. Faris 1972)

5 Penny Tweedie 1997 (Photo: Penny Tweedie/Colorific)

page 148

1 Gerard ter Borch *Woman at a Mirror* (detail) c.1650, oil on panel, 34.5 × 26 cm, Amsterdam, Rijksmuseum

page 149

2 Ambrose McEvoy *The Ear-Ring* c.1911, oil on canvas, 76.2 × 63.5 cm, London, Tate Gallery (Photo: © Tate Gallery, London)

page 150

1 Kitagawa Utamaro *A Beauty applying Cosmetic to her Neck* c.1795–6, colour woodblock, 36.9 × 25.4 cm (Sotheby's Picture Library)

2 Clarence White *The Mirror* (detail) 1912, platinum print, 25.1 × 19.4 cm, New York, The Museum of Modern Art, Gift of Mrs William Helburn (copy print © 1998 The Museum of Modern Art, New York)

page 151

3 Balthus *Les Beaux Jours* (detail) 1945–6, oil on canvas, 148 × 199 cm, Washington, Hirshhorn Museum and Sculpture Garden, Smithsonian Institute, Gift of Joseph H. Hirshhorn, 1966 (Photo: Lee Stalsworth)

4 Norman Rockwell *Girl at the Mirror* (detail) 1954, oil on canvas, 80 × 75 cm, Stockbridge, The Norman Rockwell Museum. Photo courtesy of The Norman Rockwell Museum. Printed by permission of the Norman Rockwell Family Trust. Copyright © The Norman Rockwell Family Trust.

5 Gerald Brockhurst *Adolescence* (detail) 1932, etching on paper, 36.5 × 26.5, London, British Museum (Photo © British Museum)

page 152

1 Jean-Frédéric Schall *Evening Toilet* c.1785–90, oil on panel, 23.5 × 17.5 cm, Amsterdam, Rijksmuseum

2 E.J. Bellocq *Untitled (Storyville Portrait)* c.1912, printing-out paper, gold-toned, Collection of Lee Friedlander, courtesy Fraenkel Gallery, San Francisco

3 Rembrandt *A Woman bathing in a Stream (Hendrickje Stoffels?)* 1654, oil on oak, 61.8 × 47 cm, London, National Gallery

4 Twentieth Century Fox Still from *Snow White and the Three Clowns* 1961 (Photo: BFI Films: Stills, Posters and Designs)

page 153

5 Alfred Stevens *'La Parisienne japonaise'* (detail) c.1872, oil on canvas, 150 × 105 cm, Collection du Musée d'Art moderne et d'Art contemporain de la Ville de Liège

6 Nicholas Régnier *A Young Lady at her Toilet* (detail) 1626, oil on canvas, 130 × 105 cm, Lyon, Musée des Beaux-Arts (Photo: Studio Basset)

7 Jacob de Gheyn III *A Woman with a Mirror at a Toilet-Table (Vanity)* early 17th century, engraving on paper, 27.6 × 18.5 cm, London, British Museum (© British Museum)

8 Roy Lichtenstein *Girl in a Mirror* (detail) 1965, enamel on steel, 106.7 × 106.7 cm (© Estate of Roy Lichtenstein/DACS 1998; Photo: © 1979 Sotheby's, Inc.)

page 154

1 Hans von Aachen *Couple with Mirror* c.1596, oil on copper, 25 × 20 cm, Vienna, Kunsthistorisches Museum

page 155

2 Thomas Rowlandson *The Curious Wanton* c.1810–20, etching on paper, 17 × 11 cm, London, British Museum (© British Museum)

3 Kitagawa Utamaro *Hanamurasaki of the Tamaya, Shirabe, Teriha* from *Six Jewel Rivers* 1793, colour woodblock with metallic fillings, 36.2 × 25.1 cm, London, British Museum (© British Museum)

4 Titian *Lady at her Toilet* (detail) c.1515, oil on canvas, 93 × 76 cm, Paris, Musée du Louvre (© Photo RMN)

5 Kangra School *The Lady and the Mirror* c.1820, gouache on paper, 20.5 × 15 cm, London, Victoria & Albert Museum (V&A Picture Library)

page 156

1 Follower of Leonardo *Narcissus* c.1490–9 – p.12

page 157

2 Unknown Italian Artist *Narcissus* probably 15th century, formerly in the collection of The Dayton Art Institute

3 French or Franco-Flemish Tapestry *Narcissus* 1480–1520, wool and silk tapestry, 282 × 311 cm, Boston Museum of Fine Arts, Charles Potter Kling Fund (Courtesy Museum of Fine Arts, Boston)

page 158

1 John William Waterhouse *Echo and Narcissus* (detail) 1903, oil on canvas, 109.2 × 189.2 cm, Liverpool, Walker Art Gallery (The Board of Trustees of the National Museums and Galleries on Merseyside)

2 Berthe Morisot *Study* (detail) 1864, oil on canvas, 60.3 × 73 cm, Collection of Margo K. Schoneman, courtesy of Mount Holyoke Art Museum, South Hadley, Massachusetts

page 159

3 Michelangelo Merisi da Caravaggio *Narcissus* c.1599–1600, oil on canvas, 113 × 95 cm, Rome, Galleria Nazionale d'Arte Antica, Palazzo Corsini (Photo SCALA, Firenze)

page 160

1 Jacob Matham *Pride* from *The Vices* (after Goltzius) (detail) 17th century, engraving on paper, 22 × 14.1 cm, London, British Museum (© British Museum)

2 Studio of Hans Memling *Vanity* (detail) c.1500, oil on oak, 22 × 14 cm, Strasbourg, Musée des Beaux-Arts (Musées de Strasbourg)

page 161

3 Attributed to Jean Cousin *Woman with Mirror* (detail) 16th century, oil on wood, 53 × 34cm, Maçon, Musée Municipal (LAUROS-GIRAUDON, Paris)

4 Sassetta *Luxury* (detail from *Saint Francis in Glory*) 1437–44, tempera on panel, 195 × 119.5 cm, Florence, Villa I Tatti, Berenson Collection, reproduced by permission of the President and Fellows of Harvard College

page 162

1 Jacopo Tintoretto *Susanna and the Elders* (detail) c.1555, oil on canvas, 146.6 × 193.6 cm, Vienna, Kunsthistorisches Museum

page 163

2 Diego Velázquez *The Toilet of Venus ('The Rokeby Venus')* 1647–51, oil on canvas, 122.5 × 177 cm, London, National Gallery

3 Titian *Venus with a Mirror* (detail) c.1555, oil on canvas, 124.5 × 105.5 cm, Washington, National Gallery of Art, Andrew W. Mellon Collection, © 1998 Board of Trustees, National Gallery of Art, Washington

page 164

1 Fontainebleau School *Woman at her Toilet* c.1560, oil on canvas, 105 × 76 cm, Dijon, Musée des Beaux-Arts

page 165

2 Titian *Allegory of Vanity* c.1515, oil on canvas, 97 × 81.2 cm, Munich, Alte Pinakothek, Bayerische Staatsgemäladesammlungen (Photo: ARTOTHEK)

3 Paris Bordone *Venetian Women at their Toilet* (detail) mid-1540s, oil on canvas, 97 × 141 cm, Edinburgh, National Gallery of Scotland

4 Giorgio Vasari *The Toilet of Venus* (detail) 1558, oil on poplar, 154 × 124.5 cm, Stuttgart, Staatsgalerie

page 166

1 Hans Baldung *Vanity* 1529, oil on lime, 82.5 × 35.5 cm, Munich, Alte Pinakothek, Bayerische Staatsgemäladesammlungen (Photo: ARTOTHEK)

2 Hans Baldung *Death and the Woman* (detail) 1517, varnished distemper on lime, 29.5 × 17.5 cm, Basel, Kunstmusem, Öffentliche Kunstsammlung Basel (Photo: Martin Bühler)

page 167

3 Hans Baldung *The Three Ages and Death* c.1509–10, oil on lime, 48.2 × 32.7 cm, Vienna, Kunsthistorisches Museum

4 Albrecht Dürer *Allegory of Youth, Age and Death* c.1520–1, pen and brown ink on paper, 18.7 × 9.9 cm, London, British Museum (© British Museum)

page 168

1 Italian School *Allegory of Vanity – Death Surprising a Woman* 16th century, engraving on paper, 35.5 × 26.3 cm, London, British Museum (© British Museum)

page 169

2 Georges de La Tour *The Repentant Magdalen* (detail) c.1640, oil on canvas, 113 × 92.7 cm, Washington, National Gallery of Art, Ailsa Mellon Bruce Fund, © 1998 Board of Trustees, National Gallery of Art, Washington

3 After Caravaggio *Martha reproving Mary Magdalen for her Vanity* early 17th century, oil on canvas, 97.7 cm × 135.8 cm, Oxford, Christ Church (by permission of the Governing Body)

page 170

1 Unknown French Artist *Allegory of Justice and Vanity (?)* c.1630, oil on canvas, 101 × 82 cm, Oxford, Ashmolean Museum

page 171

2 Jeremias Falck *Old Woman at her Toilet* (after Johann Liss) (detail) 17th century, engraving on paper, 37.5 × 30.4 cm, London, The British Museum (© British Museum)

3 Otto Dix *Woman before a Mirror* (detail) 1921, oil on canvas, dimensions not recorded, destroyed in war (Otto Dix Foundation, Schaffhausen; ©1998 DACS, London)

4 Lucas Furtnagel *Portrait of the Artist Hans Burgkmair and his Wife Anna* (detail) 1529, oil on wood, 60 × 52 cm, Vienna, Kunsthistorisches Museum

page 172

1 Lucas van Leyden *Prudence* from *The Virtues* (detail) 1530, engraving, 162 × 107 cm, Washington, National Gallery of Art, Rosenwald Collection, © 1998 Board of Trustees, National Gallery of Art, Washington

2 Andrea della Robbia *Prudence* c.1475, glazed terracotta, 163.8 cm diameter, New York, Metropolitan Museum of Art, Purchase, Joseph Pulitzer Bequest, 1921 (21.116). (Photograph Schecter Lee © 1986 The Metropolitan Museum of Art)

page 173

3 Simon Vouet *Allegory of Prudence* (detail) c. 1645, oil on canvas, 116 × 90 cm, Montpellier, Musée Fabre (cliché Frédéric Jaulmes)

pages 174 and 175

1, 3 Thielman Kerver *The Virgin with Emblems* from *Heures à l'usage de Rome* Paris 1505, San Marino, California, The Huntington Library

2 Michel Colombe *Prudence and a Mirror* 1502–7 (cast from tomb of François II and Marguerite de Foix, Nantes, Cathédrale Saint-Pierre-et-Saint-Saul) Paris, Musée des Monuments Français (Photo: GIRAUDON)

page 177

1 Albrecht Dürer *Self-Portrait* 1484, silverpoint on prepared paper, 27.5 × 19.6 cm, Vienna, Graphische Sammlung Albertina

page 178

1 Albrecht Dürer *Self-Portrait* c.1491, pen and dark brown ink on paper, 20.4 × 20.8 cm, Erlangen, Universitätsbibliothek, Graphische Sammlung der Universität

page 179

2 Albrecht Dürer *Holy Family* (detail) c.1492–3, pen and ink on paper, 29 × 21.4 cm, Berlin, Kupferstichkabinett, Staatliche Museen Preussischer Kulturbesitz (Photo: Jörg P. Anders)

3 Albrecht Dürer *Melancholia I* 1514, engraving on paper, 23.9 × 18.5 cm, Cambridge, Fogg Art Museum, Harvard University Art Museums, Gift of William Gray from the Collection of Francis Calley Gray

4 Albrecht Dürer *Christ as Man of Sorrows* c.1494, oil on pine, 30 × 19 cm, Karlsruhe, Staatliche Kunsthalle

page 180

1 Albrecht Dürer *Self-Portrait at the Age of 22* c.1493, pen and brown ink on paper, 27.8 × 20.2 cm, New York, Metropolitan Museum of Art, Robert Lehman Collection, 1975. (1975.1.862). (Photograph Schecter Lee © 1997 The Metropolitan Museum of Art)

page 181
2 Albrecht Dürer *Self-Portrait* 1500 – p.36
page 182
1 Master of Saint Veronica *Saint Veronica with the Sudarium* c.1420, oil on walnut, 44.2 × 33.7 cm,
London, National Gallery
2 Coronation Master (?) *Marcia painting her own Portrait* from Boccaccio *Livre des femmes nobles et renommées* Paris c.1402–3, Paris, Bibliothèque nationale de France (cliché Bibliothèque nationale de France)
page 183
3 Clementina Lady Hawarden *Seated in Reflection* 19th century, London, Victoria & Albert Museum
(V&A Picture Library)
page 184
1 Diane Arbus *Self-Portrait (in mirror)* 1945, gelatin-silver print, 16.5 × 11.7, Los Angeles County Museum of Art, The Audrey and Sydney Irmas Collection.
Copyright © 1986 the Estate of Diane Arbus
2 Albrecht Dürer *Self-Portrait* (detail) 1500 – p.36
3 Robert Mapplethorpe *Self-Portrait* (detail) 1980, gelatin-silver print, 35.3 × 40.2 cm, Los Angeles County Museum of Art, The Audrey and Sydney Irmas Collection © 1980 the Estate of Robert Mapplethorpe
page 185
4 Ilse Bing *Self-Portrait in Mirrors* (detail) 1931, gelatin-silver print, 26.5 × 32.3 cm, Los Angeles County Museum of Art, The Audrey and Sydney Irmas Collection
5 Man Ray *Self-Portrait* (detail) c.1944, gelatin-silver print, 17.3 × 12.8 cm, Los Angeles County Museum of Art, The Audrey and Sydney Irmas Collection
© Man Ray Trust/DACS 1998
6 André Kertész *Self-Portrait with Distortion No. 91* 1933, toned gelatin-silver print, 17.8 × 24.7 cm, Los Angeles County Museum of Art, The Audrey and Sydney Irmas Collection © 1985 Estate of André Kertész
7 Edouard Boubat *Self-Portrait* (detail) 1958, gelatin-silver print, 34.9 × 25.8 cm, Los Angeles County Museum of Art, The Audrey and Sydney Irmas Collection
© 1985 Edouard Boubat/TOP
page 186
1 Sir Stanley Spencer *Self-Portrait* 1913, oil on canvas, 62.9 × 50.8 cm, London, Tate Gallery (©1998 DACS, London; Photo © Tate Gallery, London)
page 187
2 Johannes Gumpp *Self-Portrait* (detail) 1646, oil on canvas, 89 cm diameter, Florence, Galleria degli Uffizi (Photo: © Raffaello Bencini, su concessione del Ministero per i Beni Culturali e Ambientali, Firenze)
page 188
1 Rembrandt *Self-Portrait* c.1665, oil on canvas, 114.3 × 94 cm, London, Kenwood House (English Heritage Photo Library)
page 189
2 Norman Rockwell *Triple Self-Portrait* 1960, oil on canvas, 113.5 × 87.5 cm, Stockbridge, The Norman Rockwell Museum. Photo courtesy of The Norman Rockwell Museum. Printed by permission of the Norman Rockwell

Family Trust. Copyright © The Norman Rockwell Family Trust.
page 190
1 Sir William Orpen *Ready To Start – Self-Portrait* 1917, oil on panel, 60.9 × 50.8 cm, London, Imperial War Museum
2 Stephen Conroy *Self-Portrait* 1987, oil on canvas, 102 × 46 cm, Private Collection
3 Victor Emil Janssen *Self-Portrait at the Easel* (detail) 1828, oil on paper on to canvas, 56.6 cm × 32.7 cm, Hamburg, Hamburger Kunsthalle
(Photo: Co Elke Walford, Hamburg)
page 191
3 Sir Joshua Reynolds *Self-Portrait* (detail) c. 1747, oil on canvas, 63.5 × 74.3 cm, London, National Portrait Gallery
4 Lovis Corinth *Self-Portrait* (detail) 1925, oil on canvas, 80.5 × 60.5 cm, Zurich, Kunsthaus, ©1998 by Kunsthaus, Zurich. All rights reserved.
5 Giorgio de Chirico *Self-Portrait with Palette* (detail) 1924, tempera on canvas, 76 × 61 cm, Winterthur, Kunstmuseum (©1998 DACS, London)
page 192
1 Artemisia Gentileschi *Self-Portrait as La Pittura* c.1630, oil on canvas, 96.5 × 73.7 cm, London, Kensington Palace, The Royal Collection © 1998 Her Majesty the Queen
page 193
2 Parmigianino *Self-Portrait in a Convex Mirror* 1524 – p.45
3 Maurits Cornelis Escher *Hand with Reflecting Sphere* 1935, lithograph, 31.8 × 21.3 cm, The Hague, Gemeentemuseum. © 1998 Cordon Art B.V. – Baarn – Holland. All rights reserved.
page 194
1 Lucian Freud *Small Interior (Self-Portrait)* (detail) 1968, oil on canvas, 22.2 × 26.7 cm, Private Collection (Photo: The Bridgeman Art Library, London)
page 195
2 Lucian Freud *Interior with Hand Mirror (Self-Portrait)* 1967, oil on canvas, 25.5 × 17.8 cm, Private Collection
page 196
1 Nicolaes Maes *The Naughty Drummer* c.1655, oil on canvas, 62 × 66.4 cm, Madrid, Museo Thyssen-Bornemisza (All rights reserved © Museo Thyssen-Bornemisza, Madrid)
page 197
2 Caspar David Friedrich *View of the Artist's Studio, Right Window* (detail) 1805–6 – p.98
3 Nicolaes Maes *The Naughty Drummer* (detail) c.1655 – p.196
4 Abraham Hendricksz van Beyeren *Banquet Piece* (detail) c.1675 – p.42
page 198
1 Albrecht Dürer *Self-Portrait* 1484 – p.177
page 199
2 Albrecht Dürer *Self-Portrait* 1500 – p.36
3 Garrett Price *Mirror* 1953 (Garret Price © 1953 from The New Yorker Collection. All Rights Reserved)
page 200
1 John Bratby *Three Self-Portraits with a White Wall* 1957, oil on hardboard, 241.9 × 169.9 cm, Liverpool, Walker

Art Gallery (The Board of Trustees of the National Museums and Galleries on Merseyside)
page 201
2 Giovanni Girolamo Savoldo *Portrait of a Man* c.1521 – p.114
page 202
1 James Abbott McNeill Whistler *The Little White Girl; Symphony in White No. 2* (detail) 1864, oil on canvas, 76.5 × 51.1 cm, London, Tate Gallery (© Tate Gallery, London)
page 203
2 Jean-Auguste-Dominique Ingres *Madame Moitessier* 1856, oil on canvas, 120 × 92.1 cm,
London, National Gallery
page 204
1 Richard Taylor *Alone* 1955 (Richard Taylor © 1955 from The New Yorker Collection. All Rights Reserved)
page 205
2 V.S. Ramachandran *Mirror synæsthesia* 1995 (Reproduced by courtesy of V.S. Ramachandran)
page 207
Sir William Nicholson *The Silver Casket* 1919 – p.5
pages 208 and 209
Jonathan Miller *Untitled* 1998
page 210
Jan Jansz. Treck *Still Life with a Pewter Flagon and Two Ming Bowls* 1649, oil on canvas, 76.5 × 63.8 cm,
London, National Gallery
page 211
2 Joseph Mallord William Turner *Reflections in a Single Polished Metal Globe and in a Pair of Polished Metal Globes* lecture diagram c.1810, oil and pencil on paper, 64 × 96.8 cm, London, Tate Gallery (© Tate Gallery, London)
3 Kitagawa Utamaro *The Priest Huiyuan* from *Three Laughters at Children's Playful Spirits* c.1802, colour woodblock, 37.9 × 25.2 cm, London, British Museum (© British Museum)
page 212
1 Helen Chadwick *Vanity* 1986, cibachrome photograph on paper, 59.7 × 59.7 cm, Birmingham Museums and Art Gallery
page 213
2 John William Waterhouse *Destiny* 1900, oil on canvas, 68.5 × 55 cm, Burnley, Towneley Hall Art Gallery and Museum, Burnley Borough Council (Photo: The Bridgeman Art Library, London)
pages 214 and 215
1, 2 Donna T. Bierschwale *Chimps: Self-Recognition in a Mirror* 1997 – p.13
page 216
Christen Købke *Portrait of the painter Frederik Sødring* 1832 – p.101

Every effort has been made to contact current copyright holders. The publishers would be pleased to make good any errors or omissions brought to our attention in future editions.

Index